£5.00

ROYAL TREASURES
FROM THE LOUVRE

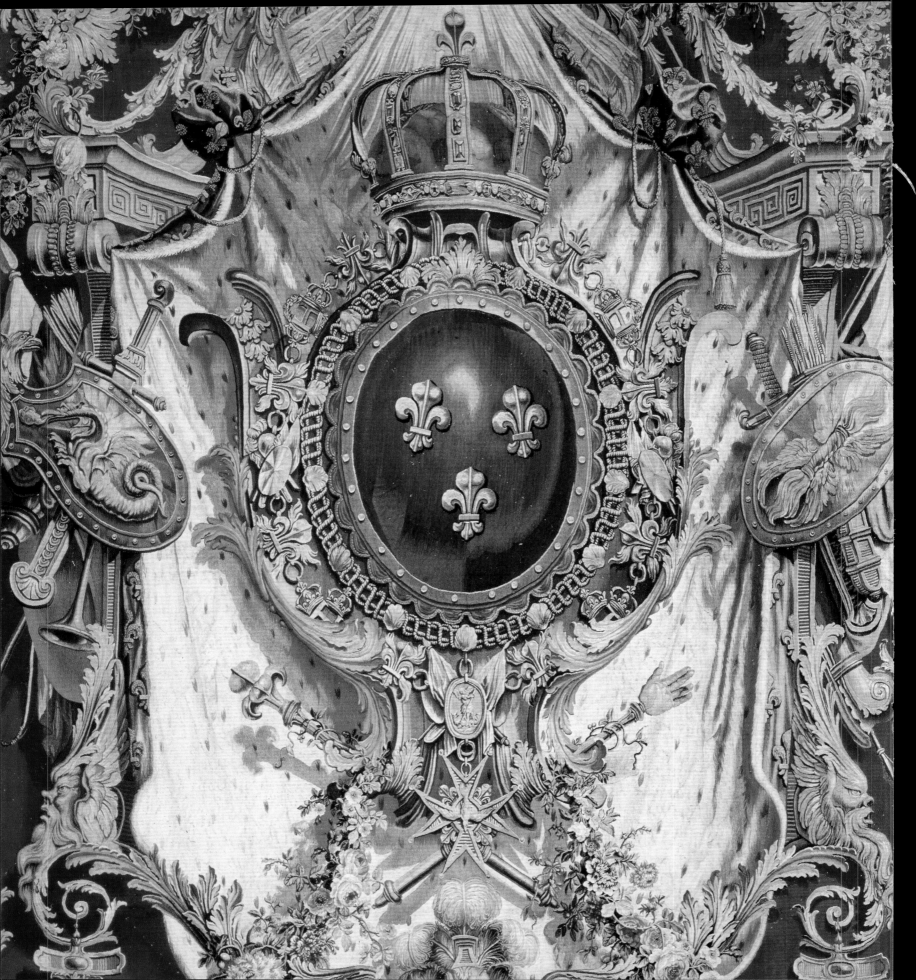

ROYAL TREASURES FROM THE LOUVRE

LOUIS XIV TO MARIE-ANTOINETTE

MARC BASCOU
MICHÈLE BIMBENET-PRIVAT
MARTIN CHAPMAN

FINE ARTS MUSEUMS OF SAN FRANCISCO

DELMONICO BOOKS • PRESTEL

MUNICH LONDON NEW YORK

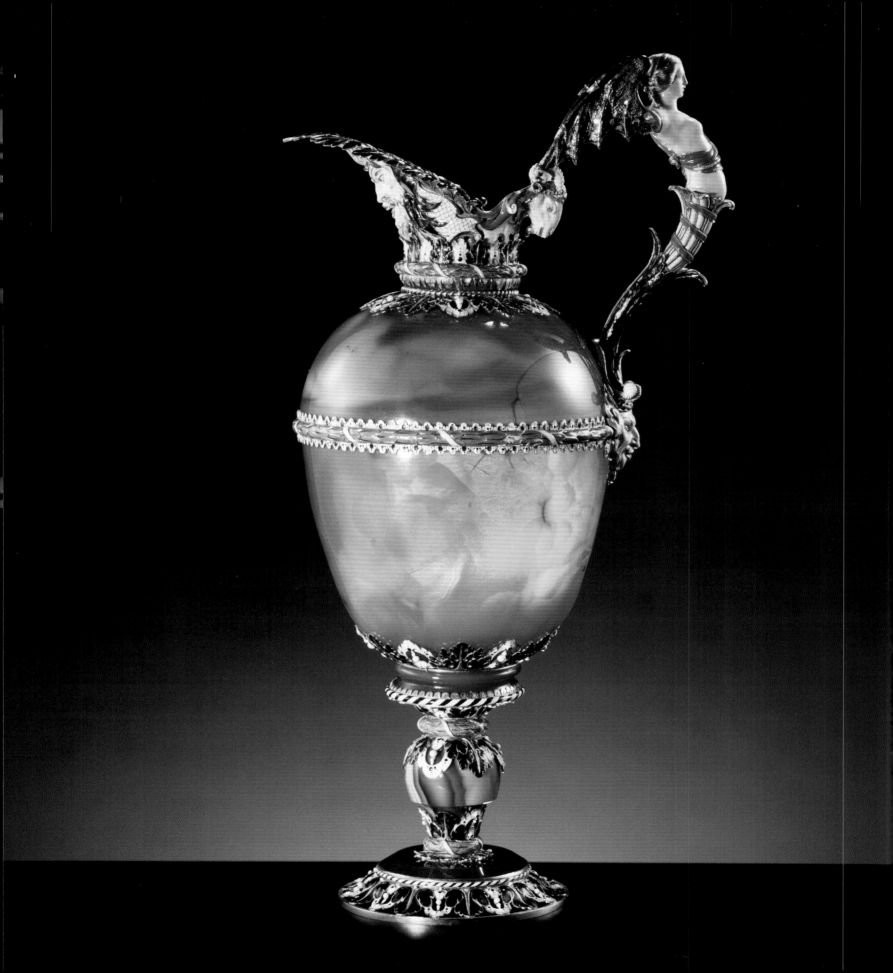

CONTENTS

FOREWORD

he Fine Arts Museums of San Francisco and the Musée du Louvre are very pleased
T to collaborate on the exhibition *Royal Treasures from the Louvre: Louis XIV to Marie-Antoinette*. It is a historic occasion for the Fine Arts Museums as this is the first partnership with the Louvre, which is often acknowledged as the greatest encyclopedic museum in the world.

The Musée du Louvre houses a spectacular collection of objets d'art and furniture of the eighteenth century—a remarkable and prolific period for artistic creation in France, when talented artists and artisans invented styles that would be admired and copied all over the world. Their artistic and technical mastery in the decorative arts remains unrivaled to this day. The American Friends of the Louvre have joined the museum's efforts to ensure the success of the complete refurbishment of the eighteenth-century galleries, in order to offer a more educational and aesthetically stimulating experience to visitors. When the galleries reopen in 2013, a new display, both scholarly and beautiful, will allow visitors to discover the splendors of decorative arts that flourished under the French monarchs.

In order to support such an ambitious renovation project, the Louvre has agreed to lend for this unique exhibition in San Francisco a generous selection of its treasures, many shown for the first time outside of France. One of the highlights of the exhibition will be the Gemmes de la Couronne of Louis XIV, the king's precious hardstone vases mounted in gold with gemstones, which represent the pinnacle of princely collecting in Europe. It also contains a selection of pieces from the former royal collections that show the patronage of the kings of France. An exceptional survival is one "*boîte à portrait*"—a portrait of Louis XIV surrounded by large diamonds, which was made to be given by the king as a diplomatic present. The kings of France had other gifts made at the Gobelins factory, tapestries in particular, and later at the Sèvres porcelain factory. The dinner services and vases given to foreign rulers helped to shape the course of European politics and wars in the latter half of the eighteenth century. From the last years of the ancien régime we have the precious works of art collected by Queen Marie-Antoinette that she kept in her private apartments at Versailles. Miraculously escaping destruction during the

French Revolution, this group of objects includes hardstones and some of them are mounted in gold, showing the queen's personal taste for the rare and the refined.

We are very proud that this presentation heralds an accord between our two museums that will be held over the next five years. Following this exhibition we will continue to work together on projects of mutual interest by lending some of our renowned collections of French and American art and by mounting dossier shows of objects that show the crosscurrents between the holdings common to our museums.

We would like to thank Marc Bascou, Director of the Département des Objets d'Art, and Michèle Bimbenet-Privat, Chief Curator in the Département des Objets d'Art at the Louvre, who worked so efficaciously to assemble the exhibition; and Martin Chapman, Curator in Charge of Decorative Arts and Sculpture at the Fine Arts Museums, who initiated this project and led the installation. We are grateful to Christopher Forbes, Chairman of the American Friends of the Louvre, for his trust and support. Knowing well of his love of France and his earnest desire to form a relationship with the Louvre, we would like to dedicate this exhibition and catalogue to the memory of the former Director of the Fine Arts Museums, John E. Buchanan, Jr.

Diane B. Wilsey
President, Board of Trustees
Fine Arts Museums of San Francisco

Henri Loyrette
President-Director
Musée du Louvre, Paris

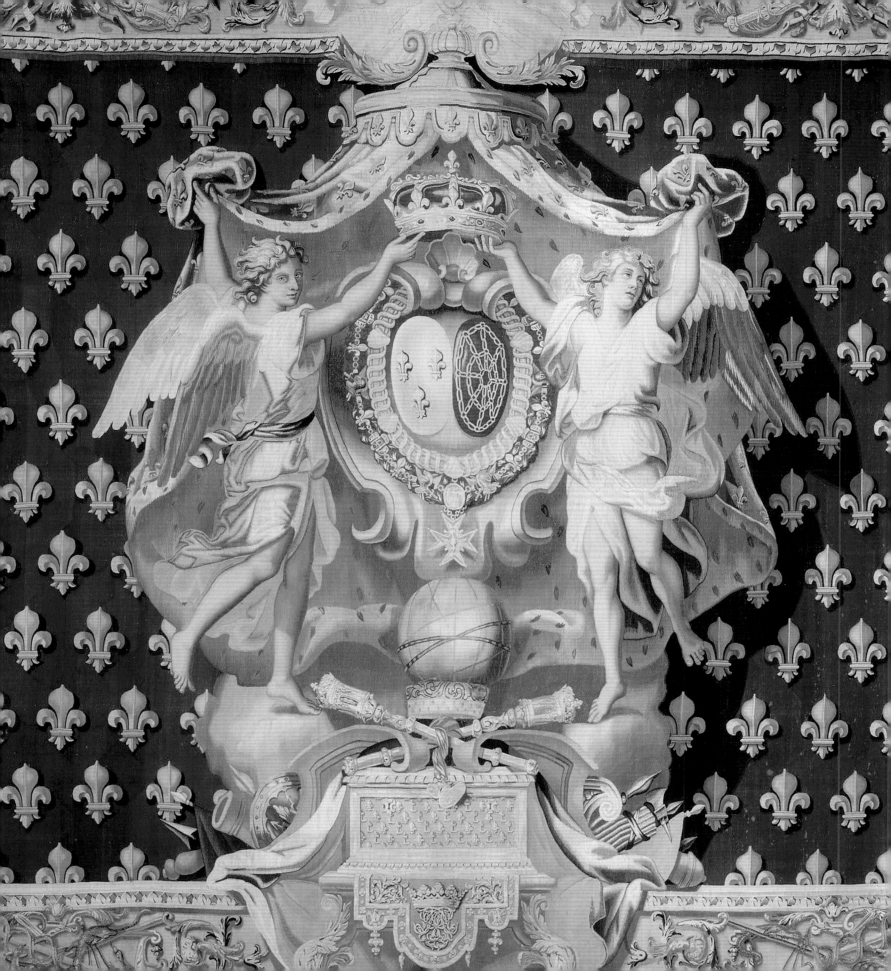

INTRODUCTION
ROYAL HERITAGE: MOUNTED HARDSTONES, GOLD AND SILVER, FURNITURE WITH PIETRE DURE, AND TEXTILES IN THE MUSÉE DU LOUVRE

Marc Bascou

R oyal patronage and collecting at the French court had a long tradition that can be traced back to the early Carolingian (751–987) and Capetian (987–1328) kings. In more modern times, great sovereigns of the Valois and Bourbon dynasties such as Charles V, Francis I, Henry IV, and Louis XIV were strong protectors of the arts as well as avid collectors. The opulence of court ceremonials required maintaining a historic heritage as well as favoring new trends and new fashions; throughout the centuries, the finest artists and craftsmen were eager to demonstrate their skills for each king and his close circle.

The so-called Appartement des Bains created for Francis I (1494–1547) at Fontainebleau, the apartments redecorated in the Louvre for Henry IV (1553–1610), and the private apartments of Louis XIV (1638–1715) at Versailles must have been the most extraordinary interiors of their time, displaying the rarest objects in unique settings.

ART TREASURES OF THE SUN KING

What remains today of this prestigious heritage goes back mostly to the time of Louis XIV. In the best years of his long reign, between 1661 and 1690, the Sun King assembled amazing collections. The general inventory of the Mobilier de la Couronne gives a full description of these treasures: gold objects, jewels, church plates, silver gilt and silver pieces including enormous quantities of silver furniture, silver tableware, gold and silver filigree, agates, rock crystal and other hardstones, mirrors, tapestries, carpets, marbles and bronzes, arms and armor, porcelain, rock crystal chandeliers, Venetian glass, cabinets, tables and pedestals, brocades and embroideries, and more.

All of these treasures were used to furnish the royal apartments in the Louvre, and at the Tuileries and Versailles. The king proudly showed his prized collection of precious hardstones and fragile filigree to distinguished visitors in a series of rooms in his new private apartments at Versailles, organized in the 1680s: the rooms were known as the Cabinets des Raretés, des Curiosités, des Bijoux, des Médailles, and des Coquilles. The Petite Galerie was the climax of these interiors: with its ceiling painted by Nicolas Mignard, its colorful marquetry floor

Tapestry: *Chancellerie*,
ca. 1685
(detail of cat. 2)

by Alexandre-Jean Oppenordt, and its walls decorated with Corinthian pilasters and paneled with mirrors and tortoiseshell tinted in lapis blue, it was the most appropriate setting for the Gemmes de la Couronne (the king's mounted hardstone vases). Today it is hard to imagine the luxury of these rooms, which have completely vanished. Descriptions from contemporaries, or preparatory drawings that we can identify, are some of the only sources left to help us visualize all these lost decors.

We can get a better idea of the splendor of the king's court when we look at the large Gobelins tapestries from the series "Histoire du Roi," which commemorates historic events. It includes scenes such as the audiences given to comte de Fuentès, the ambassador of Spain, in 1662 or to the papal legate, Cardinal Fabio Chigi, in 1664 (fig. 1); or Louis XIV's visit to the Gobelins factory in 1667 (section 1, fig. 3), where the director Charles Le Brun had taken great care to include the monumental cabinets, solid silver furniture, and precious carpets of which the king was so proud.

This splendor was short lived. Louis XIV had to send his fabulous silver furniture to be melted down at the Royal Mint in 1689–1690 during the War of the League of Augsburg (1689–1697). It is a pure miracle that two of the most elaborate cabinets with pietre-dure inlays, which he ordered from Domenico Cucci, have survived intact (see fig. 2). The king's taste in his later years was for less glamorous pieces—and indeed his way of life was changing rapidly by the beginning of the eighteenth century.

FOR LOUIS XV'S SERVICE AND PLEASURE

By the 1730s, fashion had dramatically shifted. The young Louis XV (1710–1774) had no liking for his great-grandfather's collection of rarities, and he returned them to the Garde-Meuble de la Couronne in Paris (the institution that oversaw furniture and works of art in the royal palaces); he also approved the sale of outmoded furniture, hardstone vases, and Asian porcelains, first in 1741 and again in 1751–1752. He had his private apartment at Versailles completely transformed and redecorated. The most inventive architects, designers, and craftsmen had to conceive domestic spaces and furnishings fit for a more intimate lifestyle (see fig. 3).

In this age of perfection and elegance, royal life remained luxurious, but it was expressed in a more refined way. Gold was still present everywhere, in delicate gilded carvings on paneling, on chairs and bed frames, in new types of furniture embellished with colorful marquetry and covered with a lace of gilt bronze, in charming light fittings, and in precious mounted porcelain and lacquer. Although court life was ruled by ceremony in public, comfort and conversation were paramount in private quarters, where a new form of civility and socializing was taking hold in Paris as well as in Versailles. Similarly, court dining adhered to the specifications of the *service à la française*, but ordinary meals in the royal apartments became less formal.

Furniture and objects were constantly renewed for the king and his family. The modern silver delivered over the years by Nicolas Besnier, Thomas Germain, and Jacques Roettiers

Fig. 1 Tapestry: *L'audience du légat*, from the series "Histoire du Roi," 1673
Cardinal Fabio Chigi, nephew of the pope, presents himself to King Louis XIV in his room at the Château de Fontainebleau
Gobelins Manufactory
After Charles Le Brun
Wool and silk with gold, 192^{15}/$_{16}$ × 277^{9}/$_{16}$ in. (490 × 705 cm)
Mobilier National, Paris, on loan to the Musée du Louvre, GMTT 95-1

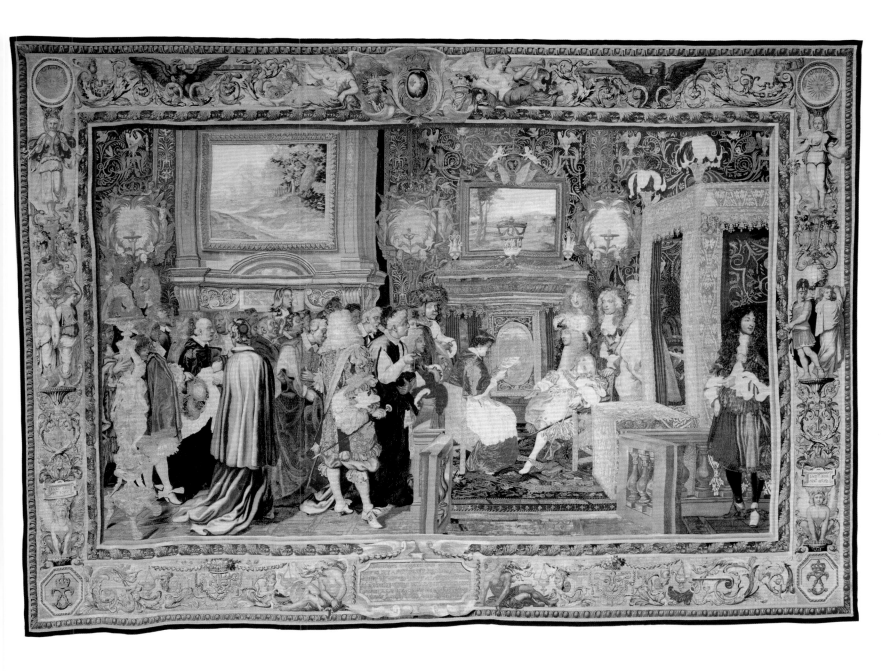

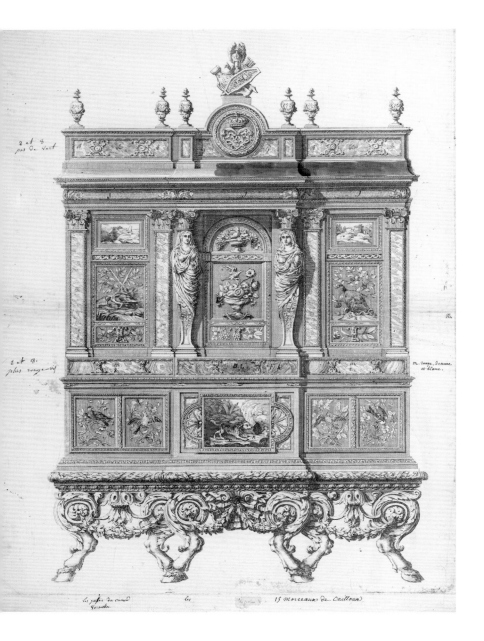

followed the trend of fashion. The *marchands-merciers* (dealers in luxury goods) also provided the court with the latest pieces of furniture and the indispensable utensils for tea or coffee, for the toilette, for writing, for travel, and more. The *Journal du Garde-Meuble*, which listed all the new works delivered to the court, also reveals many details about the private life of the royal family.

The king himself was not a collector but he was a true connoisseur, always inclined to acquire for his own use or offer to his entourage the finest objects bought in Paris. Unlike the shy and pious Queen Marie Leczinska (1703–1768), the royal mistresses Madame de Pompadour and Madame du Barry were avid purchasers of luxury goods, eager to lead the style. It is no surprise to find masterpieces of cabinetmaking by Bernard van Risenburgh, Jean-François Oeben, or Martin Carlin listed in their various apartments. In one specific field— the production of soft-paste porcelain at the Sèvres royal manufactory—the influence of Madame de Pompadour was decisive, setting a completely new ideal in royal and noble circles.

THE TWILIGHT OF THE VERSAILLES COURT

This luxurious lifestyle was maintained by Louis XVI (1754–1793) and Marie-Antoinette (1755–1793) when they acceded to the throne. Like his grandfather, the young king enjoyed furniture with elaborate mechanisms and had a keen interest in Sèvres porcelain. The queen's private apartments in Versailles (fig. 4) and Trianon, as well as Marly and Saint-Cloud, were subject to constant alteration. In 1784, she had new apartments created for herself at the Tuileries, furnished by the cabinetmaker she favored most, Jean-Henri Riesener, so that she could enjoy evening entertainment in Paris (see cat. 83).

More than her husband, the queen developed a real fondness for collecting, mixing Japanese lacquer she had inherited from her mother, Empress Maria Theresa (1717–1780), with newly mounted hardstones and exotic porcelain she commissioned for herself. And it is quite significant that she chose the most elaborate baroque hardstones among Louis XIV's Gemmes de la Couronne for her state and private apartments at Versailles (see section 2, fig. 1): in her grand bedroom, the brilliant nef of the Sun King was the central piece on the console table.

Fig. 2 Monumental cabinet decorated with inlaid precious stones made for Louis XIV by Domenico Cucci, Paris, 1677–1682
Engraving with brown ink wash and watercolor,
26¾ × 9¹¹⁄₁₆ in. (68 × 50 cm)
Musée National des Châteaux de Versailles et de Trianon, inv. GRAV 7209 10-518550

Indeed, in this period there was a greater respect for royal heritage, as well as a desire to make accessible to a larger public the rare objects inherited or collected by the Bourbon kings, which were unfashionable and therefore no longer used by the royal family.

THE FIRST ROYAL MUSEUM

Under the former kings of the Valois and Bourbon dynasties many treasures had already disappeared; it was common practice to alter furnishings, to destroy rich hangings, or simply to dispose of unused items. An ancient custom required that some of the royal furnishings be handed over to Crown officers after the death of the sovereign or one of his heirs. There were also objects given as diplomatic or personal gifts, as the king chose.

Yet what remained was still impressive. From 1776, a special museum was open to the public on certain days in the hôtel du Garde-Meuble de la Couronne, located on place Louis XV (today place de la Concorde) in Paris (see section 7, fig. 1). The four main galleries—the Salle d'Armes, the Galerie des Grands Meubles, the Salle des Bijoux, and the Galerie des Bronzes (which was installed later, in 1786–1788)—contained sumptuous fabrics and embroideries, precious hardstone objects and jewels, bronzes, and weapons and armor, which for the most part had been collected by the first Bourbon kings and were regarded as Crown property.

Around the same time, the comte d'Angiviller had the idea to display the royal collection of old master paintings in the Grande Galerie, facing the river in the old Palais du Louvre, together with pieces of sculpture, marble tables, and vases. In December 1782 spectacular purchases were made on behalf of the king at the sale of a great connoisseur, the duc d'Aumont, adding to the royal Garde-Meuble the finest antique columns and vases mounted in gilt bronze by Pierre Gouthière as well as rare furniture applied with pietre dure (cats. 75–77).

THE GREAT DISPERSAL

The enormous quantity of furnishings accumulated in the various royal residences since the time of Louis XIV was dispersed or simply destroyed—all the silver went to the Royal Mint to be melted down—during the French Revolution. These disastrous revolutionary sales, which started in August 1793, lasted for a year in Versailles and were continued in the châteaux at Fontainebleau, at Marly, at Saint-Cloud, and elsewhere. This explains how in the nineteenth century King George IV (1762–1830) and other great British connoisseurs managed to acquire the most splendid pieces made for the French Crown. Some of the finest furniture delivered for Louis XV, Louis XVI, and Marie-Antoinette has since entered major American institutions such as the Metropolitan Museum of Art in New York and the J. Paul Getty Museum in Los Angeles.

But the situation was rather confusing in the early years of the Revolution as there was also a spirit of preservation. The Commission Temporaire des Arts wished to save some of the most valuable furniture and historic relics for public instruction, while the rival Commission des Revenus Nationaux and Commission de Subsistance sought only the easiest way to raise funds

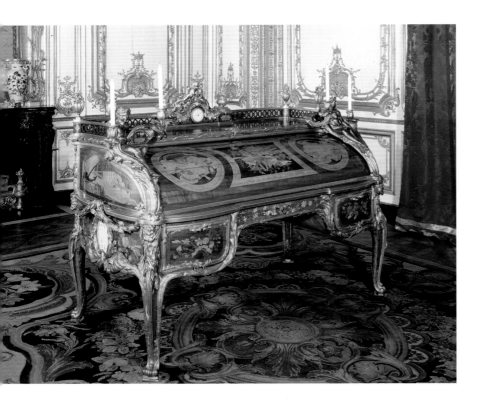

Fig. 3 The study (*cabinet de travail*) in Louis XV's Petits Appartements du Roi at the Château de Versailles, designed by Ange-Jacques Gabriel and carved by Jacques Verberckt. The famous *bureau du roi* (the king's desk), finished in 1769, was made by Jean-François Oeben and Jean-Henri Riesener.

for food and to supply the army. In the end, to satisfy the desires of the authorities of the new regime, some of the best furniture and objects—particularly the latest furnishings delivered for Louis XVI, Marie-Antoinette, and their close family at Compiègne, Saint-Cloud, and Bellevue—were withdrawn from the sales. The magnificent collections acquired or commissioned by Louis XIV were considered national heritage: hardstones and bronzes, Gobelins tapestries, Savonnerie carpets, marble and pietre-dure tables, and columns and vases.

TREASURES SAVED FOR THE NEW MUSEUM

The creation of the Museum Central des Arts in the Palais du Louvre, established by decree on July 27, 1793, played a large part in the preservation of the former royal treasures. The members of the Commission des Arts insisted on removing from the Garde-Meuble what they thought should be destined for the new museum. As a result 124 objets d'art, most of which were from the royal collection—including vases in marble and porphyry, gilt bronzes, and porcelain—were selected to decorate the Grande Galerie. Three years later, in 1796, the best examples from the Gemmes de la Couronne and Bronzes de la Couronne were sent to the Louvre. Some of Marie-Antoinette's personal treasures, which the queen had entrusted to the marchand-mercier Dominique Daguerre when she left Versailles, also found their way to the museum (see section 8).

Alas, the impulse to sell and disperse abroad objects that had been linked with royalty proved more powerful. The first collection of objets d'art chosen for the new museum was partly dismantled in the following years. It was dramatically reduced in 1796 when a number of precious vases and bronzes were sold to pay the Republic's creditors. Some of the finest works from the Garde-Meuble went to foreign agents, such as Jacques de Chapeaurouge and Pierre van Recum. In 1797, however, the administrators of the Louvre succeeded in saving more than 150 tapestries from the former Garde-Meuble, some of which were displayed in the Grand Salon.

HISTORIC TREASURES IN THE PALACES DURING THE NINETEENTH CENTURY

A number of historic objects selected to adorn the imperial apartments at the Tuileries, Saint-Cloud, Compiègne, and Trianon during the First French Empire were removed from the Louvre and the Garde-Meuble. In the first years of his reign, Napoleon (1769–1821) had to use important royal eighteenth-century furniture—by necessity rather than by choice—before

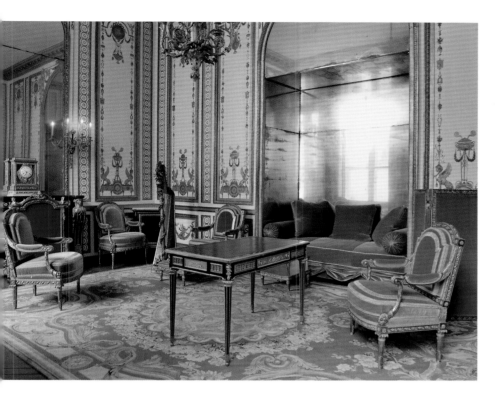

Fig. 4 Marie-Antoinette's Cabinet Doré in her private apartments at the Château de Versailles was designed by Richard Mique with paneling carved by Jules-Hugues Rousseau and Jean-Siméon Rousseau, in 1783. This photograph shows the room after its 2011–2012 restoration.

he could order new furnishings or, in rare instances, when new pieces did not satisfy him. He had a special liking for the imposing furniture made by André-Charles Boulle, and he selected it for his own use. Empress Joséphine (1763–1814), while promoting the best designers of her time, could not resist keeping for herself spectacular pieces saved during the Revolution, such as the Sèvres tea table made for Madame du Barry (cat. 60) or the Sèvres service that had been designed for Marie-Antoinette's dairy at Rambouillet. She was an eclectic collector, more adventurous in her taste for "troubadour" paintings that revived scenes from medieval and Renaissance history than for ancient objects.

When they returned to power in 1815, the brothers of Louis XVI who were the last Bourbon kings, Louis XVIII (1755–1824) and Charles X (1757–1836), found the palaces and castles entirely refurnished. They showed little desire to reclaim lost royal treasures; even more surprising, they let the Garde-Meuble organize the sale in 1827 of fine furniture commissioned by the Crown in the previous century. A tragic loss during the Revolution of 1830 was the theft of twenty-six Gemmes de la Couronne from the Salle des Bijoux in the Louvre: only four were later identified and recovered.

King Louis-Philippe (1773–1850) was convinced of the importance of historic heritage. When he decided to convert Versailles into a museum devoted to French history, he had the state and private apartments restored and partly refurnished. In Louis XIV's bedroom, he clearly intended to re-create the setting he had known before the Revolution (which actually had been entirely remodeled for Louis XVI)(see fig. 5). He inherited from his mother, Louise-Marie-Adélaïde de Bourbon-Penthièvre (1753–1821; she was a great-granddaughter of Louis XIV), the only grand silver tableware that had miraculously escaped being destroyed when all of the royal family's gold and silver plate was melted down. Louis-Philippe's eldest son, Ferdinand-Philippe, duc d'Orléans (1810–1842), was the royal prince who showed the greatest interest in the arts. A true collector, he could easily spot some of the best historic pieces among the old furniture at the Garde-Meuble, and he used them for his apartments in the Tuileries: large Boulle wardrobes; Louis XV's rolltop desk by Riesener; Fontanieu's mechanical table, also by Riesener; and a pair of Carlin's lacquer *encoignures* (corner cupboards) from Bellevue.

Due to the admiration that Empress Eugénie (1826–1920) had for Marie-Antoinette, important pieces of the queen's furniture—like the rolltop desk by Riesener (cat. 83) that she had used at the Tuileries until the somber months of 1791—were given places of honor in the empress's apartments at the Tuileries, Fontainebleau, Compiègne, and Saint-Cloud (see fig. 6). When eighteenth-century royal pieces, or pieces believed to be so, resurfaced on the art market, she was always willing to buy them: her most prized purchase was certainly the fragile little table by Adam Weisweiler (section 6, fig. 3) in gilt bronze, steel, ebony, Japanese lacquer, and mother-of-pearl, which had indeed belonged to Marie-Antoinette.

TREASURES PRESERVED IN THE LOUVRE

The short-lived Musée des Souverains (1852–1870), installed in five rooms on the first floor of the Colonnade, on the east side of the Louvre's Cour Carrée, recalled the former glory of the French monarchy: one of the most distinctive objects was the so-called gold casket of Anne of Austria (wife of Louis XIII), more likely made for Louis XIV himself. It had previously been displayed at the Tuileries, in the king's bedchamber, during the Restoration and in the Salon de Famille under Louis-Philippe.

The Galerie d'Apollon, with its ceiling glorifying the Sun King as a new Apollo—which had been designed in 1663–1677 by Charles Le Brun in collaboration with the sculptors François Girardon, Thomas Regnaudin, and the Marsy brothers, Gaspard and Balthazar—was fully restored and finally completed by the architect Félix Duban between 1848 and 1851. Ten years later large glass cases supported by richly carved gilt tables in the Louis XIV style were installed to display the Gemmes de la Couronne (see section 2, fig. 4). But it was not until September 1870, with the fall of the Second Empire, that the last precious vases were finally brought back from Saint-Cloud and Trianon. It was also at this tragic time, just before the Tuileries and Saint-Cloud were burned down, that major furniture of historic significance was put in the Louvre for protection. A collection of Boulle and lacquer cabinets that had been gathered at Saint-Cloud passed then to the Galerie d'Apollon at the Louvre.

The new section devoted to French eighteenth-century decorative arts, including magnificent pieces from the former royal residences by Boulle, Riesener, Carlin, and Guillaume Beneman, was inaugurated at the Louvre much later, on May 20, 1901, in five large rooms on the first floor of the west wing in the Cour Carrée. This very consistent group of furniture, gilt bronzes, and Gobelins tapestries had been assembled for the *Exposition rétrospective de l'art français* at the World's Fair of 1900 before it was sent to the Louvre.

FORGOTTEN ROYAL TREASURES

Some previously unidentified royal objects appeared in collections assembled by nineteenth- and twentieth-century collectors that were given or bequeathed to the French state. In most cases, the true provenance of the pieces was only established much later. A medievalesque chessboard in rock crystal and silver, as well as a small agate cup that had belonged to Cardinal

Fig. 5 Jean-Baptiste-Fortuné de Fournier
Vue de la chambre de Louis XIV à Versailles, 1861
Gouache, 14½ × 19½ in.
(36.8 × 49.5 cm)
Musée National des Châteaux de Versailles et de Trianon,
inv. V 2011-39-2

This gouache shows the nineteenth-century re-creation of Louis XIV's state bedchamber.

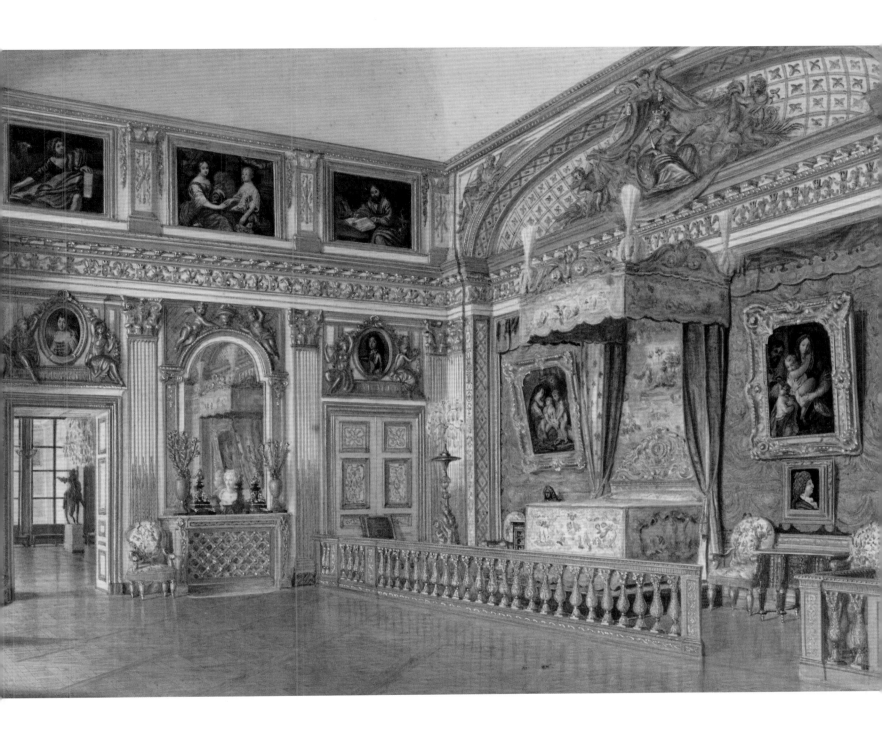

INTRODUCTION

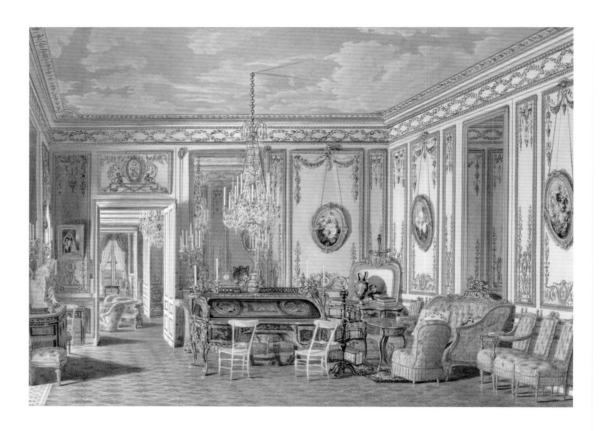

Mazarin, both listed with the Gemmes de la Couronne in 1791, were among the objects sought by the collector Alexandre du Sommerard in the 1830s. The eclectic collection assembled by Adolphe Thiers included a Florentine bronze of an ostrich that had been part of Louis XIV's collection. Other bronzes—*Venus Burning Cupid's Arrows* by Giovanni Francesco Susini and *Hercules and Cerberus* by Antonio Susini—were acquired by the Louvre in 1924 and 1935.

The extensive bequests of comte Isaac de Camondo in 1911 and baron Basile de Schlichting in 1914 included rare royal furniture (see fig. 7). A set of seats by Nicolas-Quinibert Foliot (1706–1776), known as the *Mobilier des dieux*, was thought to come from Versailles, although it was actually delivered for the Dauphine Marie-Antoinette at Choisy. A little mahogany table by Ferdinand Schwerdfeger, unrecognized at the time, is revealing of the queen's taste prior to the Revolution: it is closely linked to a set of mahogany furniture she ordered for her Chambre du Treillage at the Petit Trianon.

Historians interested in old French silver thought extremely highly of a silver-gilt *écuelle* (dated 1690–1692) by Sébastien Leblond bearing the coat of arms and cypher of the Grand Dauphin, son of Louis XIV. This unique example of seventeenth-century royal plate was presented by the Société des Amis du Louvre in 1923. Until recently, little was known about Sèvres tableware bought by the royal family: even a discriminating collector of eighteenth-century porcelain such as Mrs. Élise Dosne-Thiers had no idea that she owned rare examples intended for the service of Louis XV or Louis XVI.

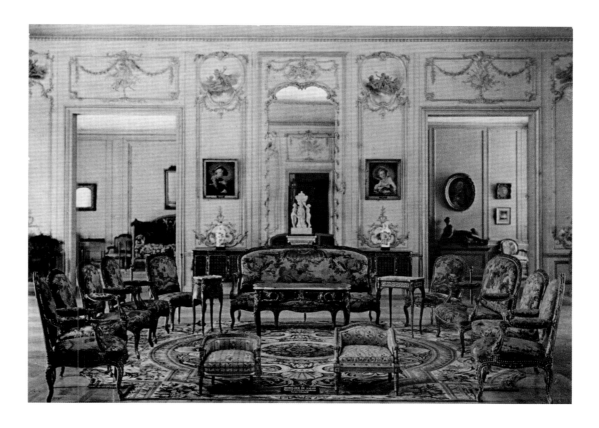

Fig. 7 The Salle Camondo, installed in 1914 in the Mollien wing at the Musée du Louvre. Musée du Louvre, Archives photographiques, Fonds Christiane Aulanier

HUNTING FOR LOST TREASURES

It was after World War II that many lost pieces came to light again, thanks to Pierre Verlet's patient research on the furnishings of the former royal residences in the eighteenth century. As head of the Louvre's Département des Objets d'Art, he recovered, by purchase or by gift, important royal furniture that he was able to identify through old inventory markings and numberings, including a lovely blue-and-white corner cupboard made by Matthieu Criaerd in 1743 for the Château de Choisy and a fine marquetry writing table by Gilles Joubert that was used by the young Marie-Antoinette, newly married in 1770. Verlet knew that two superb marquetry commodes in elaborate floral style, with amazingly fine gilt bronze, had been delivered by Riesener in 1782 for the queen at Marly: one had remained in the Garde-Meuble, and Verlet found the second one in a distinguished private collection. It finally entered the Louvre in 2002. More discoveries were to come, with rare furniture intended for Queen Marie Leczinska's private use: a small desk delivered by Antoine-Robert Gaudreaus in 1733 (fig. 8) for her Cabinet de Retraite at Marly and a commode richly ornamented with Japanese lacquer, made by van Risenburgh in 1737 for her cabinet at Fontainebleau.

Some historic hardstones and bronzes have resurfaced occasionally since 1945. Two agate vases—a Milanese cup carved like a shell with silver-gilt mounts featuring a dolphin, and a rich ewer with an elaborate setting in enameled gold and rubies by Pierre Delabarre—were bought by the Louvre in 1968 and 1971. Other bronzes, including *The Fowler* by Antonio Susini

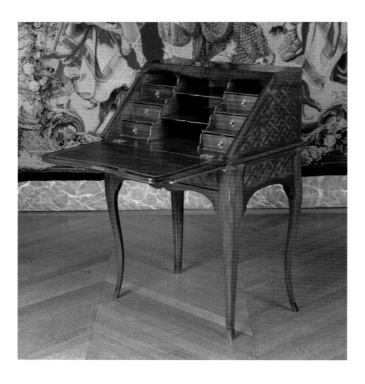

Fig. 8 Writing desk, 1733
Made for Marie Leczinska
at Marly
Antoine-Robert Gaudreaus
Cherry with veneer, bronze,
and silver plate,
39 3/8 × 26 3/8 × 18 5/16 in.
(100 × 67 × 46.5 cm)
Musée du Louvre, Département
des Objets d'Art, OA 12013

opposite:
Fig. 9 Traveling service (*nécessaire de voyage*), 1787–1789
Made for Marie-Antoinette
Jean Philippe Palma and Jean-Pierre Charpenat
Porcelain, ivory, silver gilt,
ebony, brass, and mahogany,
7 1/2 × 32 5/16 × 19 1/8 in.
(19 × 82 × 48.5 cm)
Musée du Louvre, Département
des Objets d'Art, OA 9594

and *Apollo and Daphne, Roger and Angelica* by Ferdinando Tacca, were offered as gifts or were purchased.

Important pieces of royal silver that escaped changes of taste and destruction are exceedingly scarce. A gold beaker with delicate foliage engraved between spiral ribs, which by tradition belonged to Anne of Austria, counts among the rarest pieces from the time of the first Bourbon sovereigns. The Louvre was very fortunate to acquire Marie Leczinska's refined chocolate and tea service by Henri-Nicolas Cousinet, as well as Marie-Antoinette's large traveling service (fig. 9). The Société des Amis du Louvre offered in 1969 the silver-gilt altar plate ordered from François-Thomas Germain in 1752 for the young duc de Bourgogne, Louis XV's grandson. Thirteen pieces of Rococo silver by Thomas Germain, Edme-Pierre Balzac, and Antoine-Sébastien Durand, mainly from the Penthièvre-Orléans dinner service, were reunited over time thanks to the generosity of the David-Weill family and the friends of the museum; some pieces were also acquired on the art market.

One last example stands apart: the delicate urn in agate mounted in gold on a pedestal with miniatures imitating cameos, made by Charles Ouizille and Jacques-Joseph de Gault in 1784–1785 for Marie-Antoinette (cat. 89). Verlet recognized this unique piece in the sale of former King Farouk of Egypt in 1954 and it was finally acquired at auction in 1982.

It seems so obvious today that this prestigious royal heritage should represent the nucleus of the vast collections of the Louvre, which encompass ancient Greek and Roman art, old master paintings and drawings, sculpture, and decorative art. Yet it should be remembered that only part of this heritage entered the museum when it was founded. In more than two hundred years, a fair number of these royal heirlooms have been slowly reassembled in the main galleries of the Louvre, especially in the Département des Objets d'Art.

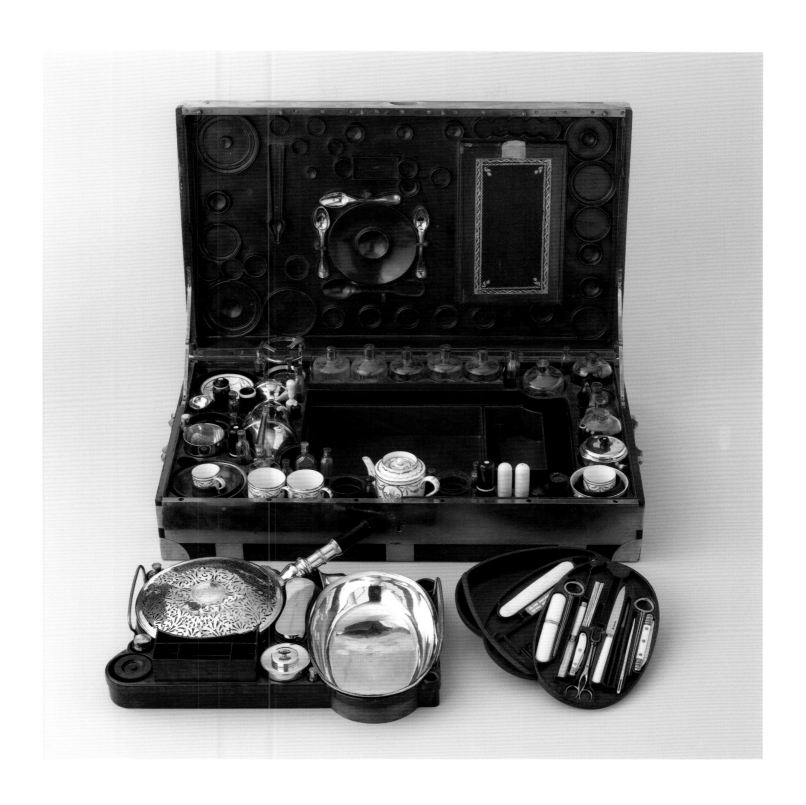

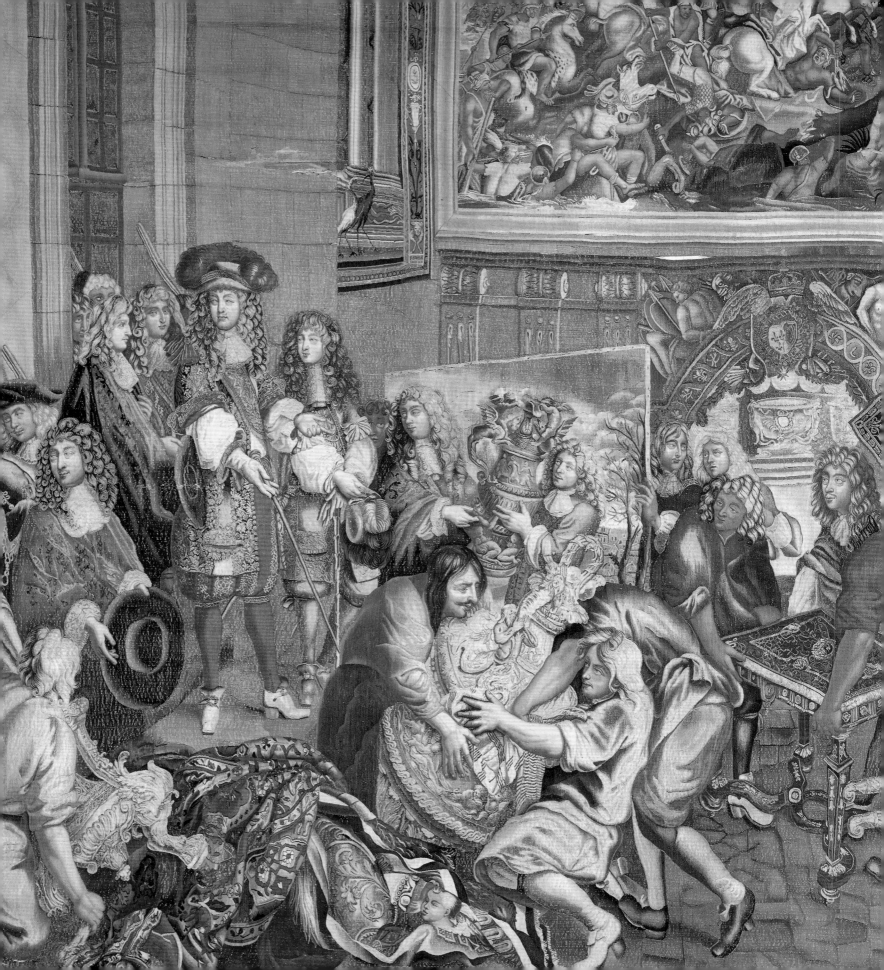

ART IN THE SERVICE OF THE KING: THE GALERIE DU LOUVRE AND THE GOBELINS

Michèle Bimbenet-Privat

I t was during the seventeenth century that the role of "artist to the king" truly acquired its meaning. Previously those in service to the royal court, most of whom were Parisians, were given official titles—for example, *peintre du roi*, *tapissier valet de chambre du roi*, *orfèvre suivant la cour*, and *tailleur de la Garde-Robe*[1]—along with a pension from the Maison du Roi and, most importantly, legal privileges and significant tax exemptions. As with Fontainebleau in the sixteenth century, the construction, expansion, and decoration of Versailles were achieved by Parisian workers. In both cases, hundreds of artists and their employees were housed on-site, outside Paris, and paid by the royal administration throughout the many decades they were there. But there were important differences in their situations as well.

In 1595, Henry IV (1553–1610) ordered the construction of the Grande Galerie du Louvre, an immense corridor more than a quarter mile long that ran alongside the Seine. In accordance with the king's grand architectural plan (fig. 1), the Galerie would connect the older buildings of the Louvre with those of the Palais des Tuileries, which was the newer royal residence.[2] In June 1607, before the work was completed, the king decided to create living and working spaces for artists on the Galerie's lower floors. Twenty-seven apartments and five large ateliers were installed in the corridor along the quay, for a "number of the best craftsmen and masters of painting, sculpting, gold work, clockmaking, gem engraving, along with other excellent arts."[3] The idea that artists deserved special distinctions was not new in France, but a gathering such as this—artists working in diverse disciplines, living closely together and influencing one another—not only was unprecedented in Paris but almost certainly contributed to the city's reputation in Europe as an artistic capital. In another innovation, the Galerie's artists, regardless of their places of birth, were all granted certain privileges. The guilds, for example, usually allowed an artist to train only one apprentice at a time; however, as acknowledged masters in their various métiers, the Galerie artists could train several. The apprentices, in turn, could become master craftsmen in Paris (or in any city in France) without having to produce a masterpiece or pay a duty. This was done "to create a nursery for workers who would, under the tutelage of such talented masters, produce many others, who would afterward spread throughout

Tapestry: *Visite de Louis XIV aux Gobelins, 15 octobre 1667*, from the series "Histoire du Roi," 1673 (detail of fig. 3)

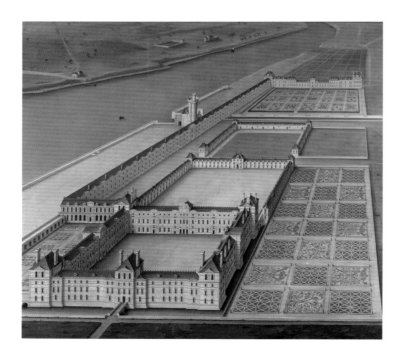

Fig. 1 Louis Poisson
*Grand dessin d'Henri IV
(château du Louvre)*, ca.
1600–1615
Wall mural
Château de Fontainebleau,
Galerie des Cerfs, Musée
National du Château de
Fontainebleau

*This depiction shows a view
of the Grande Galerie du Louvre
along the Seine.*

our entire kingdom and be able to serve the public to very good purpose."[4] Evident in this premise is a spirit of generosity and a desire to spread the knowledge developed in the Galerie du Louvre. It was conceived as a source of artistic talent that would be nurtured and increased under the benevolent eye of the king.

We possess very precise information about the tenants of the Galerie, thanks to the nineteenth-century historians who patiently researched the *brevets de logement* (appointments) of the artists.[5] The image that emerges is one of a wonderful diversity of specialties. In addition to painters and sculptors, there were makers of clocks, damask, Turkish rugs, high-warp tapestries, perfume, mathematical instruments, coins, cutlery, and swords, and inlayers of gold and silver; there were gem engravers, weavers, makers of astronomical globes, cabinetmakers, joiners, and carpenters. The weavers' workshops, together with those of the sculptors, occupied five large ateliers, the great size of which was essential for their artworks. Although the Galerie was a prestigious place to live—its inhabitants were called *les Illustres* (the Famous)—it was in fact extremely cramped and crowded. The individual apartments spread vertically over three levels, with the shops and ateliers on the ground floor and the living area for the families on the upper floors. Some of the artists made alternative living arrangements: in 1631 the silversmith François Roberday moved to the Tuileries; cabinetmaker André-Charles Boulle, officially admitted to the Galerie in 1672, did not move in until 1679, after he had obtained additional, much larger rooms in another wing of the palace. And in 1601 Henry IV provided "a large house that used to be a dyeing factory" to the Flemish low-warp tapestry makers. The house was in the faubourg Saint-Marcel, close to the river Bièvre, in a place called the Gobelins.

Artists and artisans who possessed skills that were not traditionally found in France were of course in the highest demand, and this created the multilingual "republic of the arts" inhabited by *les Illustres*. Jean Vangrol was one of numerous diamond dealers from Antwerp; Marc Bimbi, an Italian, joined his fellow enamelers and goldsmiths from Florence; and Jean Nocret, a painter, was from Lorraine. Carlo Vigarani, an Italian scene designer, worked on the theater at Versailles. There were Roman plasterers, such as the Branchi. The cabinetmaker Boulle (originally named Bolt, from Gueldern, Germany) worked among other German cabinetmakers and marquetry makers. In addition to international diversity, the first generations at the Galerie du Louvre reflected the newfound religious freedom that had been introduced in France after the Edict of Nantes in 1598. Numerous Protestants were admitted to the Galerie, and some occupations (for example, goldsmiths, engravers, jewelers, clockmakers,

and makers of mathematical instruments) were dominated by Huguenots from the French provinces or those returning from Geneva or the Protestant German nations. The most beautiful French portrait medals from the beginning of the seventeenth century were made by Guillaume Dupré, and the finest mounted objects in Cardinal Mazarin's collections (later inherited by Louis XIV) were created by two families of goldsmiths, the Delabarres and the Légarés. Under Louis XIII, who reigned from 1610 to 1643, the goldsmiths of the Galerie du Louvre originated a particularly florid ornamental style, called *cosse de pois* (peapod) for its botanical components.[6]

Significantly, none of the artists at the Galerie du Louvre were defectors from the Maison du Roi, and it appears that these two privileged groups, at least initially, did not interact. A closer study, however, reveals that their responsibilities were complementary: the Garde-Robe (which supplied the royal family's jewelry and the gemstones for their attire) did not encroach on the prerogatives of the Galerie du Louvre, whose goldsmiths primarily provided mounts for gemstones and hardstone objects. This meant that the Valois dynasty's collection of precious objects, which had been dispersed during the French Wars of Religion (1562–1598), could be partially reconstituted in Paris under Louis XIII, well before the acquisitions from Cardinal Mazarin's collections. Under Roberday's supervision, the Tuileries ateliers revealed themselves to be pioneers in the production of the silver furniture for which Versailles would later become famous.[7]

Louis XIV's chief minister of finance, Jean-Baptiste Colbert,[8] had exemplary logistic and organizational skills: during the king's reign he not only restructured the workshops of the many different royal artists but also reorganized the Crown's collections.[9] Working under Colbert, Gédéon Berbier Du Metz, intendant of the Garde-Meuble, compiled the *Inventaire général du garde-meuble de la Couronne*,[10] the first general inventory and description of the royal holdings, including gold and silver objects, rock crystals and precious stones, tapestries, paintings, marbles, weapons, furniture, beds, and linens and other fabrics. Du Metz also introduced a new register, the *Journal du Garde-Meuble*, to track the frequent movements of the objects from one royal residence to another—and to make sure that none disappeared. The *Journal* is a particularly valuable source of information because it was amended, without interruption, until the end of the ancien régime in 1792. This rigorous system of inventory management has enabled later generations to possess a greater knowledge of the French royal collections. There are gaps in this knowledge, however: the gold and silver objects are a special case, because most of them were destroyed during the extensive meltings of 1689–1690. The original forms and impressive dimensions of these works are still reflected in the beautiful faience from the city of Nevers and in the figures and vessels of gilt bronze, which also extended the success of models created by Louis XIV's great silversmiths into the eighteenth century. The objects are also known from designs, drawings, and cartoons, and from their representations on Gobelins tapestries. Scenes in three series of tapestries—"Histoire du Roi," "Mois," and "Les Maisons Royales"—portray some of the firedogs, tea tables, vases,

perfume burners, ewers, *branchards* (handled stands), and bowls produced for Louis XIV by the artists at the Galerie du Louvre.

Artist Charles Le Brun oversaw the design and creation of all of these types of objects. A pupil of Simon Vouet, Le Brun first trained in Italy. In 1664 Louis XIV appointed him *premier peintre du roi* (first painter to the king); a year later he was appointed director of the Gobelins.[11] Le Brun, a true visionary and an inspiration to those who worked with him, was the central figure of the art world that surrounded Louis XIV. Even journalists during his own time failed to find sufficient words to describe every aspect of his career, and in 1690 the *Mercure Galant* concluded his obituary: "Finally, Le Brun was so universal that all arts worked under him, and he even supplied the designs for locksmiths."[12] It was Le Brun who provided his sketches to about fifty painters, employed by the Gobelins, who were responsible for transforming his ideas into the design elements of Louis XIV's silver furniture. The furniture would be made by a team of silversmiths, likewise hired by the Gobelins and assisted by their colleagues at the Galerie du Louvre. Each painter had a specialty: figures, architectural elements, ornaments, or landscapes. The same process of production was used for most of the works of arts represented in the royal ateliers, including tapestries, silver (fig. 2), engraving, and furniture. Like the artists in the Galerie du Louvre, those artisans employed by the Gobelins were given certain privileges: they were allowed to live on-site with their families, and foreign workers were given papers of naturalization. At its busiest times under Le Brun, the Gobelins employed up to eight hundred craftsmen, and it was often compared to *une petite ville* (a small town). Also like the Galerie, cramped living conditions were the norm. The wages of the workers varied according to the difficulty of the work they had to create. After completing a six-year apprenticeship, followed by four years of service with the masters at the manufactory, apprentices would be given the status of master craftsmen.

Soon, the Galerie artists and their counterparts at the Gobelins began collaborating on artistic projects. At the Louvre, silversmith Claude Ballin I was assisted by his student, silversmith Nicolas Delaunay, as well as by Pierre Merlin and Pierre Germain. An excellent designer, Ballin collaborated with the Gobelins painters to produce the designs for the "Histoire du Roi" tapestries,[13] which doubtless explains the great number of silver works depicted in the series. (Rewoven seven times, the third version is preserved in its entirety at the Château de Versailles.)[14] At first the Gobelins factory was intended solely to produce tapestries. Only after the official 1667 edict "for the establishment of a royal furniture manufactory at the Gobelins" did silversmiths appear among the Gobelins residents: on the list, they come after the painters, tapestry makers, and sculptors, but before the founders, engravers, stonecutters, joiners, cabinetmakers, carpenters, and dyers.[15] The desire of the Gobelins to diversify into other artistic areas is evident in the display that was staged by Le Brun to welcome Louis XIV on his visit to the ateliers on October 15, 1667 (fig. 3). According to the *Gazette de France*:

Fig. 2 Charles Le Brun
Sketch for a silver
gueridon, ca. 1668
Red chalk, 12 × 8 in.
(31.7 × 20.5 cm)
Musée du Louvre,
Département des Arts
Graphiques,
inv. 29835 recto

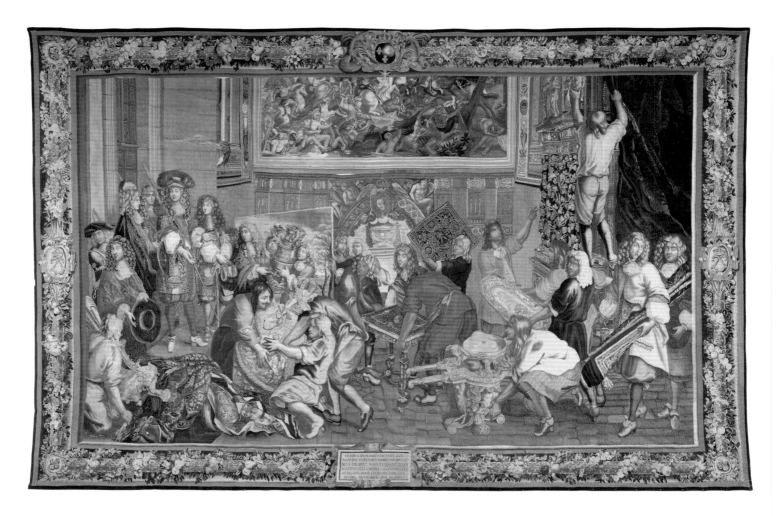

Fig. 3 Tapestry: *Visite de Louis XIV aux Gobelins, 15 octobre 1667*, from the series "Histoire du Roi," 1673 Gobelins Manufactory After Charles Le Brun Wool and silk with gold, 145 11/16 × 226 3/4 in. (370 × 576 cm) Musée National des Châteaux de Versailles et de Trianon, inv. V 384-12

The entrance to the courtyard where the pavilion is situated was ornamented with pictures, statues, trophies, and inscriptions, which formed a most magnificent sort of triumphal arch, and the great courtyard was hung round with the superb tapestries manufactured in the place, with a buffet nine fathoms in length, raised in twelve tiers, on which were arranged, in a manner as ingenious as it was magnificent, the rich goldsmiths' works, which are made in this same establishment. . . . After having examined all these beautiful articles, His Majesty went into all the places where they make the pictures, works of sculpture, miniatures, and wood for inlaid work, as well as the high- and low-warp tapestries, and carpets in the Persian style.[16]

This flawless organization never overlooked even the smallest detail, and its master artists and craftsmen were regularly assigned to produce works on both a monumental and a modest scale. It is known how much Louis XIV became personally involved in the creations from the Gobelins. Turning to the *Mercure Galant*, whose journalist visited the Gobelins in 1673:

Mr. Cucci, from Rome, works on large ebony cabinets, sculptures, miniatures, silver ornaments and precious stones; he also works on locks for doors and windows for the royal palaces, all finely crafted; he has produced many locks for Versailles, and they are considered masterpieces by everybody who has seen them. He has been in France for fifteen years, and it was His Majesty who brought him here. He completed six large cabinets for the King, which are works of stunning beauty. The first is called the Cabinet of Apollo and the second, that of Diana. The next two he made represent the Temple of Peace and the Temple of Virtue, and that is what His Majesty calls them. The latest two are still at the Gobelins.[17]

Domenico Cucci, a craftsman skilled in cabinetmaking, hardstones, and gilt bronze, was called to France by Cardinal Mazarin and given an apartment and an atelier at the Gobelins in 1662. He was joined in 1668 by a team of Florentine workers in hardstones, under the direction of Filippo Branchi and Ferdinando Megliorini. This created an entire workshop devoted to the cutting and inlaying of hardstones (agate, lapis lazuli, jasper, and amethyst) for the mosaic tables that had come into fashion after the cabinets.[18] The importance of these artists can be assessed by their salaries, which were twenty times higher than those of the tapestry makers. The tabletop (cat. 3) delivered between 1688 and 1693 is undoubtedly one of the atelier's masterpieces and wonderfully demonstrates the talent of the Gobelins' marquetry workers. Each corner has a globe decorated with the fleurs-de-lis taken from the king's coat of arms, surmounted by a lyre of Apollo, and two of the sides are adorned with splendid, fruit-filled agate bowls on lions' paws.

Thus, within a far-reaching economic program, new and novel structures were put in place. Although their initial purpose was the furnishing and decoration of the royal residences, their success and longevity clearly far exceeded those initial objectives. As Roger-Armand Weigert wrote in his study about the Gobelins, its production, through all kinds of turmoil, changes of political regimes, and administrative vicissitudes, participated without faltering in the evolution of taste, aesthetics, and thought.[19]

1. These titles roughly translate to the following: painter to the king, tapestry makers "valet de chambre" of the king, goldsmith or silversmith attached to the court, and tailor of the Garde-Robe.

2. *Le Louvre et son quartier: 800 ans d'histoire architecturale* (Paris: Mairie Annexe du 1er Arrondissement, 1982), no. 38.

3. Patent letters dated December 22, 1608, resuming those dated June 30, 1607, on the artists housed at the Louvre; see G. Huard, "Les logements des artisans dans la grande galerie du Louvre sous Henri IV et Louis XIII," *Bulletin de la Société de l'Histoire de l'Art français* (1939): 18–36.

4. Foreword to the patent letters dated December 22, 1608.

5. Jules Guiffrey, "Logements d'artistes au Louvre," *Nouvelles Archives de l'Art français* (1873): 1–221; Huard, "Les logements," 18–36.

6. Peter Fuhring and Michèle Bimbenet-Privat, "Le style 'cosses de pois': L'orfèvrerie et la gravure à Paris sous Louis XIII," *Gazette des Beaux-Arts* (January 2002): 1–224.

7. Michèle Bimbenet-Privat, *Les orfèvres et l'orfèvrerie de Paris au XVIIe siècle*, 2 vols. (Paris: Paris-Musées, 2002), 1:117–122.

8. Colbert was made minister of state in 1661, superintendent of the Bâtiments du Roi in 1664, controller general of finances in 1665, and secretary of state of the Maison du Roi in 1669.

9. Pierre Verlet, *Le mobilier royal français* (Paris: Les Éditions d'Art et d'Histoire, 1955); Stéphane Castelluccio, *Le garde-meuble de la Couronne et ses intendants du XVIe au XVIIIe siècle* (Paris: C.T.H.S., 2004).

10. Archives Nationales, Paris, O1* 3330 to 3333 (1663–1715); Jules Guiffrey, *Inventaire général du mobilier de la Couronne sous Louis XIV (1669–1705)*, 2 vols. (Paris: Société d'encouragement pour la propagation des livres d'art, 1885–1896).

11. *Charles Le Brun 1619–1690: Peintre et dessinateur* (Versailles: Château de Versailles, 1963).

12. *Mercure Galant* (February 1690): 258–260.

13. Fabienne Joubert, Amaury Lefébure, and Pascal-François Bertrand, *Histoire de la tapisserie en Europe du Moyen Âge à nos jours* (Paris: Flammarion, 1995), 189.

14. Daniel Meyer, *L'histoire du Roy* (Paris: Réunion des Musées Nationaux, 1980).

15. The edict was recorded by Parliament on December 21, 1667.

16. Nine fathoms is fifty-four feet. *Gazette de France* (October 15, 1667).

17. *Mercure Galant* (1673), t. III, 117.

18. Stéphane Castelluccio, *Les meubles de pierres dures de Louis XIV et l'atelier des Gobelins* (Dijon: Éditions Faton, 2007), 40–83.

19. Roger-Armand Weigert, *Les Gobelins (1662–1962): Trois siècles de tapisserie française* (Nyon: Imprimerie du courrier de la Côte, 1962), 34.

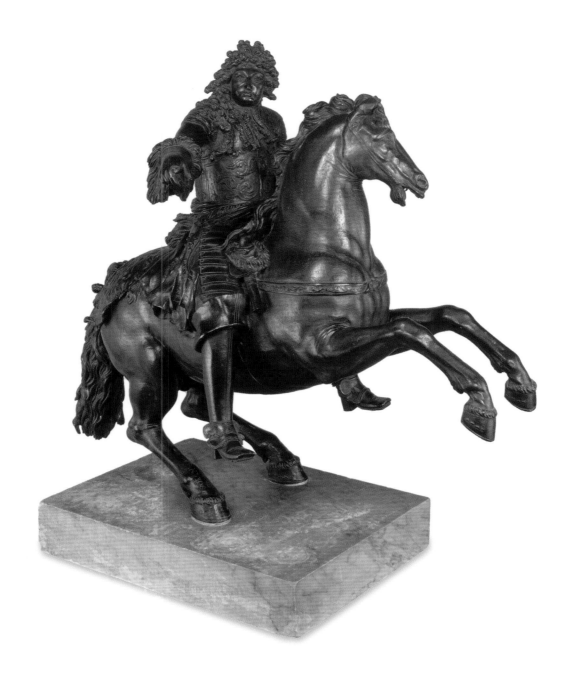

LOUIS XIV AND THE GOBELINS

In 1662 Louis XIV established court workshops at the Gobelins to furnish the royal palaces with suitably grand objects. Tapestries, carpets, silver furniture, hardstone tables, and cabinets were all made there under the direction of the artist Charles Le Brun from 1663 until his death in 1690.

1

Equestrian statue of Louis XIV, 1680–1690

After Thomas Gobert (French, ca. 1640–1708), sculptor

Bronze

This equestrian statue of Louis XIV was one of the few to survive the Revolution. It was displayed in the king's
Cabinet des Médailles at Versailles from 1707.

2

Tapestry: *Chancellerie*, ca. 1685

Beauvais Manufactory (France, active 1664)

Central section after François Bonnemer (French, 1638–1689), painter; borders after Jean Lemoyne (French, 1638–1715), painter

Wool and silk

Tapestries known as chancelleries *were given by the king to his chief justices, or chancellors. This example bears the arms of France, with the symbols (crossed maces and the casket containing the royal seals) and cypher of Chancellor Louis Boucherat in the middle of the lower border.*

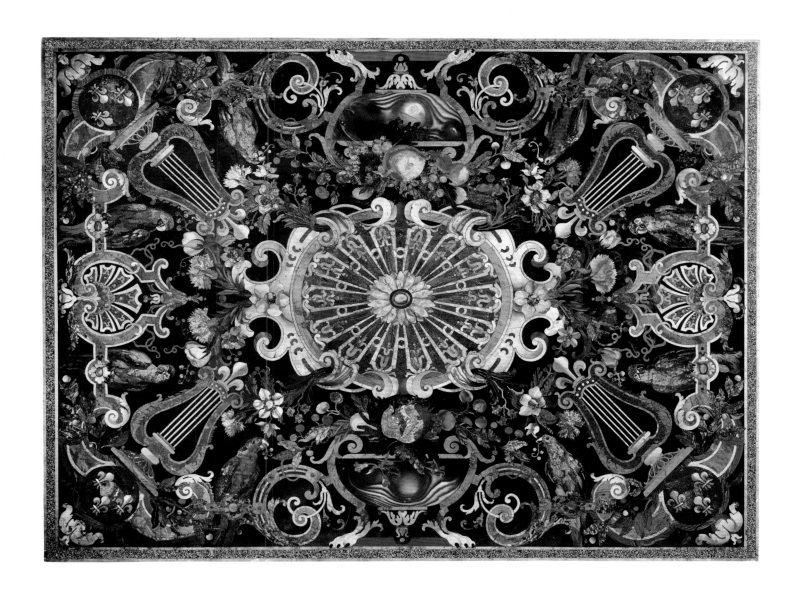

3
Mosaic tabletop with emblems of Louis XIV, last quarter of the 17th century
Gobelins Manufactory (France, established 1662)
Marble and pietre dure (hardstones)

Made of semiprecious stones in the Gobelins court workshops, this elaborate and brilliantly colored tabletop was destined for the royal collections.
It is decorated with symbols of Louis XIV—lyres of Apollo and fleurs-de-lis—interspersed with heavy garlands of flowers
and images of exotic parrots.

4
Pair of vases, 17th century
Rome, Italy
Porphyry

Porphyry has been valued since ancient times for its hardness as well as its purple color, which is associated with imperial status.
Initially mined exclusively in one Egyptian quarry, this hardest of stones is very difficult to work. These vases, made in seventeenth-century Rome,
were probably created from reused pieces of porphyry excavated at ancient sites.

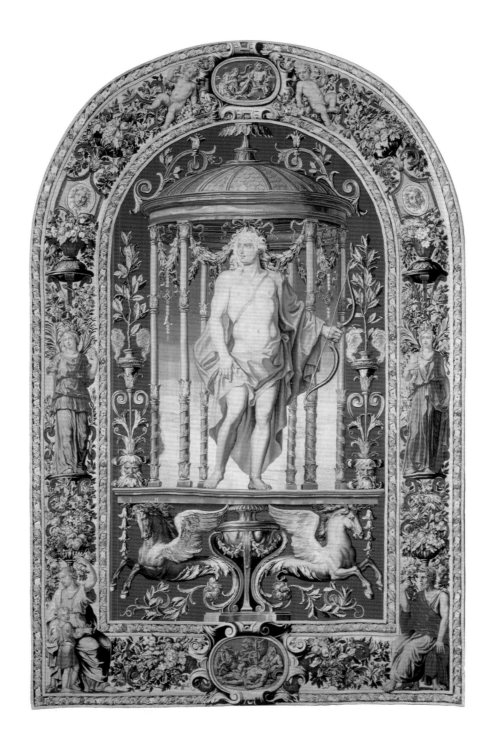

5

Tapestry: *Apollo*, from the series "Tenture des Mois Arabesques," ca. 1697
Gobelins Manufactory (France, established 1662)
Workshop of Jean de La Croix (French, 1662–1712)
After Noël Coypel (French, 1628–1707), painter
Wool and silk

This tapestry, unusual for its arched top, depicts Louis XIV as Apollo. It was woven for a niche in the king's cabinet at Trianon
(today known as the Grand Trianon), the private retreat Louis XIV built at Versailles.

ART IN THE SERVICE OF THE KING

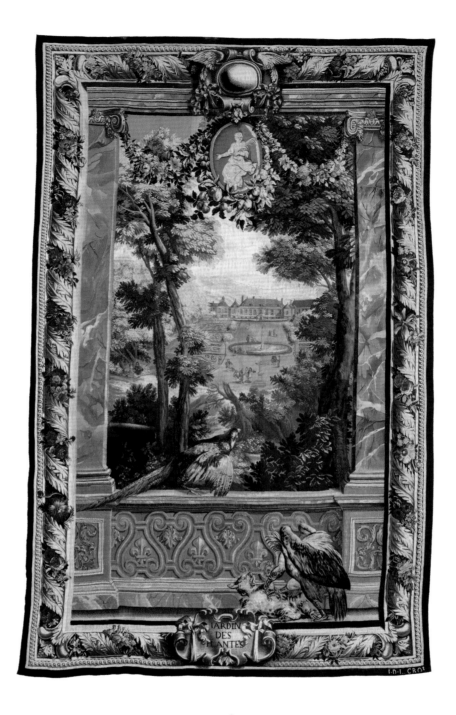

6

Tapestry: *Le Jardin des Plantes*, from the series "Les Maisons Royales," 1662–1712

Gobelins Manufactory (France, established 1662)

Workshop of Jean de La Croix (French, 1662–1712)

After Charles Le Brun (French, 1619–1690), painter

Wool and silk

Designed by the court artist Charles Le Brun, this tapestry was part of a series depicting the royal residences. The narrow width indicates that it was an entre-fenêtre, *intended to be placed between windows. Many tapestries from this series were given as diplomatic gifts, while others were used in the royal households.*

7

Pair of painted doors, ca. 1670

From the bedchamber of Queen Marie-Thérèse (1638–1683) at the Palais des Tuileries

Painted and gilded wood

The Palais des Tuileries, the principal royal residence in Paris, closed off the western end of the Louvre courtyard. The queen's apartment was renovated between 1666 and 1671; the decoration was supervised by Charles Le Brun, with the collaboration of the painters Jean Nocret (1615–1672) and Jean-François Millet (called Francisque Millet, 1642–1679). Remarkably, these doors survived the fire that destroyed the Tuileries during the Commune of 1871.

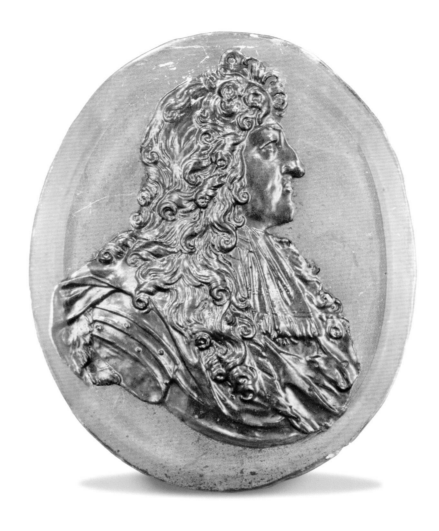

8
Portrait of Philippe, duc d'Orléans, ca. 1687–1695
Workshop of Bernard Perrot (Italian, active France; 1619–1709)
Relief in molded glass with gilding

Brother to Louis XIV, the duc d'Orléans was the patron of the Perrot glass house.

9
Pair of ewers with Bacchic scenes, ca. 1680–1685
Nevers, France
Bacchic scenes after Michel Dorigny (French, 1616–1665), painter
Faience with polychrome decoration

This group of vessels recalls the elaborate designs of the famous silver made for Louis XIV, most of which was melted down during the economic austerities of 1689 and 1709.

ART IN THE SERVICE OF THE KING

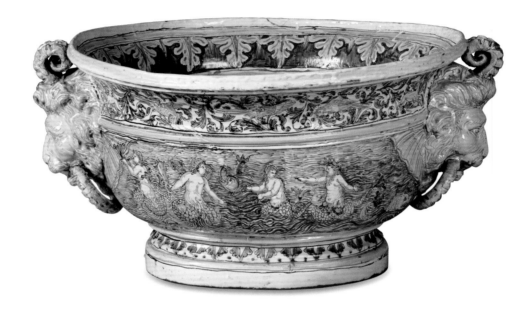

10
Wine cistern depicting "The Drunkenness of Bacchus," ca. 1680
Nevers, France
Faience with polychrome decoration

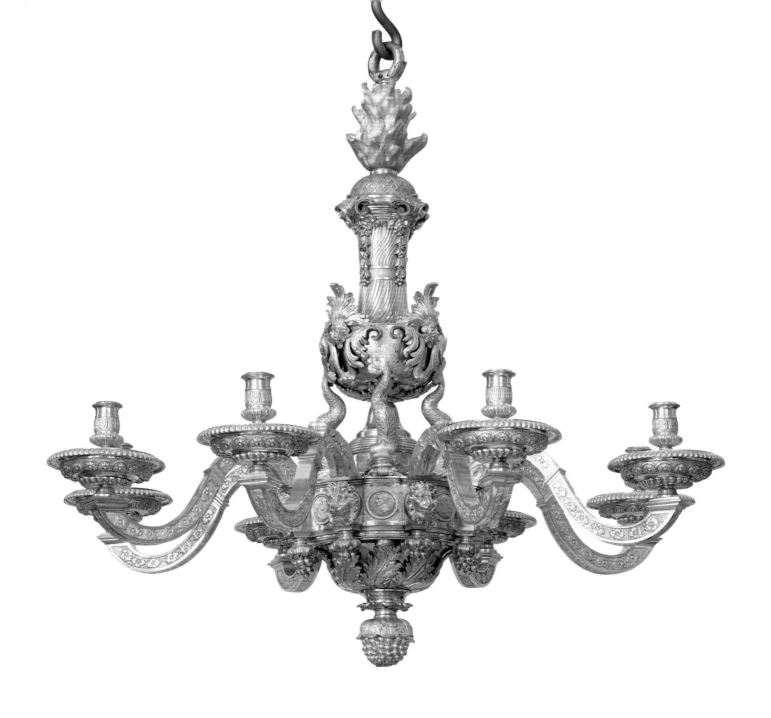

11

Chandelier, ca. 1700
Paris, France
Attributed to André-Charles Boulle (French, 1642–1732; master before 1666)
Gilt bronze

*Gilt bronze became the preferred material for chandeliers and light fixtures in the early eighteenth century. These objects continued
the tradition of the celebrated silver made for the Crown, most of which had been melted down in 1689 and 1709.*

ART IN THE SERVICE OF THE KING

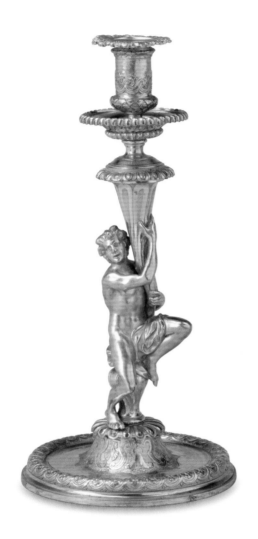
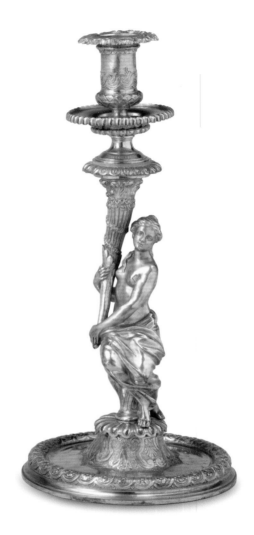

12
Pair of candlesticks, ca. 1700
After Nicolas Delaunay (French, 1646–1727; master in 1672), silversmith;
After Corneille van Clève (French, 1646–1732), sculptor
Gilt bronze

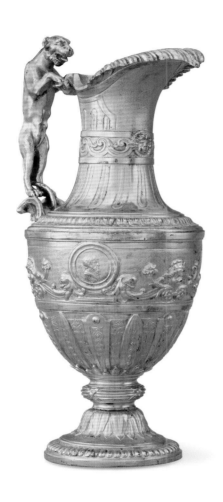
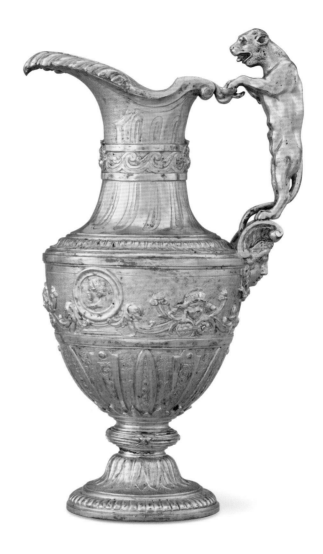

13
Pair of ewers, ca. 1700
After Nicolas Delaunay (French, 1646–1727; master in 1672), silversmith
Gilt bronze

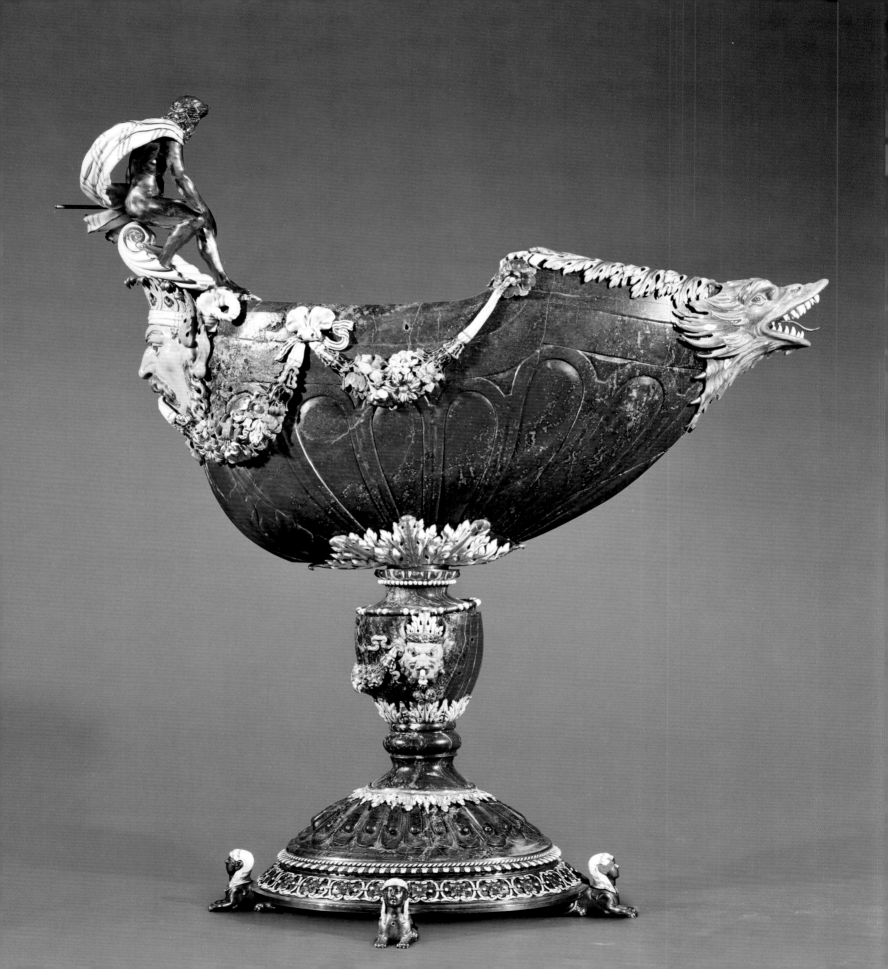

THE GEMMES DE LA COURONNE: THE FRENCH CROWN COLLECTION OF HARDSTONES

Marc Bascou
‖‖‖‖‖‖‖‖‖‖‖‖‖‖‖‖‖‖

T‌he desire to collect was instilled in young Louis XIV (1638–1715; reigned 1643–1715) by the magnificent collections of Cardinal Mazarin—but the pupil quickly surpassed his mentor. The scale of Louis XIV's acquisitions made the French Crown collection of precious and semiprecious hardstones the most complete among those assembled by any great Western ruler since the Middle Ages. While not quite as rich in Renaissance masterpieces as the Medici collection in Florence, the Habsburg collection in Vienna, or the Wittelsbach collection in Munich, it nevertheless offered an unparalleled overview of glyptics (carved and engraved semiprecious stones) from the later Roman Empire to the late seventeenth century, and it served as an extraordinary testimony to the virtuosity of European goldsmiths and jewelers from the fifteenth to the early eighteenth century. At that time, such opulence and diversity could only be found in the rival collection of the king's son, the Grand Dauphin. We might wonder, however, which acquisitions were made to display the monarchy's magnificence and which were made purely for the delight of the collector.

Over twenty-five years Louis XIV would accumulate the most splendid collection of precious and semiprecious objects and vessels in Europe: the inventory of 1713 lists a total of 823 objects, subcategorized into 446 works of rock crystal and 377 different semiprecious colored stones.[1] With the exception of a few sporadic additions between 1660 and 1680, or toward the end of his reign, the collection was primarily established during two periods: in 1665, when the king purchased the best objects in Mazarin's collections (121 items made of rock crystal and 76 of other colored gemstones); and between 1683 and 1689, after the official installation of the court in Versailles.[2]

His precious vases included an eclectic combination of antique, Byzantine, medieval, and oriental hardstones with sixteenth- and seventeenth-century mounts from Milan, Prague, and Germany. The French pieces—which often date to the reign of his father, Louis XIII, or to the regency of his mother, Anne of Austria—signify the king's fondness for the most exuberant creations from the finest Parisian goldsmiths and enamelers working between 1620 and 1650.[3] Significantly, the collection includes a greater number of older objects—made at least fifty years earlier—than it does contemporary works, with the exception of a few pieces of German

Fig. 1 Lapis lazuli nef from Louis XIV's collection, ca. 1670
Cup (Italy): lapis lazuli, 16th century
Mounts (Paris, France): silver gilt and enameled gold,
16⁹/₁₆ × 13 × 7⁵/₁₆ in.
(42 × 33 × 18.5 cm)
Musée du Louvre, Département des Objets d'Art, MR 262

hardstones and Milanese rock crystal.[4] That there were so few royal commissions from the king's goldsmiths and jewelers is indeed surprising, despite the fact that certain hardstones remained unmounted or were given simple, unornamented mounts, such as the spectacular jasper nef bearing the monogram of Emperor Rudolf II (1552–1612). Although Louis XIV declared a preference for carved rock crystal—of which there was more in his collection than any other colored stone—it does not appear that the king gave any credence to the symbolism traditionally assigned to certain minerals, or that he was aware that many of his rare hardstones had survived since antiquity and, in some cases, had origins in the Byzantine Empire.

As the collection grew in the 1660s and 1670s it took over a more and more spectacular space in the royal apartments, accompanying the king as he moved between his palaces at Saint-Germain-en-Laye, Versailles, and Paris. In 1664 the carpenter Saint Yves delivered to Versailles two cabinets designed to house and display the collection: they stood on richly carved and gilded wooden feet, and they were fitted with openwork doors and large mirrors. The following year two additional cabinets, with tortoiseshell and ivory inlays, enclosed by doors with Venetian mirrors and equipped with shelves, were added to the Cabinet des Cristaux.[5] In 1669, at the Tuileries, an enormous closet, sixteen feet wide and painted in imitation of different types of marble, filled with mirrors and tiered shelves, was necessary to contain all the agates and rock crystals.[6]

These early, temporary installations, however, were a mere prologue to the sumptuous displays at Versailles during the 1680s. The new royal apartments, which included the suites of Queen Marie-Thérèse as well as those of the marquise de Montespan, mistress of the king, finally permitted Louis XIV to present his collection in its entirety. A selection of objects was displayed in the *grand appartement du roi*, while others were reserved for the king's private apartments. Some of the collection resided in the very official Cabinet du Conseil, but most of it adorned two rooms: the Cabinet des Raretés, the four corners of which had been fitted with mirrored pentagonal niches in 1682–1683; and the dazzling Petite Galerie, which was also lined with large mirrored panels. Thus, these meticulously selected "Kunstkammer" objects gained a theatrical dimension: so many shimmering works placed on mantelpieces or tables as ornaments were exhibited in a mirrored environment that reproduced them infinite times. Although they were once merely curiosities, they became an integral part of the royal splendor and the symbolic proclamation of the glory of the Sun King.

Louis XV (1710–1774; reigned 1715–1774) did not share his great-grandfather's passion for hardstones: in the 1730s these vessels were returned to the Garde-Meuble de la Couronne in Paris to make room for new decorations in the king's apartments. In 1752 almost one hundred hardstones were sold after Moyse-Augustin de Fontanieu, the *contrôleur général* of the Garde-Meuble, ordered the sale of Louis XIV's discarded furniture and rarities.[7]

With the new reign of Louis XVI, and with the onset of Neoclassicism, the hardstones were viewed with renewed interest. The Musée du Garde-Meuble opened in 1776 on place Louis XV (now place de la Concorde) (section 7, fig. 1), and it included a Salle des Bijoux reserved for

opposite:
Fig. 2 A detail of the ceiling of the Salon de l'Abondance at the Château de Versailles painted by René-Antoine Houasse in 1683.

This painting depicts some of Louis XIV's mounted hardstones.

THE GEMMES DE LA COURONNE

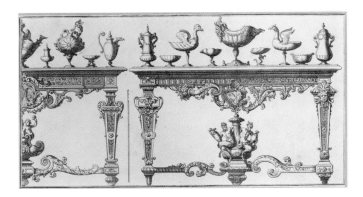

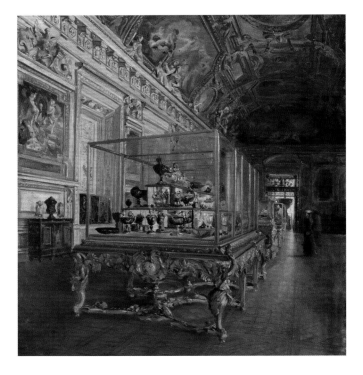

Fig. 3 Pierre Le Pautre
Livres des tables qui sont dans les appartements du roy, sur lesquelles son posés les Bijoux du Cabinet des Médailles, ca. 1700
Engraving, 9⅛ × 14⅛ in. (23.1 × 35.9 cm)
Musée National des Châteaux de Versailles et de Trianon, inv. GRAV 774

This engraving depicts some of the king's mounted hardstones.

Fig. 4 Frédéric Grasset
Une vitrine de la Galerie d'Apollon, 1900
Oil on canvas,
18⅛ × 21⅝ in. (46 × 55 cm)
Musée du Louvre,
Département des Peintures,
inv. R. F. 1969-8

the display of the king's collection of hardstone vessels and Crown jewels.[8] Marie-Antoinette (1755–1793) also had a distinct preference for such precious objects: she ordered some of the most brilliant hardstones back to Versailles, to be placed in her grand bedchamber and her private apartments (see fig. 1 and section 8).[9]

Mostly untouched by the turmoil of the French Revolution, Louis XIV's hardstones were later destined for the Museum Central des Arts, founded in 1793 at the Palais du Louvre. During the Empire, a fair number were reclaimed by the Garde-Meuble to decorate the residences of the sovereigns once again. Only near the end of the Second Empire were most of the works reunited at the Louvre. In 1861 they were installed in one of the most prestigious spaces in the museum, the Galerie d'Apollon (Apollo Gallery) (see fig. 4), which was dedicated entirely to honoring Louis XIV and where they have been stored ever since.[10]

1. Daniel Alcouffe, "Les Gemmes de la Couronne: Une collection unique au monde," *Dossier de l'art* 120 (June 2005): 62.

2. Daniel Alcouffe, *Les Gemmes de la Couronne* (Paris: Réunion des Musées Nationaux, 2001), 11–13.

3. Michèle Bimbenet-Privat, "Vases en pierres dures de la collection de Louis XIV provenant des ateliers des orfèvres de la galerie du Louvre et des Tuileries (1620–1640)," in *Les vases en pierres dures: Actes du colloque organisé au musée du Louvre* (Paris: La Documentation française, 2003), 145–151.

4. Alcouffe, *Les Gemmes de la Couronne*, 470–493.

5. Stéphane Castelluccio, *Les meubles de pierres dures de Louis XIV et l'atelier des Gobelins* (Dijon: Éditions Faton, 2007), 90–91.

6. Alcouffe, *Les Gemmes de la Couronne*, 14–15.

7. Ibid., 18.

8. Ibid., 19.

9. Daniel Alcouffe, "Un aspect du goût de Marie-Antoinette: Les vases en pierres dures," *Versalia* 2 (1999): 6–15.

10. Marc Bascou, "La galerie d'Apollon: Galerie royale et galerie des trésors," *Dossier de l'art* 120 (June 2005): 2–4.

THE GEMMES DE LA COURONNE

The Gemmes de la Couronne was a collection of hardstone vases and vessels assembled by Louis XIV for his personal collection. Mounted in gold, enamel, and gemstones, these objects were traditionally the most highly esteemed works of art in the royal collection, prized for their great rarity and beauty as mineral specimens. After acquiring many of these works from Cardinal Mazarin, Louis XIV became an avid collector. Beginning in the 1660s, he gathered 823 examples and displayed them in the various royal palaces.

14
Tazza (footed tray), ca. 1640
Paris, France
Mounts: attributed to François Roberday (French, active 1621–1651)
Sardonyx and silver gilt

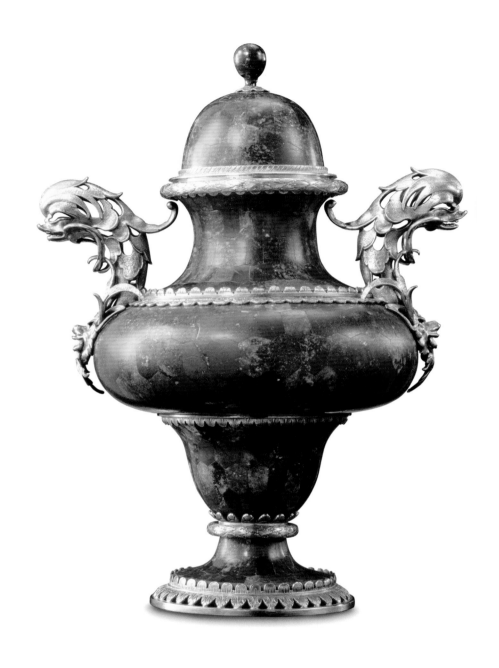

15
Covered vase with handles, ca. 1630; with additions, ca. 1680
Paris, France
Vase: lapis lazuli, ca. 1630
Mounts: silver gilt; attributed to François Roberday (French, active 1621–1651)

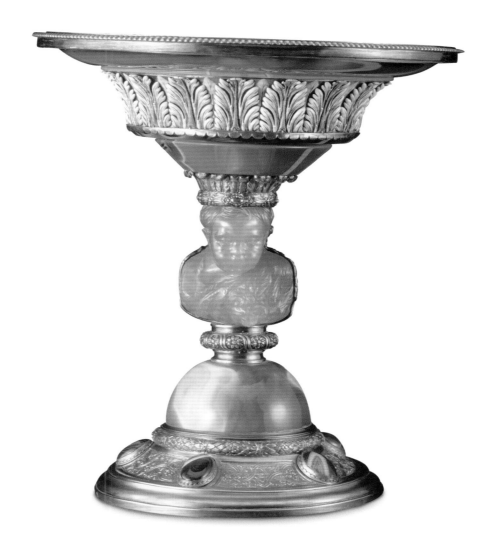

16

Cup with bust of a boy, ca. 1665

Cup and bust: sardonyx and agate, 1st century BC–AD 1st century, with later additions

Mounts (Paris, France): enameled gold, silver gilt, and agate; Louis Boursin (French, active 1697–1704), goldsmith

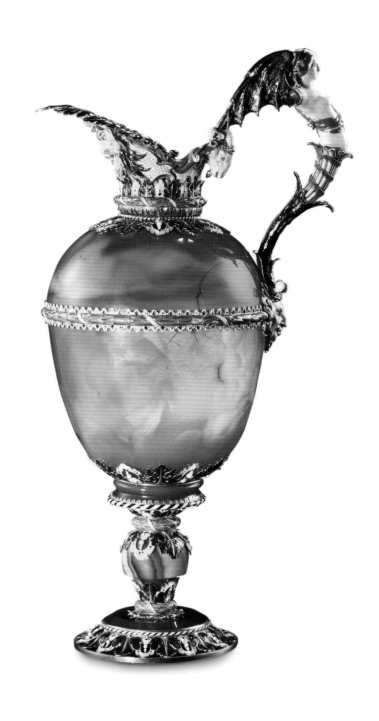

17

Ewer, ca. 1650

Paris, France

Agate with enameled gold mounts

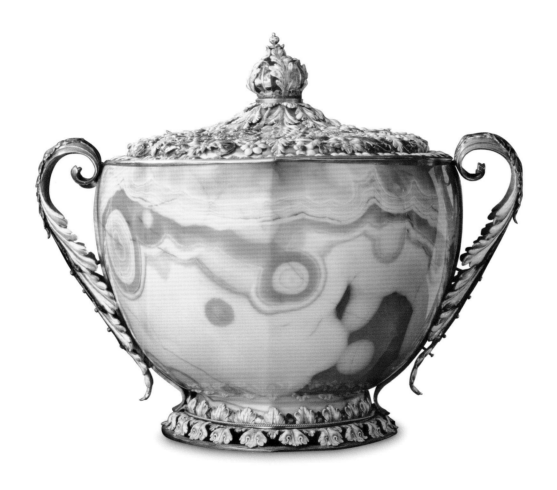

18
Covered cup, ca. 1665
Cup (Byzantium): agate, 10th–11th century?
Mounts (Paris, France): enameled gold

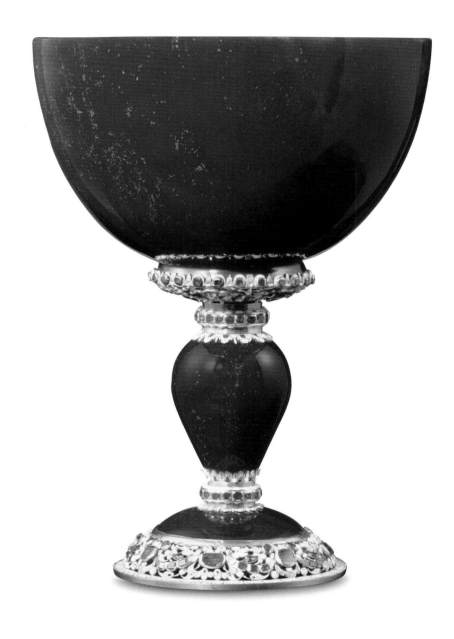

19
Cup, ca. 1630–1635
Paris, France
Bloodstone with enameled gold mounts and rubies

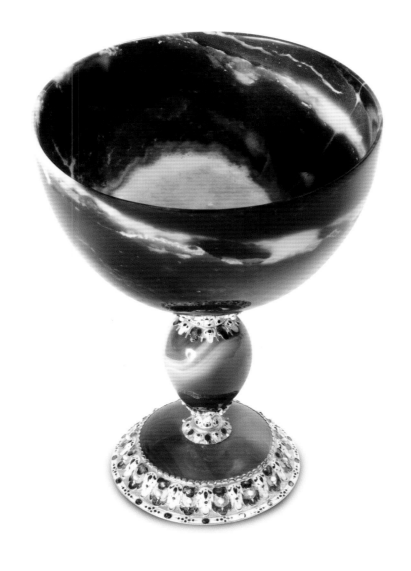

20

Cup, ca. 1650

Paris, France

Agate with enameled gold mounts

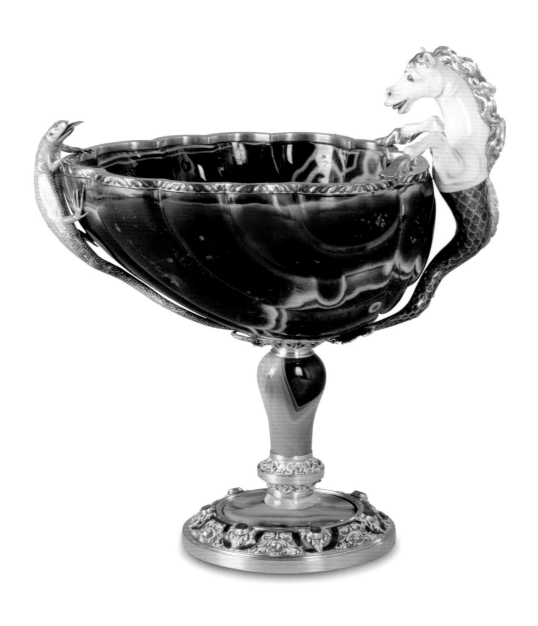

21
Shell-shaped cup, ca. 1650 and ca. 1685
Cup (Byzantium): sardonyx, 10th–11th century, with later additions
Mounts (Paris, France): enameled gold, gilt copper, diamonds, sapphires, and rubies

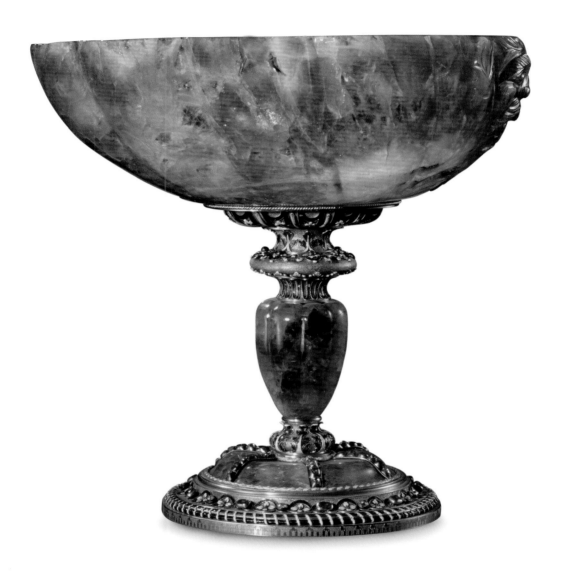

22
Shell-shaped cup, ca. 1685
Cup (Milan, Italy): amethyst, second half of the 16th century
Mounts (Paris, France): enameled gold, gilt copper, rubies, and diamonds

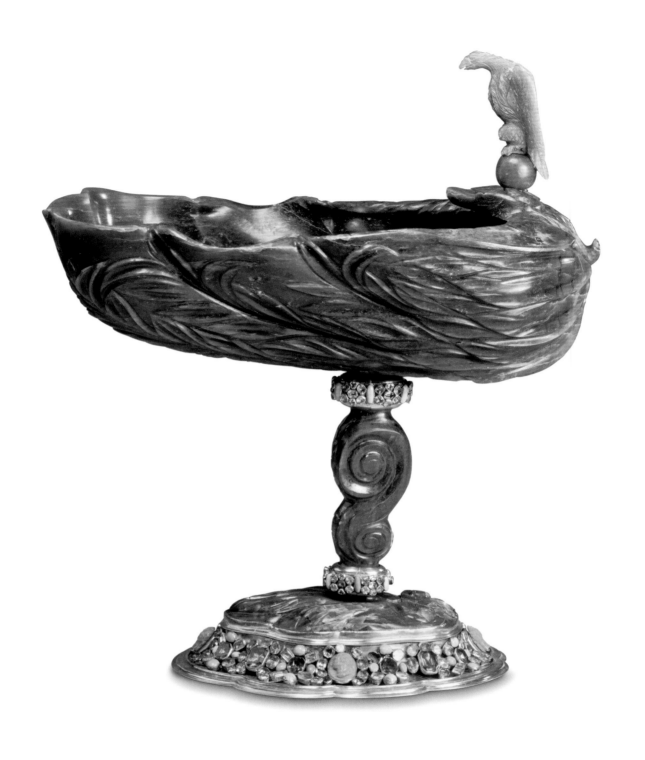

23
Shell-shaped cup, ca. 1660–1670
Augsburg, Germany
Attributed to Johann Daniel Mayer (German, 17th century)
Jade; mounts of silver partly gilt, coral cameos, amethysts, peridots, citrines, and turquoises

24
Shell-shaped cup, ca. 1660–1670
Augsburg, Germany
Attributed to Johann Daniel Mayer (German, 17th century)
Marble; mounts of enameled silver gilt

25
Cup with dolphins, ca. 1650
Königsberg, Prussia [now Kaliningrad, Russia]
Amber and ivory with gilding

26
Shell-shaped cup, ca. 1690–1700
Milan, Italy
Attributed to Giovanni Battista Metellino (Italian, active late 17th century)
Rock crystal; mounts of silver gilt

27
Handled vase or bucket, ca. 1685
Milan, Italy
Attributed to Giovanni Battista Metellino (Italian, active late 17th century)
Rock crystal; mounts of silver gilt

28
Christ at the Column, ca. 1670
Sculpture (Italy): bloodstone and rock crystal, ca. 1650
Mount (Paris, France): enameled gold and copper pedestal with medallions representing the Four Evangelists

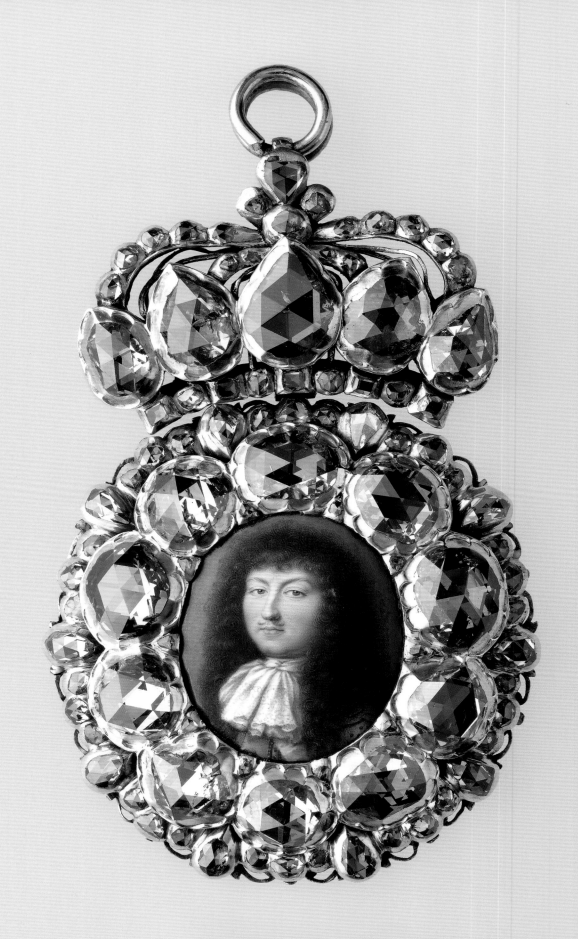

ROYAL GIFTS OF GOLD AND DIAMONDS

Michèle Bimbenet-Privat
||

he practice of giving diplomatic gifts, which had been a tradition in France since the Middle Ages, thrived during the reign of Louis XIV (1638–1715; reigned 1643–1715); this was due partly to the king's personality and partly to his great love of diamonds. In 1669, at the instigation of Jean-Baptiste Colbert, his minister of finance, Louis XIV initiated a written inventory of his gems. These registers, known as the *Livres des pierreries du roi* (Books of the king's gemstones), are today preserved at the archives of the Ministère des Affaires Étrangères (Ministry of Foreign Affairs); they list all the precious and semiprecious stones in the royal collection: diamonds, pearls, rubies, aquamarines, amethysts, topazes, emeralds, sapphires, garnets, jacinths, peridots, opals.[1] In 1669, for example, the king's collection contained 1,302 uncut diamonds and 609 cut diamonds; shapes as well as colors ("purple, tending toward peach blossom") were painstakingly noted. These gemstones were not merely destined to become ornamentation on royal dress. The true purpose of the collection was political: from it, Louis XIV drew the materials for the *boîtes à portraits* (portrait boxes) that he enjoyed presenting as gifts.[2] The *boîtes à portraits*, as tokens of the sovereign's benevolence and friendship, were given to France's powerful allies, to foreign diplomats, to faithful servants, even to courageous soldiers for their accomplishments on the battlefield. Thus the gemstone registers, compiled without interruption until 1786, were soon accompanied by a second series of inventories designated the *Registres des présents du roi* (Registers of the king's gifts).[3]

What exactly are *boîtes à portraits*? The very essence of Louis XIV's gift giving, they have long intrigued historians such as Alphonse Maze-Sencier, who had only known them from mentions in the archives.[4] Named for the silk-lined leather boxes within which they were customarily offered, each jewel-set miniature was composed of a piece of silver decorated with diamonds, at the center of which was an enamel portrait of Louis XIV; on the reverse was an enameled gold section with the king's crowned double-*L* cypher (see fig. 1). The model was so well known outside the diplomatic sphere that even an obscure goldsmith, Thomas Lejuge, felt obliged to include an example in his anthology of jewelry models published in Paris in 1678.[5]

Presentation miniature of Louis XIV in a diamond-set frame, ca. 1670 (cat. 29)

Fig. 1 Back view of cat. 29

These miniature displays of the goldsmiths' skills are extremely rare,[6] and only three are known to have survived to the present day. One example was given in 1681 to poet and scholar Carlo Cesare Malvasia after he dedicated his *Felsina pittrice*, a book on the lives of Bolognese painters, to Louis XIV; it is now in the Museo della Storia di Bologna (Museum of the History of Bologna).[7] Another miniature (now in the Gemeentemuseum, The Hague)[8] was offered by Louis XIV to Anthonie Heinsius, the grand pensionary of Holland and the most important Dutch official during the time of the United Provinces, who traveled to Versailles for the funeral of Queen Marie-Thérèse in 1683. This example no longer has its diamonds, making it possible to see the thin layer of silver that had been placed underneath the gems to accentuate their splendor. The third example, which is the earliest and the most complete of the three, was acquired by the Musée du Louvre in 2009;[9] it has a total of ninety-two diamonds, the most beautiful of which are rose cuts (cat. 29; back view: fig. 1).

Most of the *boîtes à portraits* were produced by goldsmiths Laurent Le Tessier de Montarsy and his son Pierre, who worked at the Galerie du Louvre (see section 1). The enamel portrait miniatures fitted into the center of the goldwork, however, were never signed; in fact, they were held in such little regard at the time that the artists were not noted in the *Registres des présents du roi*. It is known that the son, Pierre, bought them from a master of the genre, the famous Huguenot enamel painter Jean Petitot. In 1685, when Louis XIV revoked the Edict of Nantes, Petitot fled to Geneva; his son and namesake remained in Paris and became the main purveyor of miniature portraits to the king of France. Petitot *fils* painted with a less firm hand than his father, and in 1699 his miniatures sold for merely 140 livres, a derisory sum compared to the price of the diamonds.[10] When Pierre Le Tessier de Montarsy died in 1710, almost thirty enamel portraits of Louis XIV remained in the goldsmith's atelier.[11]

Louis XIV directly participated in the development of his gifts, which he used as tools of government. The correspondence of the minister of the Maison du Roi (the king's household) speaks for him when the king returns one of these portrait miniatures he deems unsatisfactory or when he wishes others to be "*grossir*" (enlarged).[12] Because the value of a *boîte à portrait* was based solely on the value of its diamonds, costs varied significantly. One of the

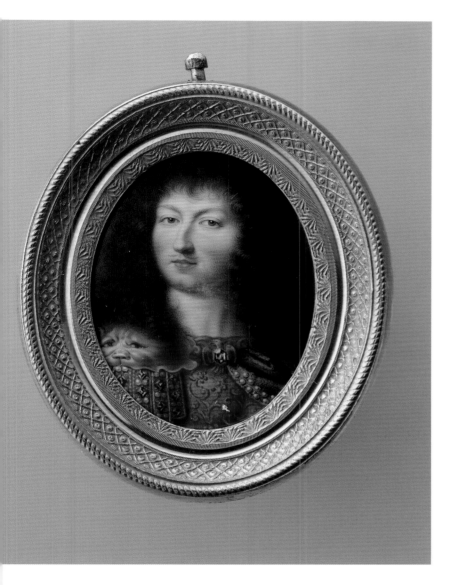

most expensive, at 41,376 livres, was offered in April 1701 to the constable of Castile, envoy extraordinary of Spain, shortly after Louis XIV's grandson, Philippe d'Anjou (1683–1746), became king of Spain in 1700.[13] It is not difficult to imagine the excitement with which the recipients greeted the news of their forthcoming gifts. In 1703 Louis XIV mentioned to Daniel Cronström, a Swedish diplomat, that he wished to give a gift to one of Cronström's countrymen, the architect Nicodemus Tessin. Colbert de Torcy, Louis XIV's minister of foreign affairs, also asked for Cronström's opinion: Would Tessin prefer a ring or a portrait miniature? Cronström and Tessin discussed the subject passionately, with Cronström advising the architect to accept the latter, writing: "It is of such a nature that it will be able to remain in your family like a mark of honor given by His Majesty." Shrewdly, he added:

> I will see the person in charge of the gemstones, Mr de Montarsy, to make sure you will be given perfect diamonds. I reckon I did well recommending the portrait over the ring: one single stone, no matter how beautiful, can not be worth more than 4,000 to 5,000 livres, so thirty or forty of them would have to be extraordinarily bad not to be worth more than that.[14]

Fig. 2 Portrait of Louis XIV, ca. 1670
Jean Petitot I
Miniature: painted enamel on gold, 7/8 × 13/16 in. (2.3 × 2.1 cm) (unframed); remounted as a pendant in the nineteenth century
Musée Condé, Chantilly, France, inv. OA 1493

Unfortunately, it was the value of the diamonds that eventually led to the destruction of almost all of the *boîtes à portraits*, because the beneficiaries or their descendants had them dismantled. An examination of the inventory reveals the full extent of the loss: between 1669 and 1684, the intendant of the Garde-Meuble de la Couronne listed exactly 338 portrait miniatures, after which the compilers of the *Registres* apparently grew weary of counting them. It is ironic that today the only relics of Louis XIV's *boîtes à portraits* are the miniature paintings that were once held in such low esteem; many have been transformed into pendants (see fig. 2) or remounted onto snuff boxes or *bonbonnières*.

When Louis XV (1710–1774; reigned 1715–1774) ascended to the throne, the custom of offering the king's portraits continued; now, however, they were mounted on snuff boxes, delicate containers that became the symbol of a lifestyle *à la française*. The Louvre has the finest collection of snuff boxes in the world, and its masterpieces include magnificent works

created by the goldsmith Daniel Govaers (see cats. 30–31). A native of Antwerp, Govaers moved to Paris in 1717. His career began to flourish in 1725, the year Louis XV married Marie Leczinska (1703–1768), when he was commissioned to create the majority of the jewels and snuff boxes that would constitute Marie's wedding gifts. He eventually became one of the king's main purveyors of portrait snuff boxes, for which he commanded very high prices: in 1726, for example, the royal administration paid him a total of 38,000 livres.[15] Keenly aware of his fame, Govaers inscribed his name on all the snuff boxes, even those that bore the hallmarks of goldsmiths to whom he had subcontracted the work, such as Jean-François Raveché and Jean-Jacques Devos. Naive and proud, involved in financial affairs that exceeded his abilities and means, he ended his career in 1737 with a resounding failure, a brief escape to Brussels, and a short imprisonment in the Bastille. His twelve years in the service of the monarchy are represented by approximately thirty surviving works that render the different facets of royal magnificence at the height of the Rocaille period. Govaers's snuff boxes are today scattered around the world,[16] a reflection of the varied geographic locations of their original recipients; their preservation over the centuries is likely due to their significance as family heirlooms. One of Govaers's snuff boxes at the Louvre carries an inscription, probably a later addition: "Donné par le Roi Louis XV au Syndic Louis Le Fort 1727" (given by King Louis XV to Syndic Louis Le Fort 1727). Le Fort was a representative of the Republic of Geneva who had been sent to Paris to defend the interests of Genevan banker Isaac de Thélusson at the French court. The shell-shaped snuff box he received was truly remarkable: the central panel of the outside lid is adorned with a large sun (the royal symbol) in low relief, the gilded rays of which are alternately embellished with fifty-six diamonds and twenty-six emeralds. Inside the lid, under a glass panel, is a miniature portrait of the young Louis XV wearing armor; the portrait may be attributed to Jean-Baptiste Du Canel, who was working for Govaers at the time (cat. 31). This small treasure is rather soberly described in the *Registres des présents du roi*: "On February 11, 1727; to M. Le Fort, resident of Geneva, a snuff box enriched with small diamonds, from Govaers, 2,100 livres."[17]

Like the French sovereigns, other heads of state used snuff throughout the eighteenth century, and the fashion for these precious and fragile snuff boxes quickly spread to royal courts all over Europe. After the revocation of the Edict of Nantes in 1685, Huguenot goldsmiths in France fled to Protestant states, ensuring the wide distribution of the techniques in making snuff boxes. Born in the French city of Metz and trained in Paris, the Huguenot Daniel Baudesson later settled in Berlin, where there was a sizable French colony. Soon discovered by Frederick the Great (Frederick II of Prussia, 1712–1786), Baudesson became one of the most prominent goldsmiths in the court at Berlin, providing the king with "a large number of precious pieces."[18] The Louvre possesses three snuff boxes[19] from this period in his career, which was notable for Baudesson's harmonious collaboration with the young enamel painter Daniel Nikolaus Chodowiecki, also of Huguenot descent. The *basse-taille* technique of enameling was used on the frames of these large, delicately carved snuff boxes, and *en*

plein enamels[20] were used to compose classic scenes from mythology inspired by the paintings of François Boucher (see cat. 37). It is easy to understand the appeal of these refined masterpieces, offered as diplomatic gifts by Frederick the Great until the beginning of the Seven Years' War (1756–1763). Later, the design of the king's snuff boxes shifted away from the French models, as shown by the impressive example with surfaces composed entirely of agate plaques lined with pink carnelian (cat. 35).[21] In the center of the lid, a grouping of jasper, carnelian, and agate cabochons is used to represent various fruits; the stones are cut in high relief to reproduce the textures of the peels and skins. The edges of the lid are outlined in a magnificent garland set with numerous diamonds representing flowers. Mosaics of gemstone cabochons such as this, called *fleurs et fruits appliqués* (flower and fruit applications)[22] in Prussia, are associated with Frederick the Great. The king was wildly fond of fruit, especially cherries,[23] and he had a guest room in his palace in Potsdam, Schloss Sanssouci, decorated with colorful carved fruits. It is known that the king personally oversaw the design and production of these little *galanteries* (gallantries), which highlight not only his personal taste but also the semiprecious stones found in his kingdom.

The sovereigns and their entourages sometimes mocked the vanity of the recipients of their gifts. In 1779 the German-born author Friedrich Melchior Grimm sent a letter to the Russian empress Catherine the Great (1729–1796) in which he described how Madame Denis, Voltaire's niece, made use of the gifts originally given by the empress to the philosopher:

> Madame Denis found a miniature portrait of Your Imperial Highness among her uncle's treasures. . . . She uses all those diamonds she owes to the imperial munificence to form an immense ribbon from which Your Majesty's portrait hangs, equally surrounded by diamonds. Thus, she can be seen in the circles of Paris with the portrait of the Empress around her neck. And if that was not enough, she offers snuff with the portrait of the Empress on the box . . .[24]

1. Série Mémoires et documents, 2040ff.; Archives of the Ministère des Affaires Étrangères, Paris.

2. Michèle Bimbenet-Privat, "Les pierreries de Louis XIV: Objets de collection et instruments politiques," in *Études sur l'ancienne France offertes en hommage à Michel Antoine*, ed. Bernard Barbiche and Yves-Marie Bercé (Paris: École des Chartes, 2003), 81–96.

3. Série Mémoires et documents, 2037–2039; Archives of the Ministère des Affaires Étrangères, Paris.

4. Alphonse Maze-Sencier, *Le livre des collectionneurs* (Paris: Librairie Renouard, 1885), 163ff.

5. Michèle Bimbenet-Privat, "Thomas Lejuge: Orfèvre de métier, graveur par nécessité," in *L'estampe au Grand Siècle: Études offertes à Maxime Préaud* (Paris: École Nationale des Chartes and Bibliothèque Nationale de France, 2010), 415–427.

6. Michèle Bimbenet-Privat, *Les orfèvres et l'orfèvrerie de Paris au XVIIe siècle*, 2 vols. (Paris: Paris-Musées, 2002), 2:401–406.

7. Carlo Jeannerat, "Un émail inédit de Jean Petitot," *Bulletin de la Société de l'Histoire de l'Art français* (1929): 74–80.

8. Roger-Armand Weigert, "Une boîte à portrait inédite offerte par Louis XIV, roi de France, à Antonie Heinsius," *Mededeelingen van den dienst voor kunsten en wetenschappen der gemeente's-Gravenhage* (December 1933): 98–102.

9. Musée du Louvre, inv. OA 12280; Former Yves Saint Laurent–Pierre Bergé collection, Christie's, Paris, 23–25 February 2009, lot 1200.

10. Maze-Sencier, *Le livre des collectionneurs*, 551.

11. Nouvelles acquisitions françaises 9565, folio 16; Département des manuscrits, Bibliothèque Nationale de France, Paris.

12. Ministre de la maison du roi to Gédéon Du Metz, November 1685; Archives Nationales, Paris, O1* 29, folio 514: "The King desires to present a *boîte à portrait* to the Polish ambassador, but it is necessary to enlarge the one I am returning to you and replace some of the diamonds so that it reaches 20 or 22,000 livres."

13. *Présents à l'Espagne* (Gifts to Spain), Ms. Fr. 14113; Département des manuscrits, Bibliothèque Nationale de France, Paris.

14. Roger-Armand Weigert and Carl Hernmarck, *Les relations artistiques entre la France et la Suède, 1693–1718: Nicomède Tessin le Jeune et Daniel Cronström, correspondance (extraits)* (Stockholm: AB Egnellska Boktryckeriet, 1964), 326; April 19, 1703.

15. Dominique Lacroix-Lintner, "L'orfèvre Daniel Govaers," vol. 1, "Sa vie, sa carrière" (master's thesis, Université de Paris-Sorbonne, 2007), 19.

16. Serge Grandjean, *Catalogue des tabatières, boîtes et étuis des XVIIIe et XIXe siècles du Musée du Louvre* (Paris: Réunion des Musées Nationaux, 1981), no. 122.

17. Maze-Sencier, *Le livre des collectionneurs*, 108.

18. Wolfgang Scheffler, *Berliner Goldschmiede: Daten, Werke, Zeichen* (Berlin: Hessling, 1968), 168.

19. Grandjean, *Catalogue des tabatières*, nos. 414, 415, 416.

20. This enameling technique is a decoration for comparatively large surfaces of gold. The enamel floats on the surface of the metal and creates a layer of its own, rather than filling carved and separated compartments. This is one of the most difficult enameling methods, and it was particularly popular in Paris in the mid-eighteenth century for snuff boxes.

21. Ibid., no. 420.

22. Lorenz Seelig, *Golddosen des 18. Jahrhunderts aus dem Besitz der Fürsten von Thurn und Taxis* (Munich: Hirmer, 2007), 383.

23. Martin Klar, *Die Tabatieren Friedrichs Des Grossen* (Berlin: Verwaltung der Staatlichen Schlösser und Gärten, n.d.), 5, 19, fig. 5; *Prunk-Tabatieren Friedrichs des Grossen: Katalog zur Potsdam-Sanssouci Ausstellung der Stiftung Schlösser und Gärten* (Potsdam: Hirmer Verlag München, 1993), no. 48.

24. Louis Réau, "Correspondance artistique de Grimm avec Catherine II," in *Archives de l'Art français,* nouvelle période, tome XVII, *L'Art français dans les pays du nord et de l'est de l'Europe (XVIIIe–XIXe siècles)* (Paris: Société de l'histoire de l'art francais, 1968), 1–206.

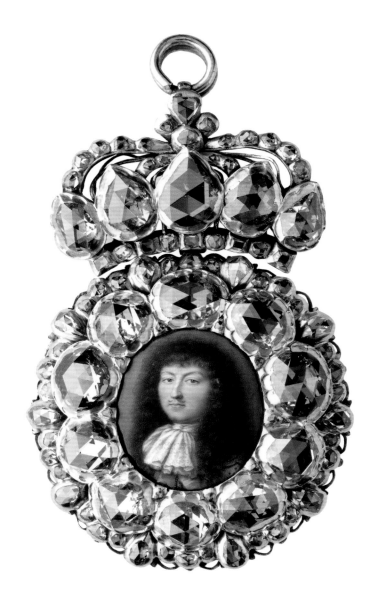

THE *PRÉSENTS DU ROI*

The kings of France commissioned costly luxury objects as gifts for foreign kings and ambassadors, known as the *présents du roi*.
Louis XIV's enamel portrait set in diamonds initiated a tradition for French diplomatic gifts that was followed by the presentation of valuable
gold boxes, also often set with diamonds and royal portraits.

29
Presentation miniature of Louis XIV in a diamond-set frame, ca. 1670
Workshop of Pierre and Laurent Le Tessier de Montarsy, goldsmiths; Jean Petitot I (Swiss, active Paris; 1607–1691), enameler
Miniature: painted enamel
Mount: rose-cut and table-cut diamonds set in silver and enameled gold

*This miniature portrait of Louis XIV lavishly surrounded by diamonds is a rare survival of this type of object, which was given by the king as
a diplomatic gift. Known as* boîtes à portraits *for the cases in which they were presented, these sumptuous miniatures were
intended to promote the prestige of Louis XIV and of France.*

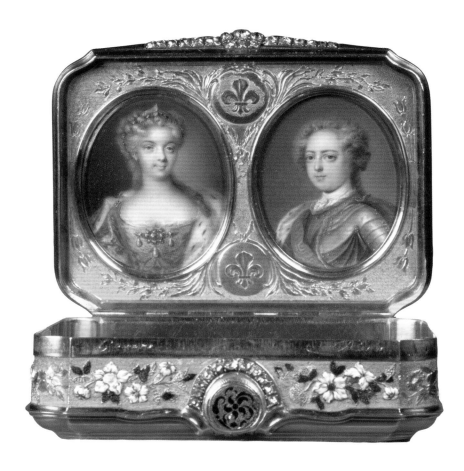

30

Snuff box with portraits of Louis XV and Marie Leczinska, 1725–1726

Daniel Govaers (Flemish, active France; 1689–1750; master in Paris in 1717), goldsmith;
Jean-Baptiste Massé (?) (French, 1687–1767), enameler
Gold, black tortoiseshell (*piqué*), enamel, and diamonds

One of the earliest gold snuff boxes made for presentation by the king, this masterpiece includes portraits of Louis XV and his queen, Marie Leczinska.
It was given in 1726 as a diplomatic gift to the ambassador of Holland, Cornelis Hop.

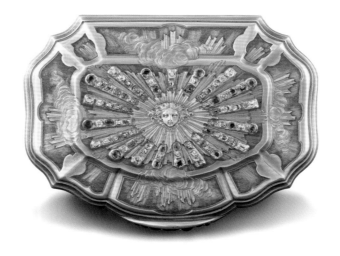

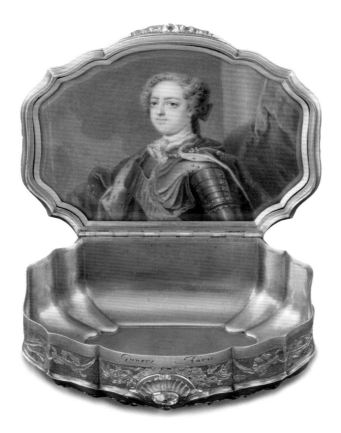

31
Snuff box with portrait of Louis XV, 1726–1727
Daniel Govaers (Flemish, active France; 1689–1750; master in Paris in 1717), goldsmith; attributed to Jean-Baptiste Du Canel, enameler
Gold, enamel, diamonds, and emeralds

This gold snuff box, decorated on the lid with a scene of Apollo set with diamonds and emeralds, was given as a présent du roi *by Louis XV to Louis Le Fort, a representative of the Republic of Geneva, in 1727.*

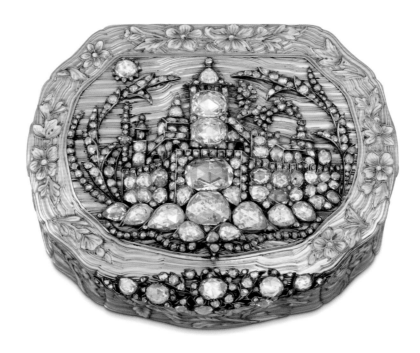

32
Snuff box, 1738–1739
Gabriel Gallois (French, 1714–1754), goldsmith
Gold, enamel, and rose-cut diamonds

The large size of the rose-cut diamonds suggests that this box might have been a diplomatic gift, possibly for a recipient in Turkey or even China.

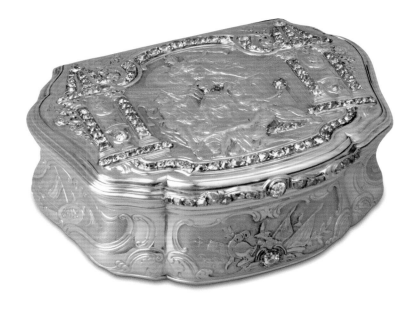

33
Snuff box, 1740–1744
Thomas-Pierre Breton (French, d. 1767), goldsmith; Pasquier-Rémi Mondon, chaser
Gold and diamonds

The scene on the lid depicts the apotheosis of a warrior surrounded by Justice and Prudence.

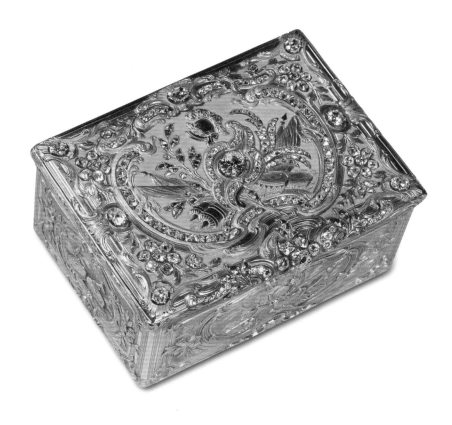

34
Snuff box with military trophies, 1759–1760
Dominique-François Poitreau (French, 1757–1781), goldsmith
Gold in four colors, diamonds, and emeralds

*The workmanship of this gold box is particularly fine, with the gold treated in four colors (rose, green, white, and yellow) and deftly chased
with military trophies highlighted by diamonds.*

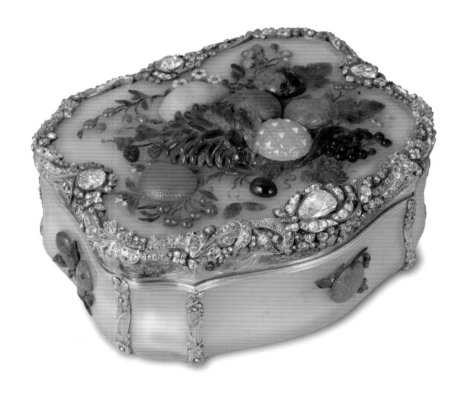

SNUFF BOXES MADE FOR FOREIGN SOVEREIGNS

Other European rulers, following the French precedent, also gave elaborate diamond-set snuff boxes as diplomatic gifts. Frederick the Great's court at Berlin was supplied by a talented group of goldsmiths that included the French Huguenot Daniel Baudesson. Many of the boxes made for the Prussian king were decorated with brilliantly colored enamels or hardstones.

35
Snuff box, ca. 1760–1770
Made for Frederick the Great of Prussia (1712–1786)
Berlin, Germany
Gold in four colors, agate, carnelian, amethyst, jasper, and diamonds set in silver

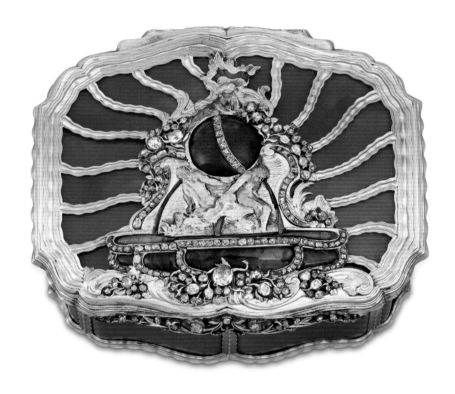

36
Snuff box, ca. 1750
Dresden, Germany
Attributed to Heinrich Taddel (German, 1715–1798), goldsmith
Gold in four colors, carnelian, amethyst, and diamonds set in silver

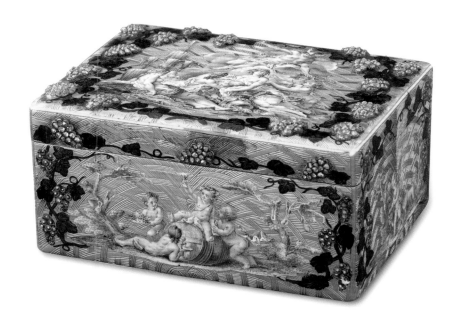

37

Snuff box depicting "The Birth of Bacchus," ca. 1755

Berlin, Germany

Attributed to Daniel Baudesson (French, active Berlin; 1716–1785), goldsmith; Daniel Nikolaus Chodowiecki (German, 1726–1801), enameler

After François Boucher (French, 1703–1770), painter

Gold, enamel, and diamonds set in silver

LOUIS XV

The era of Louis XV heralded changing ways of living: the interiors were more intimate, and they were furnished with objects
of great luxury that were finished with superb craftsmanship. The court, however, continued to commission tapestries, silver, and porcelain dining
services. Porcelain was a new and wondrous material at that time, and in 1759 the king took over ownership of the Sèvres
manufactory so that it could make prestigious porcelain for the court and for diplomatic gifts.

38
Bust of Louis XV, 1760
Sèvres Porcelain Manufactory (France, established 1756)
After Jean-Baptiste Lemoyne the younger (French, 1704–1778), sculptor
Soft-paste biscuit porcelain

*This portrait bust was made in the Sèvres manufactory, which the king had purchased in 1759. It was fashioned in biscuit porcelain that was
intentionally unglazed to heighten its resemblance to marble.*

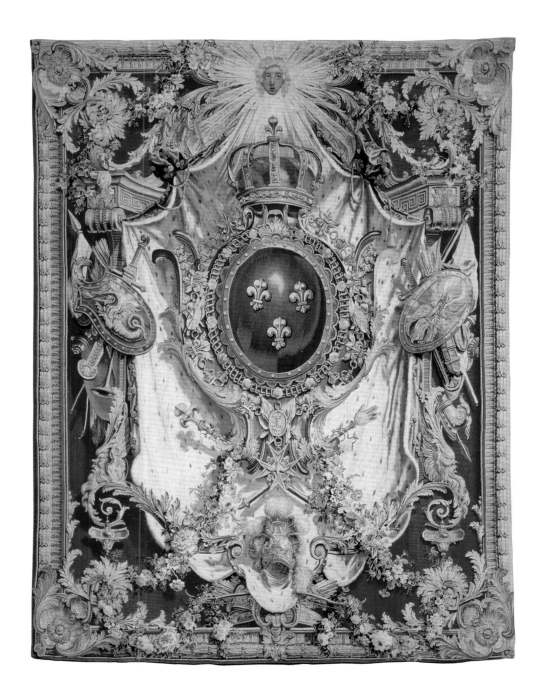

39

Portière with the arms of France, ca. 1740

Gobelins Manufactory (France, established 1662)

Workshop of Pierre François Cozette (French, 1714–1801) and Mathieu Monmerqué

After Pierre-Josse Perrot (French, active at Gobelins 1724–1735), painter

Wool and silk

Portières *were tapestries that were hung over doorways in royal palaces. Conspicuous in their use of royal symbols, they also made a statement about the prestige of the king and France. The design here includes many emblems of King Louis XV: the prominent crown, the fleurs-de-lis, and (following his predecessor's imagery) the mask of Apollo. The Gobelins tapestry manufactory wove some twenty-eight examples of this design for the royal residences and for those of French ambassadors.*

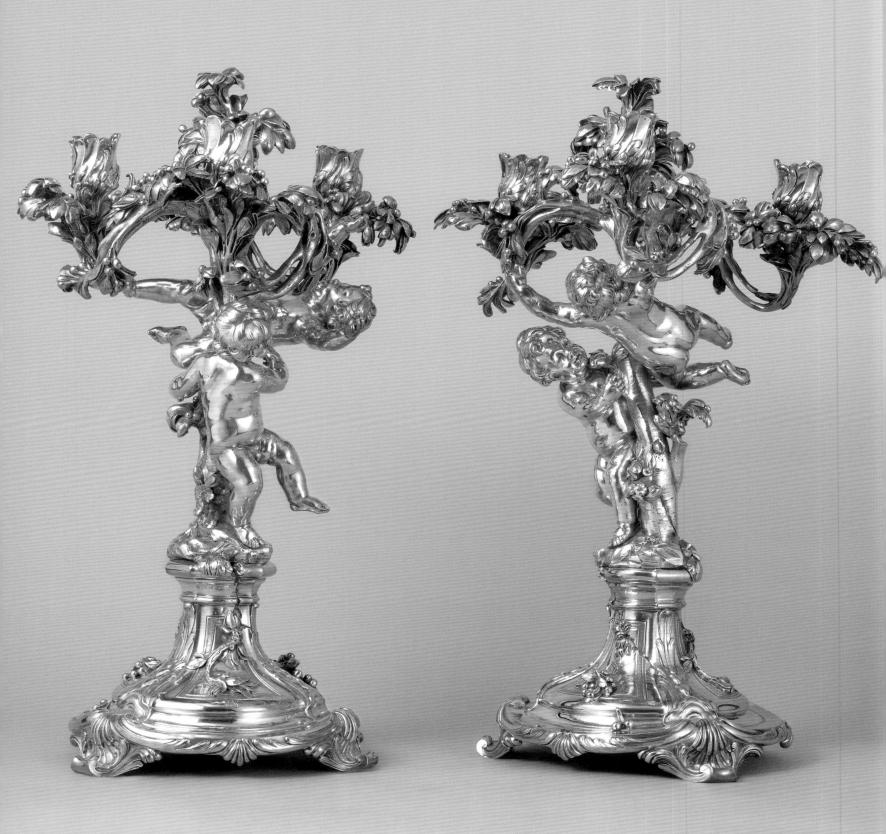

4

THE ROYAL SILVERSMITHS

Michèle Bimbenet-Privat

A s a result of the policies implemented by Louis XIV (1638–1715; reigned 1643–1715), art was put at the service of the Crown. Throughout the eighteenth century, the workshops in the Galerie du Louvre (see section 1) became groundbreaking laboratories for creativity. Not content with simply satisfying existing tastes and fashions, the royal silversmiths who worked there were true innovators, revered in their time, and they influenced the forms and decoration in other media, particularly ceramics and porcelain. Unfortunately, very few examples of their work exist today. On eight occasions, even before the French Revolution broke out in 1789, royal silver kept in the Garde-Meuble de la Couronne was melted down. One such melting, and the most disastrous, took place in October 1759, at the height of the Seven Years' War (1756–1763), when Louis XV (1710–1774; reigned 1715–1774) was forced to sacrifice his own silver, along with that of his family and all the services of the Maison du Roi (the king's household).[1] The loss of the pieces in the royal collection was even more unfortunate because they were created by highly significant artists and craftsmen.

Despite these occasional destructions of silver, the royal commissions never ceased: court life had its rules, its traditions, and its whims. The royal silversmiths had to provide as well as repair the silver of the *Bouche* (the royal kitchens) and *Gobelet du Roi* (the department responsible for the bread, fruit, and drink served at the king's table).[2] Sumptuous *services de toilette* were ordered for the bedchambers of the king and his family,[3] and the marriage of a royal princess necessitated the production of exquisite *corbeilles de mariage* (gifts for a bride from her family). Familial as well as political and diplomatic ties to the royal courts of Europe required large numbers of gifts. The rival silversmiths always tried to outdo one another, and their ingenious designs were discussed in the magazine *Mercure de France*. Parisians would swarm to the atelier of François-Thomas Germain to see the silversmith show off his latest creations. The fame these of French artisans spread throughout Europe, and royal courts in Madrid, Parma, Naples, Lisbon, Saint Petersburg, and Munich, among others, commissioned their silver from Paris.[4] It is indeed fortunate that these other European orders were placed: most of the production of Parisian silversmiths is now preserved abroad, a visible testimony

Pair of candelabra, 1757
(cat. 47)

to their excellence and skill. In the past sixty years, through both acquisitions and generous donations, the Musée du Louvre has built an extremely fine collection of French silverwork.

It is important to understand the role the royal silversmiths played in the development and evolution of design during their time. All the silversmiths were connected to one another—either directly, by family ties, or indirectly, as apprentices—and skills and techniques were passed down in an uninterrupted chain of tradition. Nicolas Besnier, for example, was the nephew and godson of the great silversmith Nicolas Delaunay, known for his contributions to Louis XIV's silver furniture and gold plate. Orphaned at an early age, Besnier studied at the Académie de France in Rome and was trained as an architect. When he returned to Paris in 1714, however, he was admitted to the Galerie du Louvre as a silversmith, beginning his career as a purveyor to the Crown.[5] After 1720, Besnier officially became the successor of Delaunay and was able to work alongside Claude Ballin II, one of the era's master goldsmiths. The young silversmith was in charge of the *courante* silver (the everyday silverware), while Ballin reserved the *extraordinaires* (sculpted pieces) for himself. The two platters in the exhibition (cat. 40) are positioned within this context, as they doubtlessly would have been accompanied by Ballin's lost *extraordinaires*. Besnier's oeuvre, emblematic of the Régence period (1715–1723), still carries the stylistic characteristics associated with the end of Louis XIV's reign: a strongly decorative presence, a varied repertory of motifs (foliage, volutes, gadroons), and a moderate use of figures.

In the ten years between 1725 and 1735, a profound change in forms occurred. This new style, then called *pittoresque*, is today known as Rococo. Because surviving examples in silver are so scarce, it is impossible to define the stages of this transformation with any precision. The goldsmith Juste-Aurèle Meissonnier, however, seems to have been its originator: his two tureens for the Duke of Kingston are considered the first manifestations of Rococo art.[6] Meissonnier also published a compilation of his designs, *Livre d'ornements* (from 1734) (fig. 1).

But artists follow their own inclinations, as demonstrated by Thomas Germain's 1733–1734 silver-gilt *écuelle* (covered bowl) (cat. 42).[7] Here, subtle variations in form reveal the artist's intention: the elongated stand, which is integrated harmoniously with the bowl; the delicacy of the knop chased to resemble an artichoke; the sense of movement suggested by the fluting chased on the cover; the incorporation of the coat of arms of Cardinal da Mota e Silva into the decorative elements of the handles; and the precision of the volutes and foliage, engraved on the stand and the cover, which reveal themselves only with a closer look by the informed eye. When combined, all of these elements suggest not merely a skilled silversmith and engraver but a true sculptor and architect, accomplished in thinking in both two and three dimensions. What is known about Germain's youth confirms these assumptions. Born in 1673, he was the eldest child of Pierre Germain, a royal silversmith and one of the creators of Louis XIV's silver furniture. The young artisan benefited from the benevolence of Louvois, Louis XIV's minister of war, who sent him to Italy; there he gained experience as a founder and chaser of Baroque bronze statuary in Rome and Florence.[8] Returning to Paris in 1706,

Fig. 1 Gabriel Huquier
Candelabrum with three
branches, fourth plate of
the *Livre d'ornements* of
Juste-Aurèle Meissonnier
Engraving, ca. 1750
Musée du Louvre, Edmond
de Rothschild Collection,
inv. L417LR

J.O Meissonier in.

Piquier Sculp et ex CPR a Paris rue St georges

Fig. 2 Dish cover, 1757–1758
Made for Joseph I, king of
Portugal (1714–1788)
François-Thomas Germain
Silver, 18½ × 22⁷⁄₁₆ × 20⁷⁄₈ in.
(47 × 57 × 53 cm)
Musée du Louvre, Départe-
ment des Objets d'Art,
OA 10923

Germain developed an interest in architecture, designed the sculpted trophies in the choir of Notre-Dame, and was put in charge of the reconstruction of the Église Saint-Thomas (Church of Saint Thomas) near the Louvre. In 1723, he was finally admitted to the Galerie du Louvre as *orfèvre et sculpteur* (silversmith and sculptor). Fate was kind to him: Delaunay retired around the same time. From then on, Germain continually supplied silver to the Garde-Meuble; sometimes the pieces were solely his creations and sometimes they were collaborations with Besnier and Ballin. This trio—the best of the French silversmiths—produced almost the entirety of the royal silver of France, which has regrettably been lost. The pieces that have survived are those that were commissioned by diplomats posted in Paris, foreign aristocrats, and the other royal courts in Europe. A covered bowl survived because it was made for da Mota e Silva of Portugal. Other works were less fortunate; only the designs remain of the *toilette de vermeil* he made for the Infanta Marie-Thérèse Raphaëlle of Spain (1726–1746). His final masterpieces, two girandoles (candelabra)[9] were destined for Louis XV's bedchamber at Versailles. Lavish and elegant examples of goldwork, they were completed in 1747, a year before his death, and no longer survive.

His son, François-Thomas Germain, became the central figure of French silver during the mid-eighteenth century, a position to which he was suited by both talent and temperament. Proud to the point of arrogance, he was known to refer to himself as "I, who have been taught all there is to know." His background certainly supported this claim. He was taught by his father, by the Académie de Peinture et Sculpture, and by the sculptors Falconet, Caffieri, and Pajou. The Germain workshop dominated the silver market in France and even throughout Europe; at its most successful, it employed dozens of workers, had countless subcontractors in Paris, and fulfilled commissions from all over Europe.[10] However, Germain was a spendthrift with poor management skills and the Seven Years' War had a substantial negative effect on the silver trade. Crippled by debt, he went bankrupt in 1765 and suffered the further humiliation of being expelled from the Galerie du Louvre, a blow from which he never quite recovered.

His masterpieces, which are too numerous to list, include the services he created for the royal court of Portugal (see fig. 2). Many of these works are now in Lisbon museums, where the finest collections of French silverware can be found.[11] A tureen (cat. 43) from 1754–1755, originally a private French commission, is a testimony to the elegance of Germain's work.[12] Intended to remain on the table for the duration of the meal, it must have been the jewel of the family's service. Presented on a large oval platter, elegantly chased and adorned with acanthus

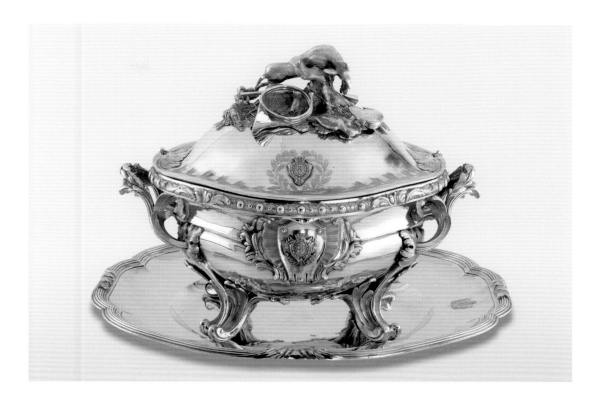

Fig. 3 Tureen (*pot à oille*) and
stand, 1758–1759
Tureen: Edme-Pierre Balzac
Stand: Robert-Joseph Auguste
Silver, tureen: 11⁷⁄₁₆ × 14⁹⁄₁₆ ×
11¹³⁄₁₆ in. (29 × 37 × 30 cm),
stand: 1⁹⁄₁₆ × 16⁷⁄₈ × 15¹⁵⁄₁₆ in.
(4 × 42.3 × 40.5 cm)
Musée du Louvre, Département
des Objets d'Art, Gift of the
Société des Amis, 1994, OA
11392–11393

scrolls, it stands on four curled feet that accentuate its shape, which swells out in the middle and is extended by two ribbed handles. The beautiful finial on the cover is composed of leaves and pomegranates that have burst open, an allusion to the bounty of Nature. Germain signed his works, and the engraved inscription here reads: "F. T. GERMAIN SCULPᴿ ORFᴱ DU ROI FECIT AUX GALLERIES DU LOUVRE A PARIS 1755" (F. T. Germain sculptor and silversmith to the king made this in the Louvre galleries, Paris, 1755). As his biographer Madame Perrin wrote, Germain was "a man of fortunate associations." He did not need to invent his own works in his own style because he could largely rely on his father's models. Toward the end of his career, however, it is evident that he increasingly abandoned the opulence of Rococo in favor of a more restrained style in which simple and harmonious forms indicated a return to Classicism.

The Louvre has the privilege of preserving silverware from the service known as the "Penthièvre-Orléans," which is named after its principal owners. Louis-Jean-Marie de Bourbon, duc de Penthièvre (1725–1793), was a grandson of Louis XIV; appointed grand admiral of France and master of the royal hunt, the duc was known for his generosity to charitable causes. Unlike other nobility during the French Revolution, including members of his own family, he was so beloved by the people that he was allowed to die peacefully in his bed. It appears that the service entered his collections rather late as an inheritance from his cousin, the comte d'Eu, who died a bachelor in 1775. The comte d'Eu had purchased it around 1760 from an impoverished English gentleman, Count Henry Janssen, Captain of the Guards.[13] The pair of wine coolers (cat. 45)[14] and the two *pots à oille* (circular tureens) in the Louvre[15] include

references to swans and reeds, Janssen's heraldic emblems. After the duc de Penthièvre's death, his daughter Louise-Marie-Adélaïde de Bourbon (1753–1821) inherited the service. She married Louis-Joseph-Philippe, duc d'Orléans (1747–1793), and the silver was later owned by her son Louis-Philippe (1773–1850), the future king of France. Some of these beautiful objects were crafted by Edme-Pierre Balzac and Antoine-Sébastien Durand, Parisian silversmiths[16] who received regular commissions from nobility. Durand was responsible for an ensemble of dish covers preserved in France and abroad.[17] The Janssen service is known to have contained eight wine coolers, including two decorated with dog heads by the silversmith Claude Ballin,[18] and almost certainly many other items. Between 1763 and 1770 the service was completed with a set of stands (cat. 46) from silversmith Robert-Joseph Auguste for use with the four *pots à oille* (now in the Louvre). Thus, by the various means of inheritance, purchase, and later additions were these large and very diverse noble services assembled.

The objects in the Penthièvre-Orléans service—whose twisted yet regular forms are sometimes underlined by acanthus scrolls and gadrooning, sometimes masked by a "second skin" of rocailles—are in a style that has often been called *Rocaille assagi* (toned-down Rococo). Plant forms are always present: vines wind around the ribbed handles of the wine coolers, and celery stalks serve as feet for Balzac's *pots à oille* and his tureen. A more violent side of nature is seen in the dramatic sculptural groupings on the lids: one portrays a dead deer lying against a tree stump, while another celebrates the successful end to a hunt, with dogs taking down a stag (fig. 3). Durand's many contributions to the original Penthièvre-Orléans service are now reduced to a single, beautifully designed saltcellar,[19] also in the Louvre (cat. 44). The elegant base with rounded corners is engraved on each side with scrolling foliage and seaweed. A naked infant sits in the center, leaning against two oyster shells and holding a ribbon; when opened, the shells reveal two silver-gilt salts. Designs such as this, characterized by chubby infants with pouting expressions and creased ribbons that perfectly imitate silk, are specific to Durand and can also be found in the mustard pots made in 1750–1751 for Madame du Pompadour.[20] In the end, the appeal of the Penthièvre-Orléans service lies in its disparities, conveying both the complex history of a noble family and the multifaceted talents of the great Parisian silversmiths of the eighteenth century.

1. Solange Brault and Yves Bottineau, *L'orfèvrerie française du XVIIIe siècle* (Paris: Presses Universitaires de France, 1959), 4–5.

2. Pierre Verlet, "Louis XV et les grands services d'orfèvrerie parisienne de son temps," *Pantheon* 35 (May–June 1977): 131–142.

3. Ibid.

4. *Versailles et les tables royales en Europe, XVIIe–XIXe siècles* (Versailles: Musée National des Châteaux de Versailles et de Trianon, 1993–1994).

5. J. de Drouas, "Un orfèvre au XVIIIe siècle: Nicolas Besnier, échevin de Paris," *Bulletin de la Société de l'Histoire de Paris et de l'Île-de-France* (1983): 97–149.

6. Peter Fuhring, *Juste-Aurèle Meissonnier: Un génie du rococo (1695–1750)*, 2 vols. (Turin-London: Umberto Allemandi & Co., 1999).

7. Yves Bottineau, *Catalogue de l'orfèvrerie du XVIIe, du XVIIIe et du XIXe siècle* (Paris: Musée du Louvre, Réunion des Musées Nationaux, 1958), no. 95.

8. J. Montagu, *Gold, Silver and Bronze: Metal Sculpture of the Roman Baroque* (New Haven and London: Yale University Press, 1996), 105.

9. Peter Fuhring, "Les deux girandoles d'or de Louis XV par Thomas Germain, chefs-d'oeuvre du Rococo," *Revue de l'art* 95 (1992): 52–60.

10. Christiane Perrin, *François-Thomas Germain, orfèvre des rois* (Saint-Rémy-en-l'Eau: Éditions Monelle Hayot, 1993).

11. Isabel da Silveira Godinho, *A Baixela de Sua Majestade Fidelissima uma obra de François-Thomas Germain* (Lisbon: Palácio Nacional da Ajuda, 2002).

12. Lent by the Musée National des Châteaux de Versailles et de Trianon to the Musée du Louvre, 2009, inv. V 4721; in the possession of the Haussonville family until 1970.

13. For a more complete history of the service, see S. Boiron, "The Origins of the Penthièvre-Orléans Service," in Sotheby's, *Royal French Silver: The Property of George Ortiz* (auction catalogue, New York, November 13, 1996), 38–57.

14. See *Nouvelles acquisitions du département des Objets d'art, 1985–1989* (Paris: Musée du Louvre, Réunion des Musées Nationaux, 1990), 169–173, no. 79. For a similar pair, dated to 1757–1760 and formerly in the collection of Arturo Lopez-Willshaw, see Sotheby Parke Bernet, *Orfèvrerie, objets d'art et bel ameublement: Provenant de la collection Arturo Lopez-Willshaw et des collections d'autres amateurs* (auction catalogue, Monaco, June 23–24, 1976), no. 51.

15. Musée du Louvre, inv. OA 11350; see Gérard Mabille in *Nouvelles acquisitions du département des Objets d'art, 1990–1994* (Paris: Musée du Louvre, Réunion des Musées Nationaux, 1995), no. 63.

16. Françoise Arquié-Bruley, "L'orfèvre Antoine-Sébastien Durant (1712–1787): Eléments biographiques," *Bulletin de la Société de l'Histoire de l'Art français, 1995* (1996): 165–185; Françoise Arquié-Bruley, "Problèmes des orfèvres au XVIIIe siècle: Les frères Balzac," *Bulletin de la Société de l'Histoire de l'Art français, 1987* (1989): 93–123.

17. Musées Royaux d'Art et d'Histoire, Brussels; Musée de la Chasse, Paris (deposit at the Musée du Louvre); Museu Calouste Gulbenkian, Lisbon; and private collections.

18. Two of them, formerly in the collection of Jaime Ortiz-Patiño; see Sotheby's, *Royal French Silver*, no. 4.

19. See *Louis XV: Un moment de perfection de l'art français* (Paris: Hôtel de la Monnaie, 1974), no. 467; *Versailles et les tables royales en Europe*, no. 463; and Arquié-Bruley, "L'orfèvre Antoine-Sébastien Durant." Another dated to 1757–1758 is preserved at the Philadelphia Museum of Art, inv. 46-26-1.

20. Museu Calouste Gulbenkian, Lisbon, inv. no. 287A/B.

ROYAL SILVERSMITHS

Although silver has always held a position of prestige for dining, few of the works made by the French royal silversmiths during the eighteenth century survive today. Difficult economic times especially affected table silver because of its intrinsic value: it could be melted down for coinage. Much of the royal and aristocratic silver was lost during the Seven Years' War, after King Louis XV issued edicts in 1759 requiring silver to be melted down to replenish depleted state coffers. The Louvre, however, possesses important mid-century examples that show the innovative sculptural design and fine workmanship executed by the best of the Parisian silversmiths who worked for the king.

40
Pair of platters, 1723–1724
Arms of William Hall, 2nd Viscount Gage (1718–1791)
Attributed to Nicolas Besnier (French, 1686–1754; master in 1714), silversmith
Silver

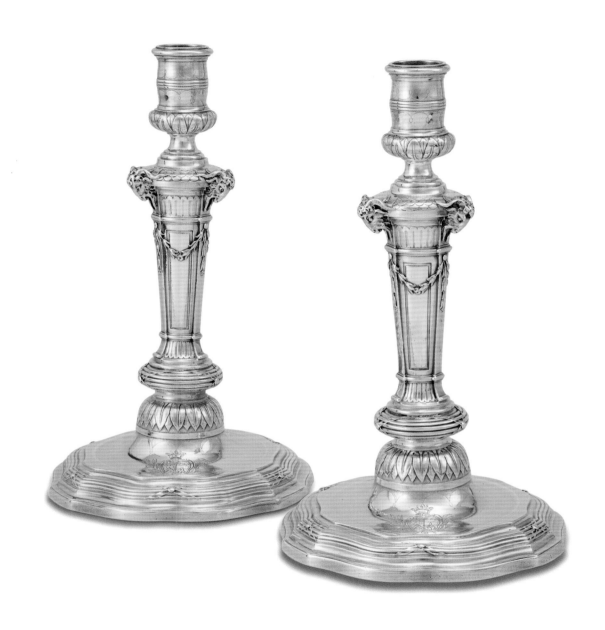

41
Pair of candlesticks, 1732–1733
Probable arms of Anne-Sophie Serre de Saint-Roman, marquise de Buzancy
Thomas Germain (French, 1673–1748; master in 1720), silversmith
Silver

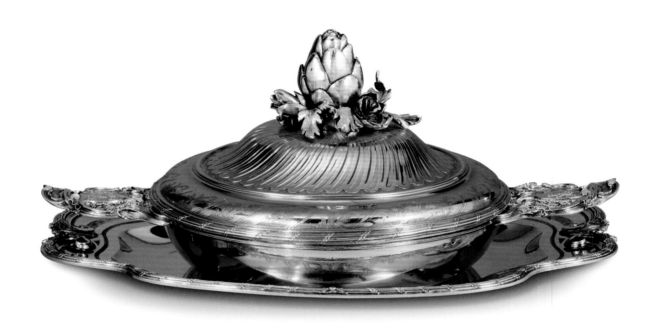

42

Covered bowl (*écuelle*) and stand bearing the coat of arms of Cardinal da Mota e Silva, 1733–1734

Thomas Germain (French, 1673–1748; master in 1720), silversmith

Silver gilt

Thomas Germain, a silversmith to the king, enjoyed an exalted role at the court of Louis XV for the superb quality of his workmanship. An écuelle *was a covered bowl for drinking broth or soup, and it was often used at breakfast. The gold* écuelle *delivered by Germain for Louis XV's personal use at Versailles in 1736 was of a similar design.*

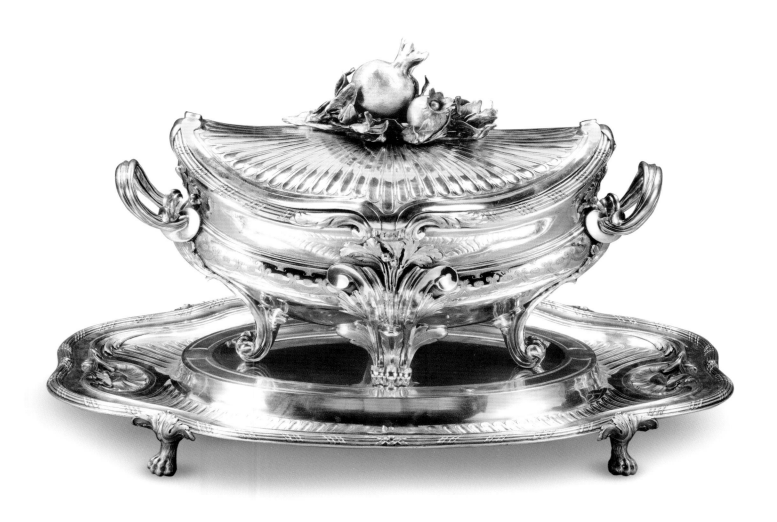

43
Tureen and stand, 1754–1755
François-Thomas Germain (French, 1726–1791), silversmith; completed by Jean-Charles Roquillet-Desnoyers
(French; master in Paris in 1772), ca. 1780
Silver

*The younger Germain followed his father as silversmith to the king, but he also referred to himself as a sculptor, which was a grander métier.
Like his father, he was known for his inventive designs and superb craftsmanship, and his workshop supplied silver not only to the French court and
aristocracy but also to foreign courts, such as those in Russia and Portugal.*

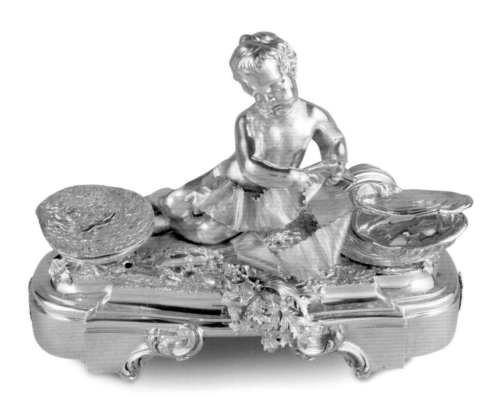

THE PENTHIÈVRE-ORLÉANS SERVICE

The Penthièvre-Orléans service is one of the finest silver dining services made in France during the eighteenth century. It was originally owned by the comte d'Eu, a grandson of Louis XIV, and inherited by his cousin the duc de Penthièvre in 1775. Seized during the Revolution, it was claimed by the duchesse d'Orléans, passed to her son King Louis-Philippe, and remained with their descendants until the twentieth century.

44
Saltcellar, 1758–1759
From the Penthièvre-Orléans service
Antoine-Sébastien Durand (French, 1712–1787; master ca. 1740), silversmith
Silver

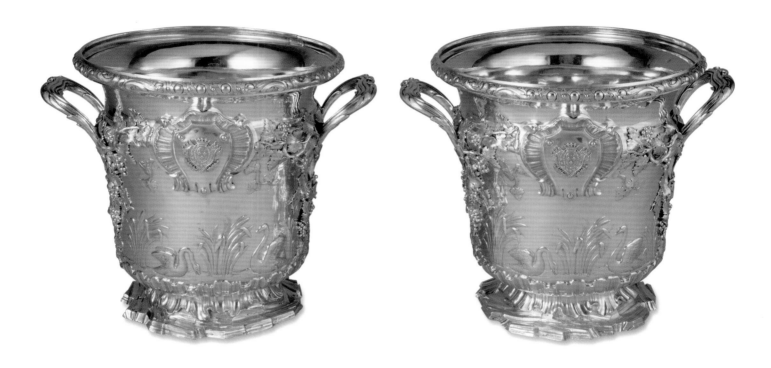

45
Pair of wine coolers, 1759–1760
From the Penthièvre-Orléans service
Edme-Pierre Balzac (French, 1705–after 1786; master in 1739), silversmith;
Liners added by Jean-Baptiste-Claude Odiot (French, 1763–1850; master in 1785), ca. 1820
Silver

These coolers held iced water for chilling bottles of wine. They were usually kept on the sideboard
where the diners' wine glasses were replenished.

46
Pair of tureen stands, 1770–1771
From the Penthièvre-Orléans service
Robert-Joseph Auguste (French, 1723–1805; master in 1757), silversmith
Silver

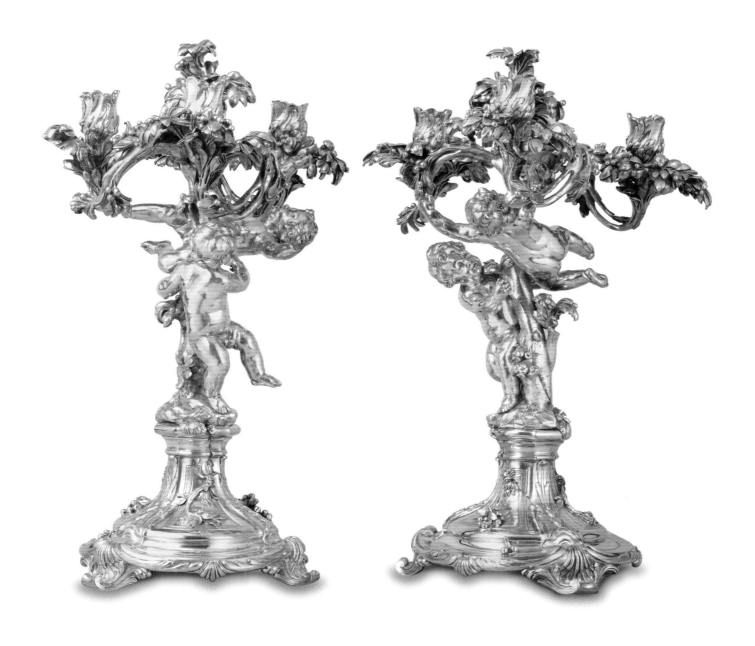

SILVER MADE FOR THE KING OF PORTUGAL

After a devastating earthquake struck Lisbon in 1755, the king of Portugal commissioned the French court's silversmith François-Thomas Germain to replace the royal silver dining service. Beginning in 1756–1757, Germain delivered some twelve hundred pieces of silver for the Portuguese royal table.

47

Pair of candelabra, 1757

Made for Joseph I, king of Portugal (1714–1777)

François-Thomas Germain (French, 1726–1791), silversmith

Silver

The design of these candelabra follows that of the famous pair of gold girandoles (now lost) that Germain's father, Thomas, made in 1747 for Louis XV's bedroom at Versailles.

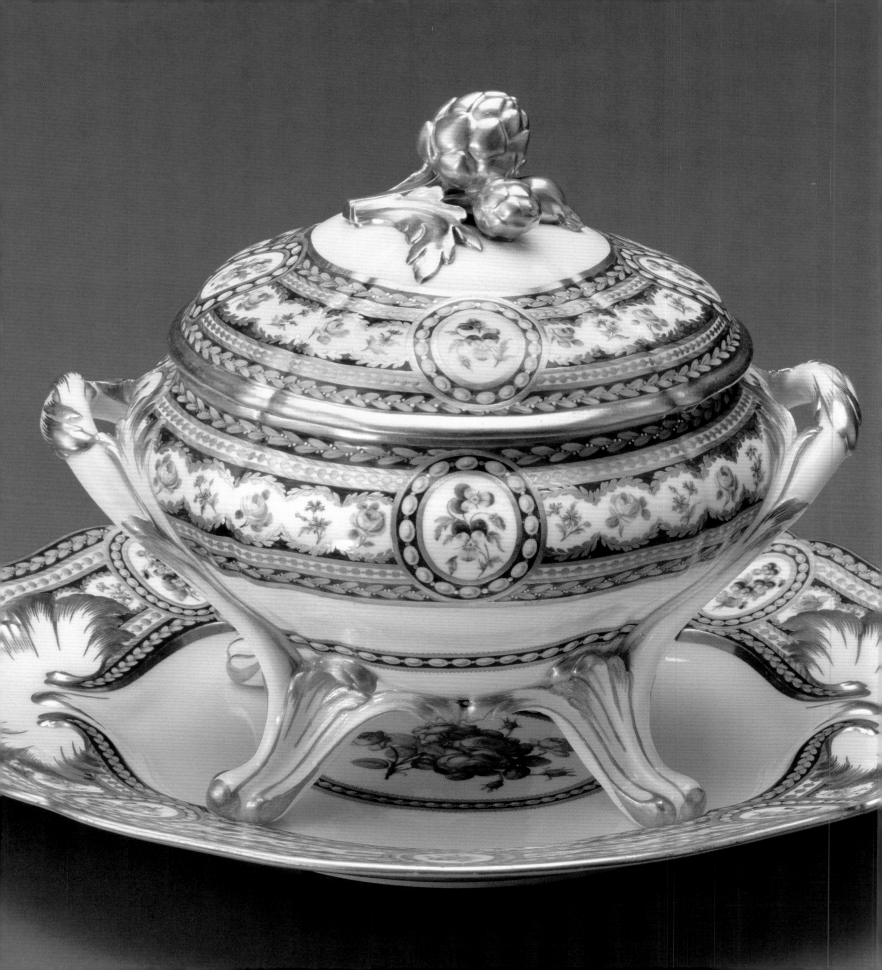

SÈVRES DIPLOMATIC GIFTS

Martin Chapman

T he Sèvres factory rose to become the most significant porcelain factory in Europe in the second half of the eighteenth century. Founded at Vincennes in 1740, it was originally intended to make porcelain in the style of the Meissen factory in Dresden, Saxony. In the first half of the eighteenth century, Meissen was the most successful European manufacturer because it was the first to combine true hard-paste porcelain with highly refined forms and decoration derived from Asian ceramics. The Elector of Saxony, Augustus the Strong (Frederick-Augustus I, 1670–1733), was so proud of Meissen's works that he often gave porcelain as diplomatic gifts. In eighteenth-century Europe, the making of Chinese-style porcelain became the passion of rulers across the Continent; even the smallest of European states set up factories in competition to make the most successful wares. France entered the fray in earnest with works made at the Vincennes factory. Although only soft-paste (imitation) porcelain was available there, Vincennes did have the whitest clays in France, and the factory rapidly developed the most fashionable forms in the Rocaille style, decorated with vibrant ground colors. After moving to Sèvres in 1756, the factory first operated under the patronage of Madame de Pompadour, then in 1759 Louis XV became the owner and principal shareholder. After this milestone, Sèvres was designated as a royal manufactory in the service of the Crown, enabling it to conceive ever more elaborate forms and extravagant schemes of decoration that were enhanced with lavish gilding. While the Seven Years' War (1756–1763) was raging across Europe, Sèvres emerged the victor in European porcelain manufacturing. Ironically, it was France's new enemy, Frederick the Great (Frederick II of Prussia, 1712–1786), who gave Sèvres its leading edge after he invaded Saxony, causing the Meissen factory to reduce its operations.

According to the *Journal des présents du roi*,[1] the kings of France added Sèvres porcelain at this time to the list of traditional diplomatic gifts for foreign sovereigns and ambassadors, which included diamond-set gold boxes, silver, Savonnerie carpets, and Gobelins tapestries. Because Sèvres was one of the most expensive luxury goods manufactured in France, it was a fitting gift to seal a treaty or make an alliance. A presentation of Sèvres could also strengthen family connections or commemorate a royal visit to Versailles. These gifts were also a form of

Tureen (*pot à oille*) and
stand, 1784
(detail of cat. 53)

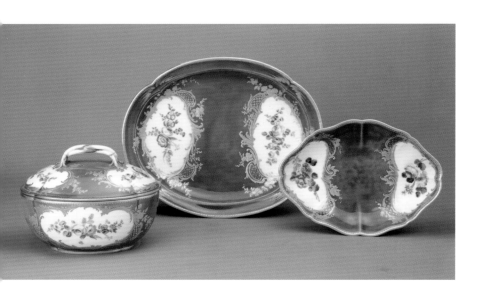

Fig. 1 Pieces from the service offered by Louis XV to Frederick V, king of Denmark (1723–1766)
Sèvres Porcelain Manufactory
Soft-paste porcelain
The State Hermitage Museum, Saint Petersburg, inv. nos. ZF-20447, GCH-755, GCH-747

promotion for the Sèvres manufactory, which by this time was producing the most prestigious porcelain in Europe.

The first French presentation of Sèvres porcelain as a diplomatic gift was a dinner service given in March 1758 to Frederick V, king of Denmark, ostensibly in gratitude for the stallion he had sent to Louis XV. In reality, it was one of three sets that had been made specifically to secure alliances or goodwill during the Seven Years' War.[2] Often considered the first major service made by the factory, the seventy-two plates were decorated with a newly invented green ground and cartouches with scenes of birds in landscapes and sprays of flowers (cat. 48). The service also included 164 vessels such as tureens, sauceboats, wine coolers, and saltcellars, and it cost the enormous price of 34,542 livres (fig. 1). Interestingly, it was bought from Sèvres by the marchand-mercier Lazare Duvaux (see section 6) on behalf of the king and then delivered to the Ministère des Affaires Étrangères (Ministry of Foreign Affairs), which then sent the service to Denmark. Louis XV's next presentation of Sèvres, to Maria Theresa, empress of Austria in December 1758, was even more politically significant: it was intended to seal the alliance between France and Austria, former archenemies. Having fought on opposite sides for the previous three hundred years, the two countries joined forces at this crucial point to turn against Prussia in the war. The set of seventy-four plates had rims with looped green ribbons entwined with garlands of flowers and gilding (see cat. 49); it was complemented with a large number of service pieces, which are still preserved in the Vienna Hofburg (see fig. 2). This new alliance would be further solidified in 1770 with the marriage of the Austrian archduchess Marie-Antoinette (1755–1793) to the future king, Louis XVI (1754–1793). Louis XV then presented a service to the Elector Palatine Charles Theodore of Bavaria to ensure his neutrality in the same treaty. Decorated with a blue-and-white *mosaïque* pattern recalling the Bavarian coat of arms (see cat. 50), the service so pleased Charles Theodore that he installed it in a specially built display case in the Residenz in Munich.

At the end of his life, Louis XV presented two more gifts that, while more familial, also reflected the alliance known as the *pacte de famille* (pact of the families) that bound the Bourbon dynasties of southern Europe (Spain, Parma, and Naples/Sicily) with France. Given in 1774, the wine cooler (cat. 51) for the queen of Naples and the sister of Marie-Antoinette was decorated with the initials *CL* (for Carlotta Luisa). Later that year, the king commissioned a service for his granddaughter, Maria Luisa of Parma, who would become queen of Spain in 1788. Delivered after the king's death in 1775, the set so enchanted the princess that she ordered more pieces in 1775, including the oval platter (cat. 52).

Louis XVI continued the tradition of presenting Sèvres as diplomatic gifts throughout his reign, from 1774 to 1792. When Prince Henry of Prussia, brother of Frederick the Great,

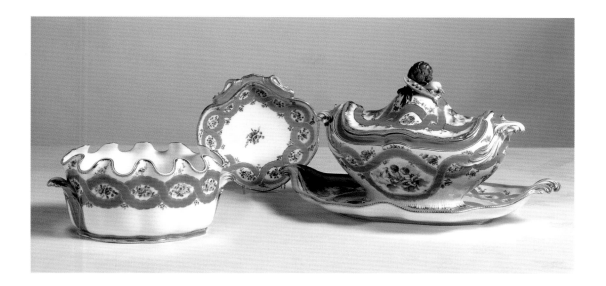

visited Paris in 1784, the importance of his political mission was recognized by the many gifts he received from the king, including Gobelins tapestries, a dinner service with a green ground, and a pair of vases with dolphin handles. The splendid vase from the gift (cat. 74) illustrates how incredibly luxurious these porcelain presents could be. It has a deep blue ground set off by rich gilding in three colors; to continue the aquatic theme, it is also decorated with frozen water, bulrushes, and seascape scenes. Louis XVI also gave Sèvres as gifts to visiting members of the royal family. Both of Marie-Antoinette's brothers were given services while they were in France: Joseph II, Holy Roman Emperor (1741–1790), on his visit in 1777; and Archduke Ferdinand of Austria (1754–1806), who arrived in France in 1786 and received a dinner service of 288 pieces (see cat. 54).

In the late 1780s, to reduce court ceremony and expenses, royal visits were often conducted incognito, with princes and kings appearing at Versailles under assumed names. Early in 1784 Marie-Antoinette had ordered a new Sèvres service of more than three hundred pieces, with rich bands of gilding and painted flowers, but a sudden and unexpected visit from Gustav III, king of Sweden, traveling under the name of the comte d'Haga, prompted Louis XVI to give the service to the king instead. Marie-Antoinette had to wait some months for another service of the same pattern to be made for her, as originally intended; it was finally delivered in August 1784. The tureen (*pot à oille*) with its stand was the most impressive and indeed the most expensive part of the dinner service, costing 600 livres (cat. 53).

1. 2095, fol. 8; Archives of the Ministère des Affaires Étrangères, Paris.

2. Dorothée Guillemé-Brulon, "Les services de porcelaine de Sèvres, présents des rois Louis XV et Louis XVI aux souverains étrangers," in *Versailles et les tables royales en Europe, XVIIème–XIXème siècles*, ed. Musée National des Chateaux de Versailles et de Trianon (Paris: Réunion des Musées Nationaux, 1993), 184–187.

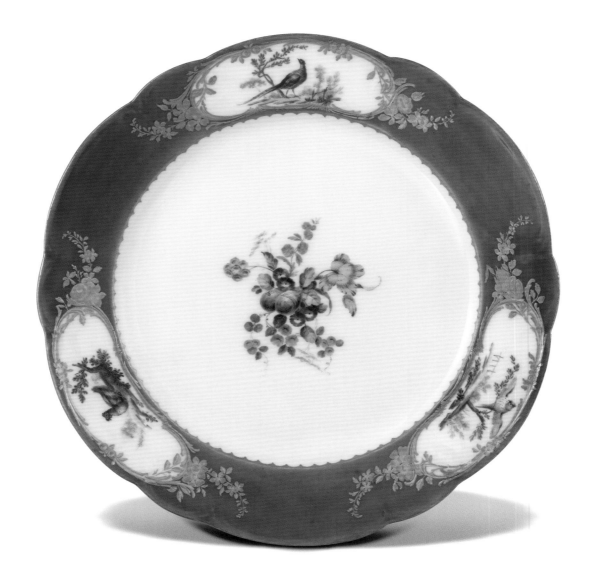

SÈVRES PORCELAIN MADE AS DIPLOMATIC GIFTS
After King Louis XV bought the Sèvres manufactory in 1759, porcelain was made there for the king's use in the royal palaces and for sumptuous diplomatic gifts specifically intended to herald the talents of French manufacturing.

48
Plate (*assiette à petites palmes*) with green ground, 1756
From the service offered by Louis XV to Frederick V, king of Denmark (1723–1766)
Sèvres Porcelain Manufactory (France, established 1756)
Soft-paste porcelain

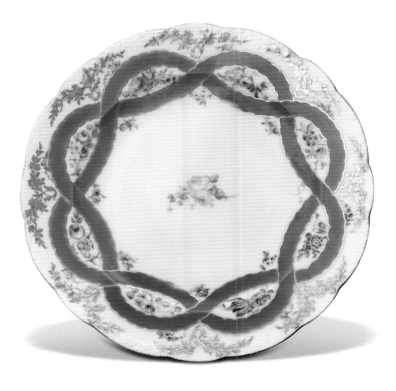

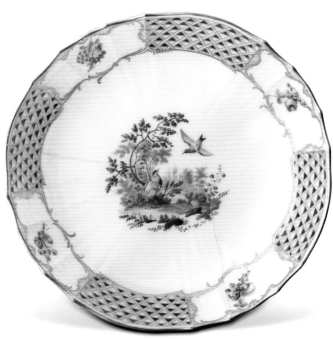

49
Plate (*assiette à guirlandes*) decorated with green ribbons, 1757
From the service offered by Louis XV to Empress Maria Theresa of Austria (1717–1780)
Sèvres Porcelain Manufactory (France, established 1756)
Soft-paste porcelain

50
Fruit plate (*compotier mosaïque*), 1759
From the service offered by Louis XV to the Elector Palatine Charles Theodore of Bavaria (1724–1799)
Sèvres Porcelain Manufactory (France, established 1756)
Soft-paste porcelain

51
Wine cooler, 1774
From the service offered by Louis XV to Maria Carolina, queen of Naples (1752–1814)
Sèvres Porcelain Manufactory (France, established 1756)
Soft-paste porcelain

52
Platter (*plat à contours*), 1775
From the dinner service offered by Louis XV to his granddaughter Maria Luisa of Parma (1751–1819)
Sèvres Porcelain Manufactory (France, established 1756)
François-Antoine Pfeiffer (active France 1741–1800), painter; Pierre-Nicolas Pierre (French, active 1759–1776), gilder
Hard-paste porcelain

53
Tureen (*pot à oille*) and stand, 1784
From the dinner service offered by Louis XVI to Gustav III, king of Sweden (1746–1792), or from a second,
identical service made for Queen Marie-Antoinette
Sèvres Porcelain Manufactory (France, established 1756)
Tureen: Jacques-François Micaud (French, active 1757–1810), painter; Étienne-Henri Le Guay (French, active 1748–1749, 1751–1796), gilder
Stand: Jacques-François-Louis de Laroche (French, active 1758–1802), painter; Henri-François Vincent the elder (French, active 1753–1800), gilder
Soft-paste porcelain

54
Soup plate (*plat à potage*), 1785
From the service offered by Loius XVI to Archduke Ferdinand of Austria (1754–1806)
Sèvres Porcelain Manufactory (France, established 1756)
Cyprien-Julien Hirel de Choisy (French, active 1770–1812), painter; Michel-Barnabé Chauvaux the elder (French, active 1752–1788), gilder
Soft-paste porcelain

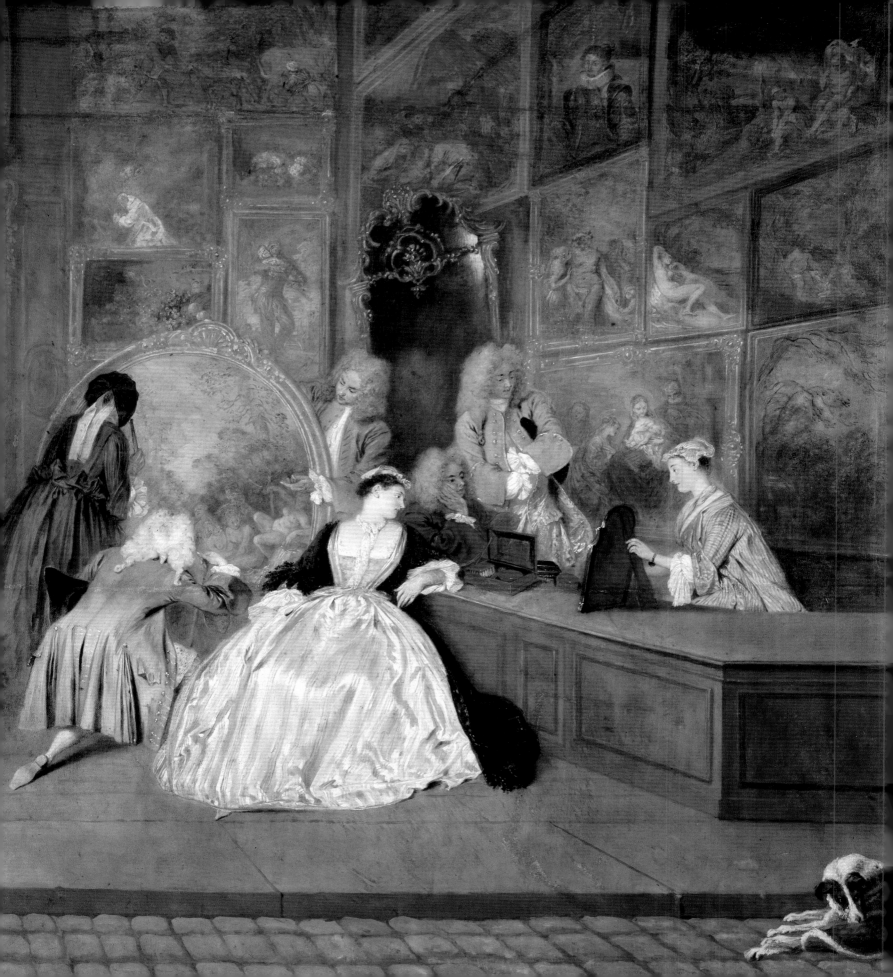

THE MARCHANDS-MERCIERS, THE DEALERS IN LUXURY GOODS

Martin Chapman

T he dealers in luxury goods known as *marchands-merciers*[1] were central to the process of providing objets d'art for royal consumption during the eighteenth century. Succeeding the system of state patronage established under Louis XIV at the Gobelins, which after 1690 had been reduced to no more than a tapestry manufactory, these dealers ruled the luxury trade in Paris until the French Revolution. The marchands-merciers not only commissioned objects from the numerous artisan workshops found throughout Paris, but also acted as designers, interior decorators, jewelers, and intermediaries between artist and patron. Famously characterized in Denis Diderot's *Encyclopédie* as "sellers of everything, makers of nothing,"[2] the marchands were essentially tastemakers who supplied the court, nobility, and wealthy foreigners with works of art and decorative objects. They also determined how these objects were to be displayed in the highly sophisticated interior decorative schemes that evolved mainly under their influence. The furnishing of extravagant interiors in Paris was the preserve of the marchands-merciers. It was they who created the demand for a variety of specialized objects such as small tables for writing, sewing, or dining; chandeliers, candelabra, and wall lights; and Chinese and Japanese porcelain mounted in gilt bronze. It was also the marchands who possessed the capital outlay to purchase expensive and exotic materials such as porcelain and lacquer, which were priced beyond the reach of the individual *ébéniste* (cabinetmaker) or *bronzier* (bronze worker). In these different ways they could cater to almost every aspect of opulent living in Paris and the court at Versailles.

One area in particular was the preserve of the marchands: the mounting of Chinese porcelain in gilt bronze. Porcelain had been mounted in silver and silver gilt in previous centuries, but the use of gilt bronze was an eighteenth-century innovation specifically created by the marchands in response to the demand for richly wrought objects that would lend an exotic flair to luxury interiors. Through the application of metal mounts, which were gilded to reflect candlelight, the highly desirable Asian porcelains were transformed into more familiar European vessel and vase forms. Although the pieces were mainly decorative, some examples were ostensibly functional, such as potpourris, candelabra, and inkstands. By having pieces made according to the evolving rules of style and comfort, the marchands assumed a financial

Antoine Watteau,
L'enseigne de Gersaint, 1721
(detail of fig. 1)

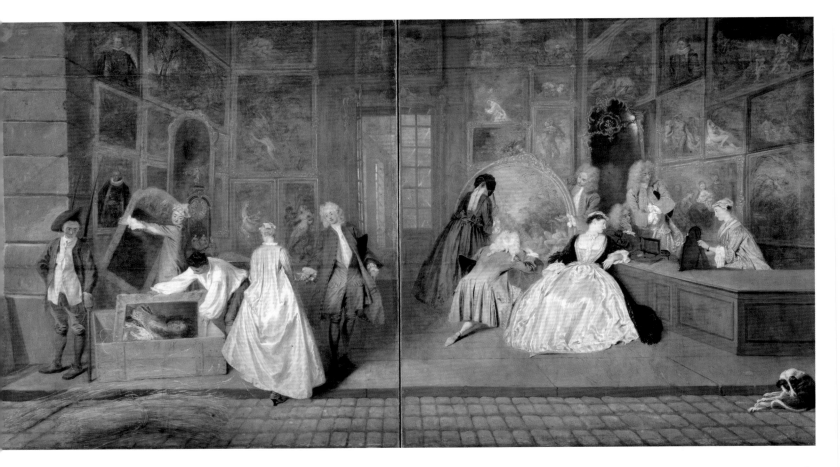

Fig. 1 Antoine Watteau
L'enseigne de Gersaint, 1721
Oil on canvas,
64³⁄₁₆ × 121¹⁄₄ in.
(163 × 308 cm)
Schloss Charlottenburg,
Preussische Schlösser
und Gärten, Berlin,
inv. Gen.Kat.I 1200-1201

Luxury works of art as well as
paintings are depicted in this
shop sign for the marchand-
mercier Gersaint.

risk. They first purchased the porcelain on the Amsterdam market, then had artisans apply carefully designed and executed gilt-bronze mounts. Although the mounts were made by a succession of specialized metalworkers—founders, chasers, and gilders in Paris's network of small workshops—the whole commission was overseen by the dealers.

The marchands operated from shops that were located primarily on and around rue Saint-Honoré in Paris. It was common in the eighteenth century for these shops to open directly onto the street, as famously depicted in the 1721 painting *L'enseigne de Gersaint* by Antoine Watteau (fig. 1). The wide variety of items sold by the dealer Edmé-François Gersaint can be seen in Watteau's painting, from furniture and mirrors to works of art and jewelry. Thomas-Joachim Hébert, who held a royal warrant as a *marchand suivant la cour* (dealer to the court), was a favorite of the royal family in the mid-eighteenth century. In addition to his premises in Paris, he opened a shop at Versailles to ensure that members of the court had immediate access to his wares. He is recorded as having sold much lacquer-mounted furniture to the royal family, as well as porcelain, clocks, and chandeliers. In 1742 for the Château de Choisy, Hébert provided a commode, now in the Louvre (fig. 2), decorated with a type of imitation lacquer called *vernis Martin* to Madame de Mailly, one of the mistresses of Louis XV. His business was so successful that his daughter married a son of the Dauphine's first lady

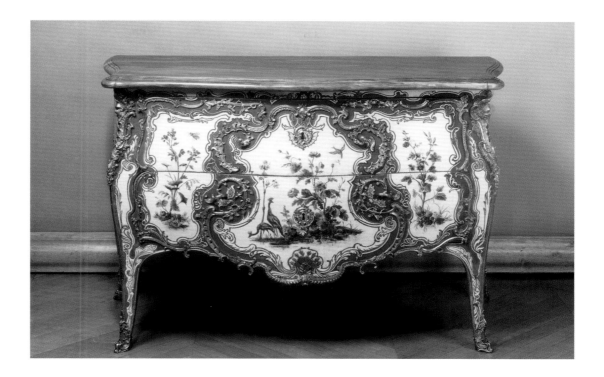

Fig. 2 Commode of Madame de Mailly, 1742
Matthieu Criaerd
Oak with fruitwood veneer, silver mounts, and blue marble,
$33^{7}/_{16} \times 51^{15}/_{16} \times 25^{1}/_{8}$ in.
(85 × 132 × 63.8 cm)
Musée du Louvre, Département des Objets d'Art, OA 11292

of the bedchamber. She reputedly brought an enormous dowry with her, enabling Hébert to retire with a royal position.[3]

The marchands also played a significant role in the porcelain production of the Sèvres factory. One dealer, Lazare Duvaux, who also held a royal warrant as a *marchand suivant la cour*, is documented as having purchased three-fifths of the total output of Sèvres in 1757.[4] As dealer to the court, he supplied the king's favorite, Madame de Pompadour, with 150 pieces of mounted porcelain between 1748 and 1758.[5] Another dealer, Simon-Philippe Poirier, specialized in commissioning furniture mounted with Sèvres porcelain plaques; between 1758 and 1770 he bought almost 700,000 livres worth of Sèvres porcelain, including plaques for furniture, for which he held the virtual monopoly.[6] Poirier was the preferred supplier to Madame du Barry, the last mistress to Louis XV, and he supervised the production of her spectacular tea table with a tilting top made for her Château de Louveciennes (cat. 60). The Sèvres porcelain plaques—some of the most splendid ever applied to a table—were combined with a solid mahogany base embellished with purple wood veneers and gilt-bronze mounts by the cabinetmaker Martin Carlin. The principal plaque depicts an exotic scene after the 1737 work *Le concert du Grand Sultan* by Carle van Loo, which must have been copied from an engraving rather than the original painting because the composition is reversed. Charles-Nicolas Dodin, the leading artist at Sèvres, painted the plaque in 1774, and records show that Poirier paid the enormous sum of 3,000 livres for the finished piece.[7]

In addition to furniture and other items necessary for the luxury interior, the marchand-mercier supplied jewelry and gold boxes, and several dealers sold these articles from their

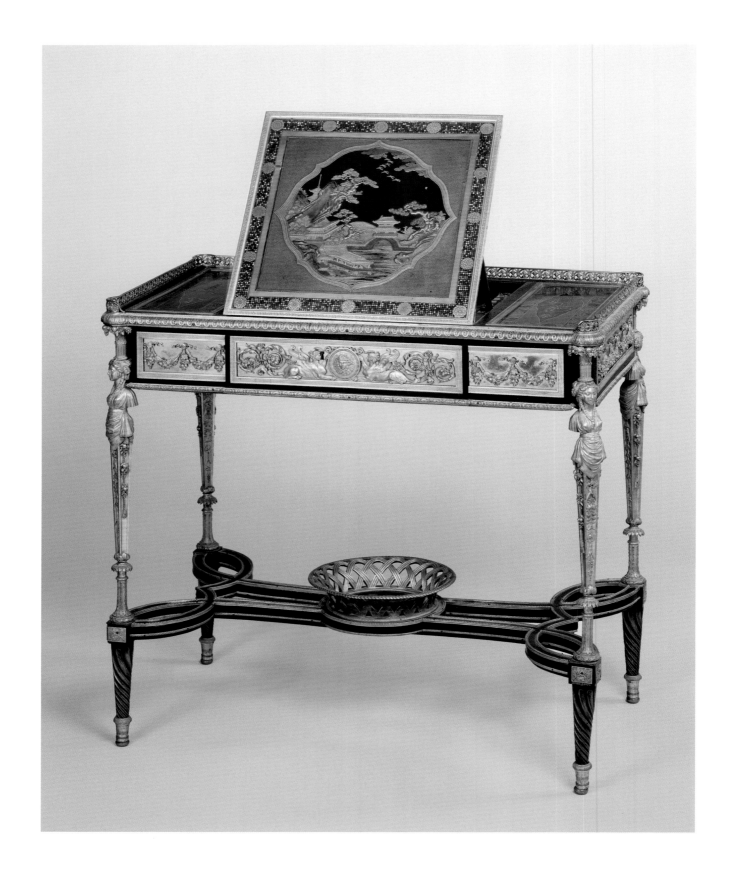

shops on rue Saint-Honoré. Like the dealers who specialized in opulent furnishings, these marchands also had the means to purchase expensive materials. A gold box for presentation by the king of France as a diplomatic gift required several different makers, and the marchand served as a liaison between the numerous craftsmen. He could commission the box frame from a goldsmith and the all-important miniature portrait from an enamel painter. An enameler was often commissioned to decorate the box's exterior, and a jeweler gave the box its finishing touch by applying the finest diamonds and other gemstones. Because of their meticulous craftsmanship, these boxes were truly major works of art in miniature. They were also extremely valuable, and some ambassadors who received them as gifts from the king were known to have later returned them to the marchands in exchange for their cash value. One box listed in the *Registres des présents du roi* (Registers of the king's gifts) was given to the same ambassador twice: first in 1770 and again in 1777. Only a month after the 1777 presentation, the same box was recorded as being returned to the goldsmith.[8] Several of the snuff boxes in the Louvre have royal origins, and they are the rare survivors of this type of object as so many were broken up and sold due to the high value of the materials incorporated into them.

Although the royal households could commission works of art directly from artists and artisans, the role of the marchand-mercier nonetheless remained vital. They could ensure that the craftsmen followed techniques to achieve the best quality and that the objects met the highest standards of design within the confines of fashion. Their oversight and involvement resulted in some of the most remarkable objects made for the royal family in the eighteenth century (see fig. 3).

1. The term translates as "merchant of merchandise." It underlines the fact that, due to ancient guild regulations, these dealers could sell but not make objects. See Carolyn Sargentson, *Merchants and Luxury Markets: The Marchands Merciers of Eighteenth-Century Paris* (London: Victoria and Albert Museum; Malibu, California: J. Paul Getty Museum, 1996).

2. In Denis Diderot and Jean le Rond D'Alembert, eds., *Encyclopédie, ou Dictionnaire raisonné des sciences, des arts et des métiers, etc.* (Neuchâtel: 1765), 10:360, *merciers* are defined as "faiseurs de rien, marchands de tout."

3. Alexandre Pradère, *French Furniture Makers: The Art of the Ébéniste from Louis XIV to the Revolution* (Malibu, California: J. Paul Getty Museum, 1989), 32–33.

4. Pierre Verlet, "Le commerce des objets d'art et les marchands merciers à Paris au XVIIIe siècle," *Annales: Économies, sociétés, civilisations* 13, no. 1 (January–March 1958): 10–29.

5. Francis John Bagolt Watson, *Mounted Oriental Porcelain in the J. Paul Getty Museum* (Washington, DC: International Exhibitions Foundation, 1986), 15.

6. Pradère, *French Furniture Makers,* 37.

7. Daniel Alcouffe, Anne-Dion Tenenbaum, and Amaury Lefébure, *Furniture Collections in the Louvre,* 2 vols. (Dijon: Éditions Faton, 1993), 1:224–227.

8. Charles Truman, *The Gilbert Collection of Gold Boxes* (Los Angeles: Los Angeles County Museum of Art; New York: Harry N. Abrams, 1991), 10.

Fig. 3 Writing table of Marie-Antoinette, 1784
Adam Weisweiler
Gilt bronze, steel, ebony, Japanese lacquer, and mother-of-pearl,
29 × 31^{15}/$_{16}$ × 17^{13}/$_{16}$ in.
(73.7 × 81.2 × 45.2 cm)
Musée du Louvre, Département des Objets d'Art, OA 5509

One of the most precious pieces of furniture made for Marie-Antoinette, this writing table was supplied by the dealer Daguerre in 1784 for the queen's use.

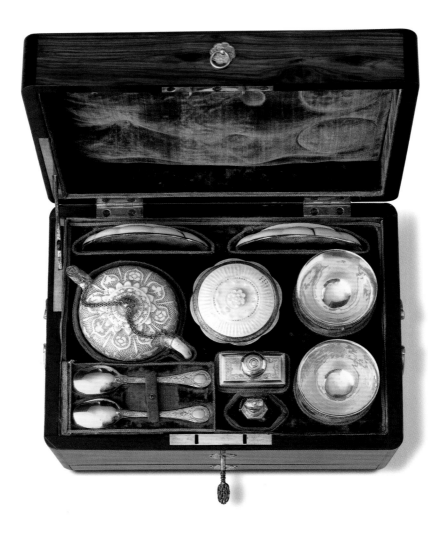

THE MARCHANDS-MERCIERS, LUXURY OBJECTS, AND THE NEW FASHION FOR INTIMATE LIVING
With the demise of the Gobelins as a manufactory, the marchands-merciers assumed the role of supplying the royal family with objects for the new style of intimate living, directing taste and setting the highest standards for the creation of luxury goods in Paris until the Revolution. Forgoing the court splendor of Louis XIV's reign, subsequent rulers of France retreated, as did the aristocracy, to live in smaller rooms decorated with highly worked objects that better suited the new standards of style and comfort. The fashion for more casual, intimate living, rather than the formal life at Louis XIV's court at Versailles, was initiated under Philippe d'Orléans, who ruled during the minority of Louis XV. Objects of great costliness were made for this new form of comfort.

55
Tea service (*nécessaire*), 1717–1722
Belonged to the duchesse d'Orléans (1677–1749), wife of the Régent, Philippe d'Orléans (1674–1723)
Paris, France
Chinese porcelain decorated with gold (*piqué d'or*), gold, and rock crystal; kingwood and mahogany case with gilt-bronze mounts, and velvet

This precious nécessaire *(tea service) has a fitted case. The canister, flask, and spoons are made of solid gold, and the porcelain is decorated with tiny gold dots in a technique known as* piqué d'or. *All the pieces were to be served on a lacquer tray (now lost) that was kept in the drawer.*

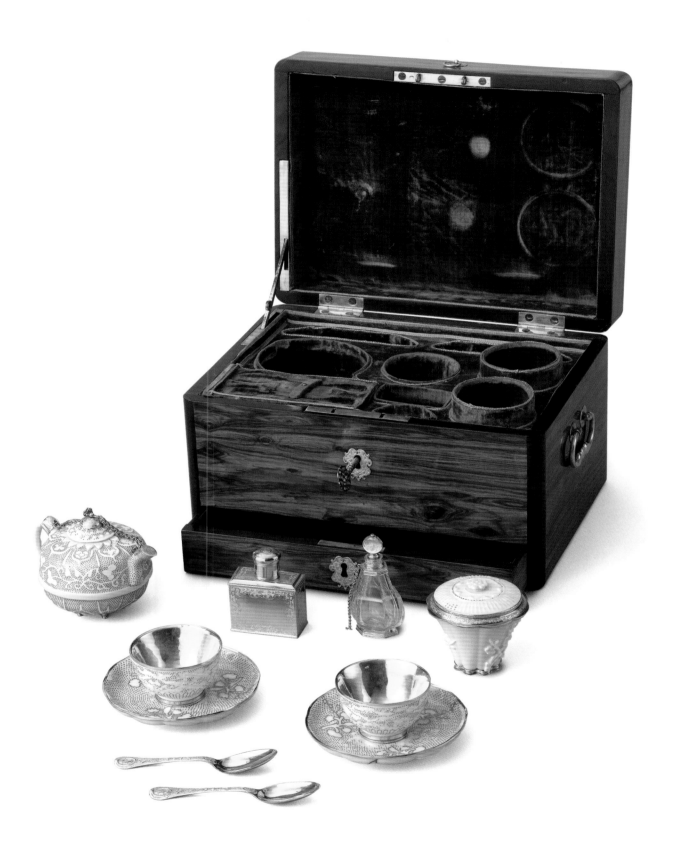

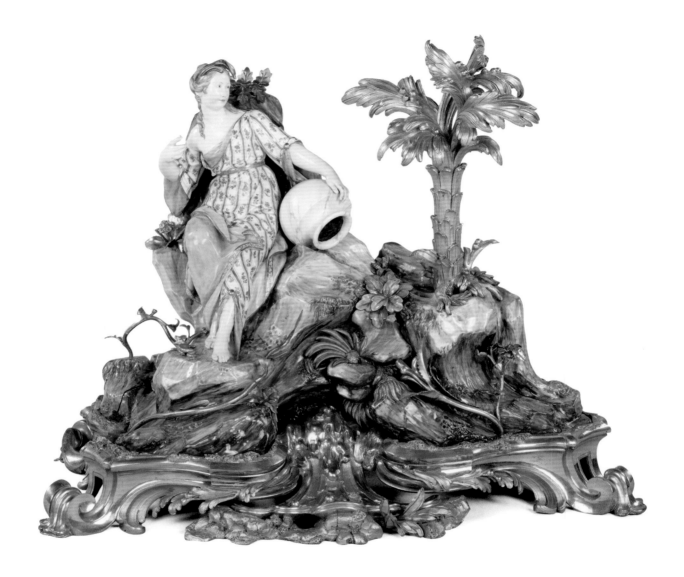

56

Figure of a Naiad, 1756

Vincennes/Sèvres Porcelain Manufactory (France, established 1756)

Charles-Nicolas Dodin (French, 1734–1803), painter;

Jean-Claude Duplessis *père* (French and Italian, active Paris; ca. 1695–1774), metalworker

Soft-paste porcelain and gilt bronze

This highly colored figure of a Naiad (a water nymph) is the only known work of sculpture signed by Dodin, who was to become the premier painter at Sèvres. It was sold by the marchand-mercier, Lazare Duvaux, to another dealer, Thomas-Joachim Hébert, who had it mounted in gilt bronze. The mounts are very much in the style of the multitalented metalworker Duplessis, who also worked as a sculptor modeling porcelain for the Vincennes manufactory. It was formerly fitted with a clock.

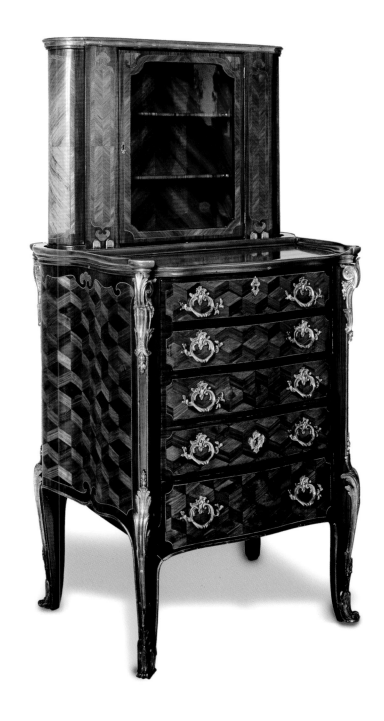

57
Table à la Bourgogne (mechanical desk), ca. 1760
Jean-François Oeben (German, active France; 1721–1763; master in 1761), cabinetmaker
Tulipwood, kingwood, sycamore, and purple wood on an oak carcase; gilt bronze; red Griotte marble, silk, glass, and velvet

In the mid-eighteenth century, with the smaller private living quarters of fashionable interiors, tables that could serve several functions became one of the wonders of modern Paris. The cabinetmaker Oeben was known for his so-called mechanical tables and secrétaires. *The example here conceals a little bookcase that rises from the back, and in the drawers a writing slope, a laptop desk that could be removed, and a flap that could be used as a prie-dieu for prayer.*

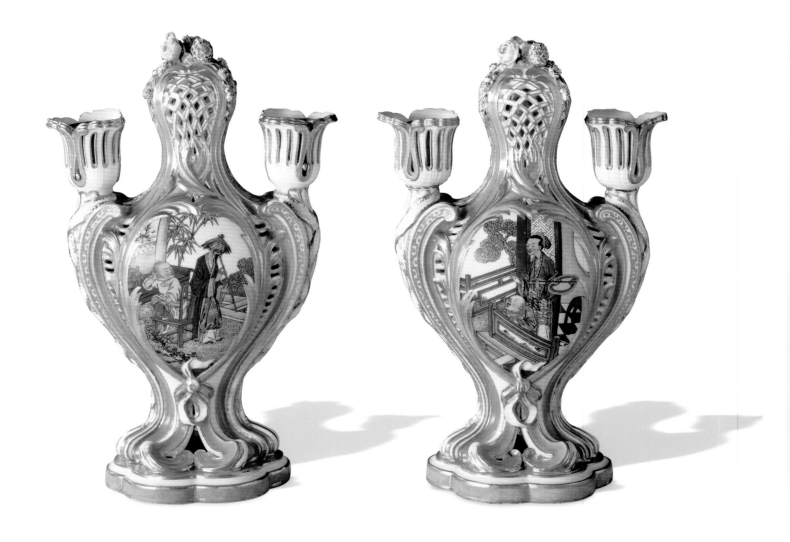

58
Pair of vases with candle branches (*pot pourris à bobèches*), ca. 1762
Made for Madame de Pompadour (1721–1764)
Sèvres Porcelain Manufactory (France, established 1756)
Charles-Nicolas Dodin (French, 1734–1803), painter
Soft-paste porcelain

These vases, which functioned both as candelabra and potpourris, were decorated with chinoiserie scenes by Dodin on one side and with sprays of flowers on the
back. They were part of a larger garniture set that was intended for display on the chimneypiece, where the backs could be seen reflected in the mirror.
The petit vert *ground color, a pale green, was much favored by Madame de Pompadour.*

59

Coffee grinder, 1756–1757

Made for Madame de Pompadour (1721–1764)

Jean Ducrollay (French, ca. 1708–after 1776), goldsmith

Gold in three colors, steel, and ivory

The new fashion for entertaining in small, private apartments, without legions of servants in attendance, meant that members of the royal family and the aristocracy could often serve themselves. Madame de Pompadour, who gave intimate dinners hosted by the king, is known to have owned several examples of gold tableware, although the only surviving piece is this coffee grinder. Made of gold in three colors (rose, green, and yellow), it is modeled with sprays of coffee branches and their berries.

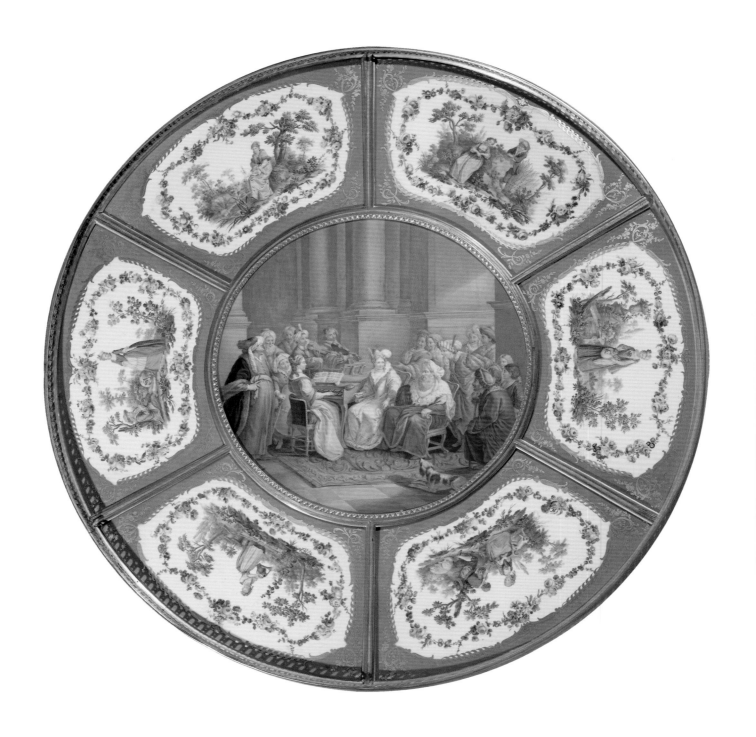

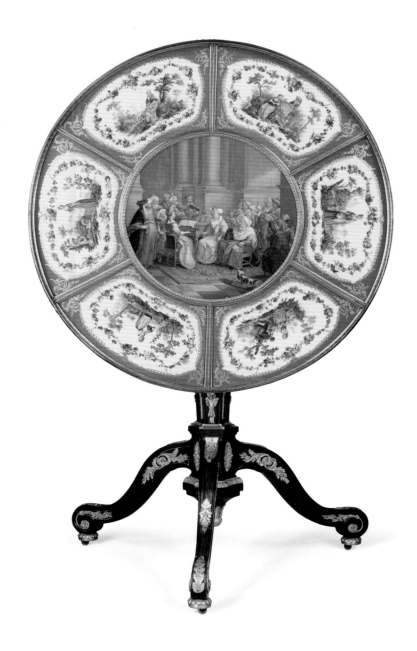

60

Tea table with Sèvres porcelain plaques, 1774
Made for Madame du Barry (1743–1793)
Martin Carlin (German, active France, ca. 1730–1785; master in 1766), cabinetmaker;
Charles-Nicolas Dodin (French, 1734–1803), painter
Oak, mahogany, and purple wood veneer; gilt-bronze mounts; and soft-paste porcelain

Supplied by the marchand-mercier Simon-Philippe Poirier for Madame du Barry in 1774, this tea table with a tilting top is one of the most elaborate examples of its type ever made. The seven porcelain plaques cost the enormous sum of 3,000 livres, and the base by Martin Carlin, the leading cabinetmaker, is of expensive purple wood veneered on mahogany and then mounted in gilt bronze. Seized at the Revolution, it was intended to be reserved for the French national collections as a masterpiece of porcelain making.

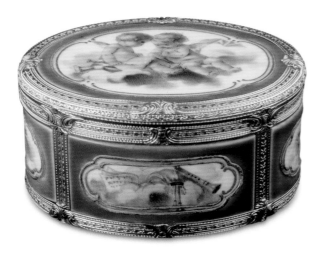

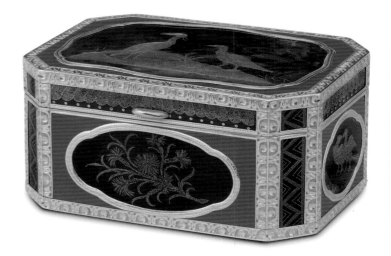

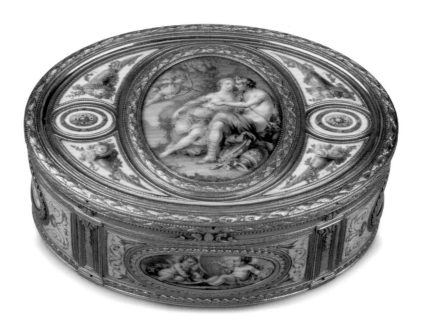

LOUIS XV: GOLD BOXES

The mid-eighteenth century was a high point for the making of gold snuff boxes. The habit of taking snuff (powdered tobacco) was widespread in
Europe, and the containers were ingeniously designed not only to keep the snuff fresh but also to reflect the tastes and
ambitions of their owners. In addition to the goldsmith, a variety of craftsmen might be commissioned by the marchand-mercier
to make these tiny works of art, including enamelers, jewelers, and painters of miniatures.

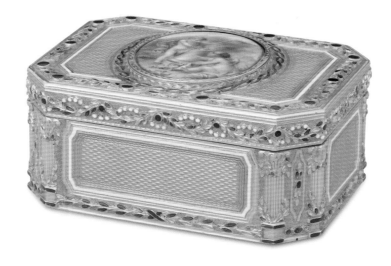

LACQUER, ENAMEL, AND PORCELAIN BOXES

61
(opposite top, left)
Snuff box with Sèvres porcelain plaques, 1756–1759
Sèvres Porcelain Manufactory (France, established 1756)
Jean Ducrollay (French, ca. 1708–after 1776), goldsmith
Gold in two colors and soft-paste porcelain

62
(opposite top, right)
Snuff box with lacquer, 1761–1763
Jean-Marie Tiron, called Tiron de Nanteuil (French, active 1748–1781), goldsmith
Gold, red, and black lacquer with piqué in four colors

63
(opposite bottom)
Snuff box depicting "Bacchus Embracing Ariadne," 1764–1765 and 1773–1774
Pierre-François Drais (French, ca. 1726–1788), goldsmith
Gold and enamel

Although the inscription on this box suggests that it was given to Madame du Barry by the king, this is probably spurious. The theme of the painted enamels is Love; a scene of Bacchus and Ariadne is on the lid, while cornucopias are in each of the spandrels.

64
(above)
Snuff box depicting "Sacrifice to Love," 1775–1776
Charles Le Bastier (French, master in 1754; active until 1783), goldsmith
Gold and enamel

The inscription indicates that this box was supplied by Au Petit Dunkerque, the shop of the marchand-mercier Charles Raymond Granchez, which was located on the quai de Conti in Paris. Granchez, originally from Dunkirk, became a dealer in luxury goods in Paris in 1767. He sold a wide variety of novelties and luxury objects.

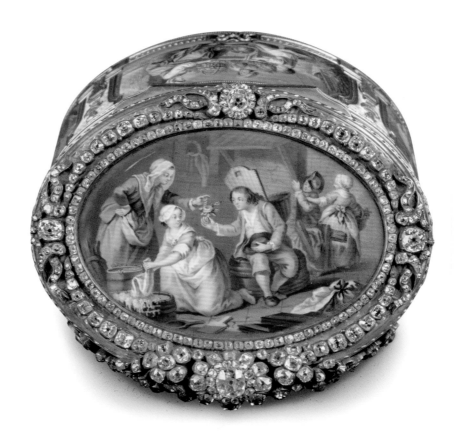

GOLD AND DIAMOND BOXES

65
Snuff box with genre scenes, 1760–1761
Mathieu Coiny *fils* (French, b. 1723; master in 1755; recorded 1788), goldsmith
Gold in two colors, diamonds, and enamel

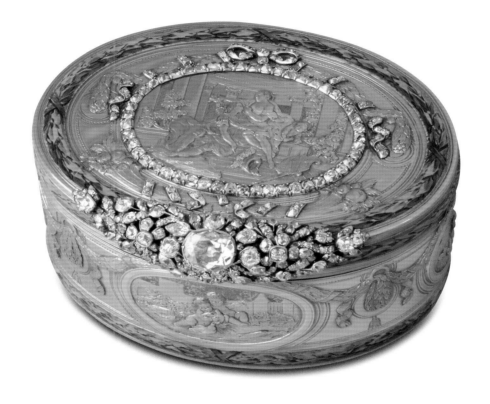

66
Snuff box depicting "Venus and Mars," 1762–1775
Noël Hardivilliers (French, active 1729–1771), goldsmith
Gold in four colors and diamonds

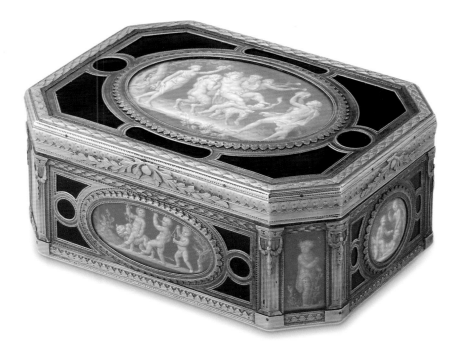

ENAMELED BOXES *"À L'ANTIQUE"*

The design of these boxes reflects the prevailing taste for Neoclassicism that arose in the 1760s. This taste, known in France as *"à l'antique"* is shown particularly in the enameled plaques, which are painted to imitate antique cameos.

67
(opposite top)
Snuff box with scenes from antiquity, 1768–1770
Pierre-François Drais (French, ca. 1726–1788), goldsmith
After Jacques-Joseph de Gault (French, ca. 1738–after 1812), painter
Gold and enamel

68
(opposite bottom)
Snuff box with scenes from antiquity, 1770–1771
Pierre-François Drais (French, ca. 1726–1788), goldsmith
After Jacques-Joseph de Gault (French, ca. 1738–after 1812), painter
Gold and mother-of-pearl

69
(above)
Snuff box with "The Triumph of Silenus," 1773
Pierre-François Drais (French, ca. 1726–1788), goldsmith
Gold, red agate, and enamel

LOUIS XVI AS A PATRON OF THE ARTS

Martin Chapman
ıııııııııııııııııııııııııııııı

A lthough the reputation of Louis XVI (1754–1793) as an art collector has been somewhat eclipsed by that of his wife, Queen Marie-Antoinette (1755–1793), the king was in fact a major patron of the arts. Influenced by the ideas of the Enlightenment, he embarked on a series of reforms during his reign, from 1774 to 1792, one of which was to found a new museum. In 1774 he installed part of the royal collection in the Garde-Meuble de la Couronne,[1] on what is known today as the place de la Concorde (fig. 1). The galleries included Louis XIV's collection of hardstone vases, called the Gemmes de la Couronne (see section 2), and the Crown jewels; they were open to the public on certain days. In 1784 he established an additional gallery devoted to the sculpture collection of Louis XIV, which proved to be very popular. During this time he supported a much grander project—establishing a museum in the galleries of the royal palace of the Louvre—and he acquired objects specifically for that purpose. This institution, to be called the Museum Central des Arts, did not open at the Louvre until the French Revolution, some months after the king's execution in 1793.

In anticipation of this project, Louis XVI bought objects that he felt reflected the greatest work of contemporary French artists and craftsmen at the sale of the duc d'Aumont in 1782. D'Aumont, who was one of the most prominent collectors of the time, had commissioned a celebrated group of hardstone vases, furniture, and decorative objects during the 1770s. He had revived the ancient craft of creating works of art from decorative marbles and hardstones by establishing a stone-turning workshop at the Menus Plaisirs (the royal department responsible for celebrations and festivities). These workshops were to rival those of Rome and Florence in the production of grand vases, and between 1770 and 1782 some of the finest hardstone pieces were made there for his own collection. Mounted by Pierre Gouthière, the famous *bronzier* (bronze worker), these objects were among the most celebrated works of art of the day. In addition to gilt bronzes and mounted vases of hardstone and porcelain, Gouthière also produced wall lights, clocks, and chandeliers that were noteworthy for their superlative chasing and gilding. From the d'Aumont sale the king purchased twenty-two vases, seventeen columns, and several pieces of furniture—including the pair of cabinets by Joseph Baumhauer mounted with Florentine pietre-dure panels (cat. 77); the cost of all of these items equaled more than

The "Temple of Love," back panel of a *lit à la duchesse* (state bed), ca. 1775 (detail of cat. 71)

Fig. 1 The hôtel du Garde-Meuble de la Couronne. The building is now the Ministère de la Marine (the naval headquarters), place de la Concorde, Paris.

half the total realized from the sale. Several of the objects are today in the Musée du Louvre, including two remarkable pieces mounted by Gouthière: a vase of green serpentine mounted with sensuous female figures (cat. 75), and one of a pair of Chinese celadon vases mounted with figures and ornaments derived from antiquity (cat. 76). Marie-Antoinette also bought from the duc d'Aumont sale, where she acquired the famous jasper perfume burner mounted by Gouthière that is today in the Wallace Collection, London (see section 8, fig. 2).[2]

The royal palaces benefited from Louis XVI's acquisitions, and he ensured that each of his residences was provided with the finest art, furniture, tapestries, and gilt bronzes. At the behest of the Garde-Meuble, the greatest craftsmen, artists, and designers of Paris were commissioned to produce their highest-quality luxury goods for the palaces. The cabinetmaker Jean-Henri Riesener supplied the royal households with more than seven hundred pieces of furniture lavishly decorated in marquetry of exotic woods and delicately finished gilt bronzes. In 1784, however, he was ousted by the new head of the Garde-Meuble, Marc-Antoine Thierry de Ville d'Avray, for charging exorbitant prices. Riesener was also responsible for Marie-Antoinette's desk at the Palais des Tuileries (cat. 83), and even after his dismissal from the Garde-Meuble the queen remained loyal to the cabinetmaker, commissioning furniture from her privy purse in the years before the Revolution.

Although the 1780s was a decade of austerity, with poor harvests and France deeply in debt, Louis XVI still initiated extensive campaigns of redecorating and refurnishing the royal palaces. The vast cost of these projects was one of the criticisms leveled at the king and queen at the outbreak of the Revolution. During his reign, Versailles was essentially a construction site, and although extensive plans were drafted for its rebuilding, its exterior renovation was never realized due to the prohibitive expense. Nonetheless, much was done inside the Château de Versailles. In his private apartments, Louis XVI had the games room of his royal predecessor converted into a library (fig. 2) where he could indulge his interest in geography. Its paneling was carved in the refined Neoclassical style that would be named for the king. In 1784 Marie-Antoinette had her private apartments at Versailles completely redecorated in a more feminine version of the Louis XVI style (see section 8). At this time, somewhat surprisingly, the king also acquired numerous new châteaux: the Château de Rambouillet, for hunting, which included a model dairy of groundbreaking design made especially for the queen; the Château de Montreuil, purchased for his sister, Madame Elisabeth; and the Château de Saint-Cloud, acquired from his cousin the duc d'Orléans (1747–1793) in 1785 for six million livres. Saint-Cloud, bought for the queen as her personal residence, had its interiors extensively remodeled by the architect Richard Mique. Unfortunately, these exquisite apartments

Fig. 2 Louis XVI's library in his private apartments at the Château de Versailles was based on a design by Ange-Jacques Gabriel that had been ordered by Louis XV but was not carried out until 1774–1775.

Some of the Sèvres figures from Les hommes illustres *are displayed on the central table.*

were destroyed in the Franco-Prussian War (1870–1871). Although the Garde-Meuble initially reused furniture from other palaces for the queen's new château—for example, the commode and *secrétaire* originally supplied by Riesener for the queen's Grand Cabinet Intérieur at Versailles (section 8, fig. 3)—new furniture was made in 1787 and 1788 in the feminine and highly decorated style associated with Marie-Antoinette.

The king inherited the porcelain manufactory Sèvres in 1774, after the death of his grandfather, Louis XV, and following his predecessor's tradition held a sale each year at Christmas to garner support for its production. He acquired many pieces for himself, building a collection of more than one hundred vases that was dispersed after the Revolution. He also commissioned a new dinner service in 1783 for use at Versailles. Intended to comprise three hundred pieces that were decorated with scenes from Greek and Roman history and mythology, it was to have been the most expensive and sumptuous service ever made by Sèvres. However, the service remained incomplete at the dawn of the Revolution, and it is today primarily in the British Royal Collection at Windsor Castle.

One of the greatest endeavors initiated under Louis XVI was the sculptural project depicting famous Frenchmen. For the Great Men of France (*Les hommes illustres*), the comte d'Angiviller, director of the Bâtiments du Roi in 1776, initially commissioned four models in marble from prominent French sculptors. Beginning in 1783, reductions of the models were made at Sèvres in biscuit porcelain, a type of unglazed ware that resembled marble (see cats. 72–73). Twenty-three of the statues were reproduced in porcelain, and the king bought several examples that he displayed in his private apartments at Versailles, including in his library (see fig. 2).[3] He also acquired additional models to be given as diplomatic gifts, furthering the important role that Sèvres played in promoting the arts of France abroad.

1. The institution that oversaw furniture and works of art in the royal palaces.

2. See James Parker's introduction to *Le cabinet du Duc d'Aumont* (1870; repr., New York: Acanthus Books, 1986).

3. Svend Eriksen and Geoffrey de Bellaigue, *Sèvres Porcelain: Vincennes and Sèvres 1740–1800* (London; Boston: Faber and Faber, 1987), 346.

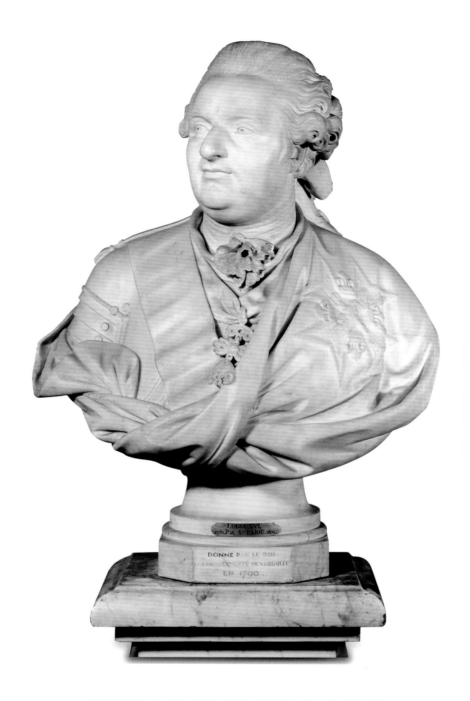

OBJECTS MADE FOR THE COURT OF LOUIS XVI

Louis XVI continued the tradition of royal patronage at the Sèvres and Gobelins manufactories by commissioning prestigious luxury goods for his residences and for diplomatic gifts. One of his primary ambitions, however, was to found a new museum at the Louvre. Although plans were made, the museum was not realized until after his death.

70

Bust of Louis XVI, ca. 1779

After Augustin Pajou (French, 1730–1809), sculptor

Marble

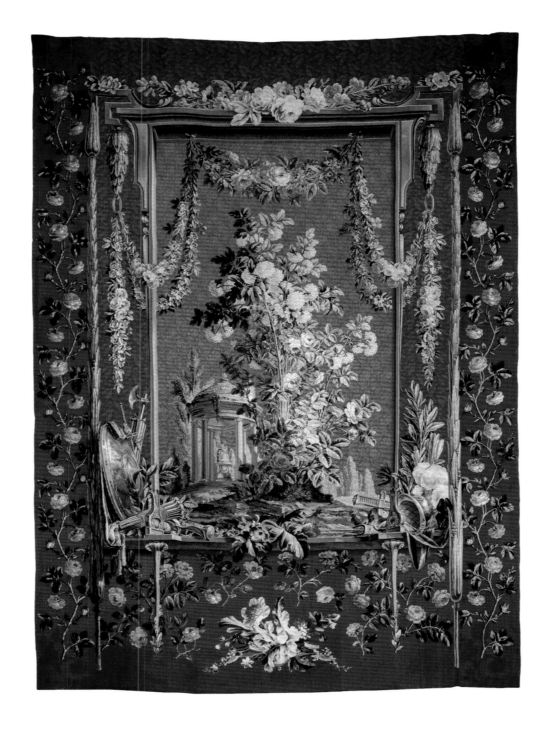

71
The "Temple of Love," back panel of a *lit à la duchesse* (state bed), ca. 1775
Gobelins Manufactory (France, established 1662)
Workshop of Jacques Neilson (English, active France; 1714–1788)
After Alexis-Simon Belle (French, 1674–1734) and Maurice Jacques (French, ca. 1712–1784), painters
Low-warp tapestry; wool and silk

This tapestry panel was part of a unique set of winter bed hangings woven for the Chambre Rose of the duchesse de Bourbon (1750–1822). In addition, the alcove in
her bedroom was hung with four Gobelins tapestries from the series "Tenture des Dieux" on a similar pink damask ground.

LOUIS XVI AS A PATRON OF THE ARTS

DIPLOMATIC GIFTS

72
Figure of Henri de La Tour d'Auvergne, vicomte de Turenne, model made in 1783
Sèvres Porcelain Manufactory (France, established 1756)
After Augustin Pajou (French, 1730–1809), sculptor
Hard-paste biscuit porcelain

*This figure and the following are from the series of sculptures of great Frenchmen commissioned by the
king for his apartments in Versailles and for diplomatic gifts.*

73
Figure of Sébastien Le Prestre de Vauban, model made ca. 1780s
Sèvres Porcelain Manufactory (France, established 1756)
Reduction of the plaster cast by Charles-Antoine Bridan (French, 1730–1805), sculptor
Hard-paste biscuit porcelain

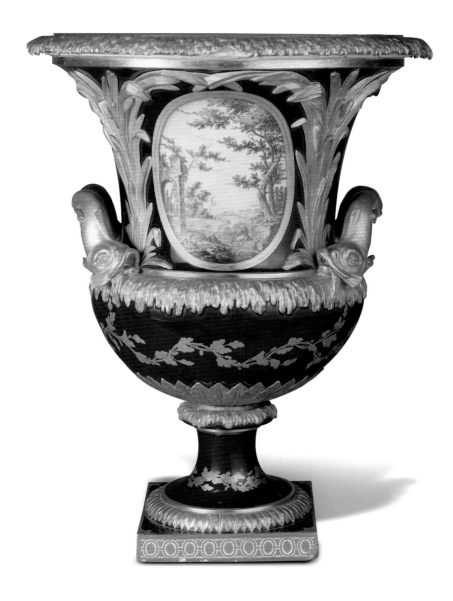

74

Vase: "Jardin à dauphins," 1781

Given to Prince Henry of Prussia (1762–1802) by Louis XVI

Sèvres Porcelain Manufactory (France, established 1756)

Pierre-Joseph Rosset *l'aîné* (French, active 1753–1799), painter; Jean-Pierre Boulanger (French, active 1754–1785), gilder

Hard-paste porcelain

This vase is one of a pair given to Prince Henry of Prussia during his visit to France in 1784. It was part of a larger diplomatic gift of Sèvres porcelain that also comprised a green-bordered dessert service and biscuit figures of great Frenchmen.

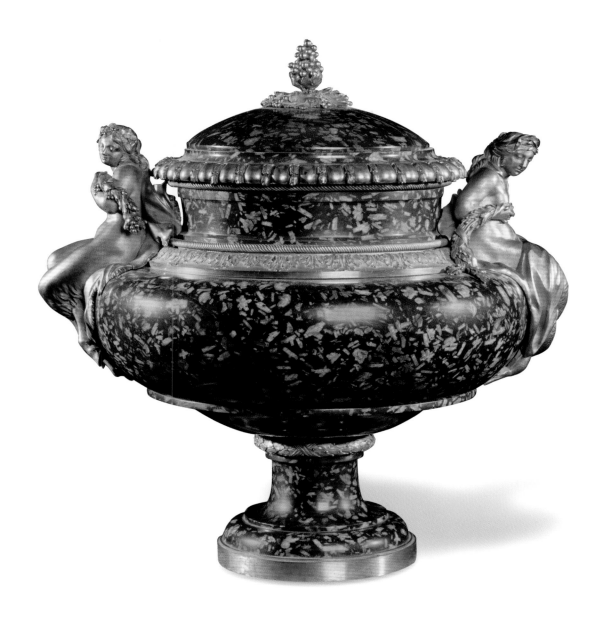

PURCHASES BY THE KING FOR THE FUTURE MUSEUM

Louis XVI bought several important works of art from the sale of the duc d'Aumont in 1782. The vases, furniture, and columns—examples that represented the finest in French craftsmanship—were intended for the new museum that would be established in the Louvre.

75

Vase in the form of a perfume burner decorated with a siren and a female faun, ca. 1775

Made for the duc d'Aumont

Pierre Gouthière (French, 1732–1813), bronze worker

Serpentine marble and gilt bronze

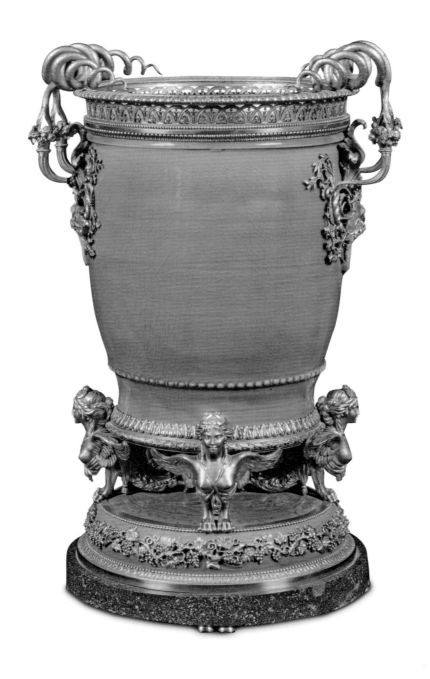

76

Great vase, ca. 1780

Made for the duc d'Aumont

Pierre Gouthière (French, 1732–1813), bronze worker

Vase: Chinese celadon, 18th century

Mounts (Paris, France): gilt bronze

Porcelain, red porphyry, and gilt bronze

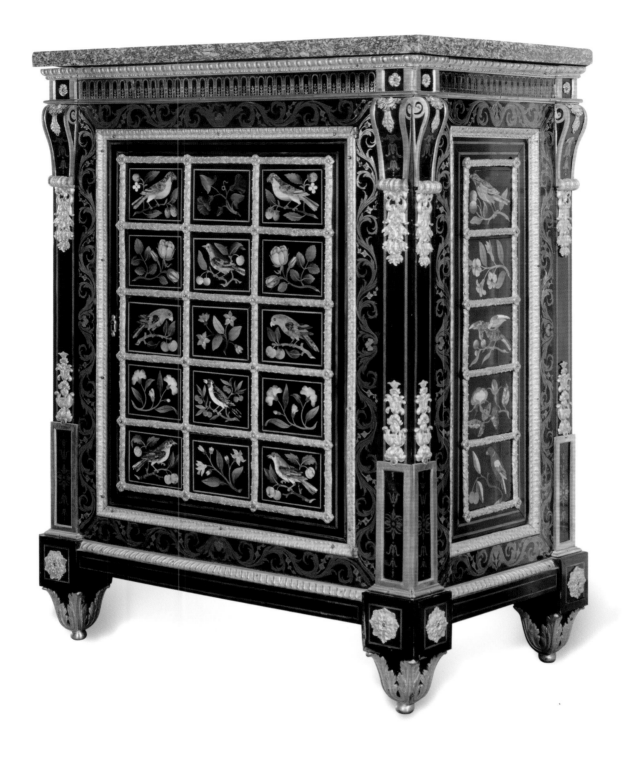

77

Low cabinet (from a pair) with Florentine pietre-dure panels, ca. 1765–1770

Made for the duc d'Aumont

Joseph Baumhauer (German, active France; d. 1772), cabinetmaker

Pietre dure (hardstones), ebony, tortoiseshell, brass, pewter, marble, and gilt-bronze mounts

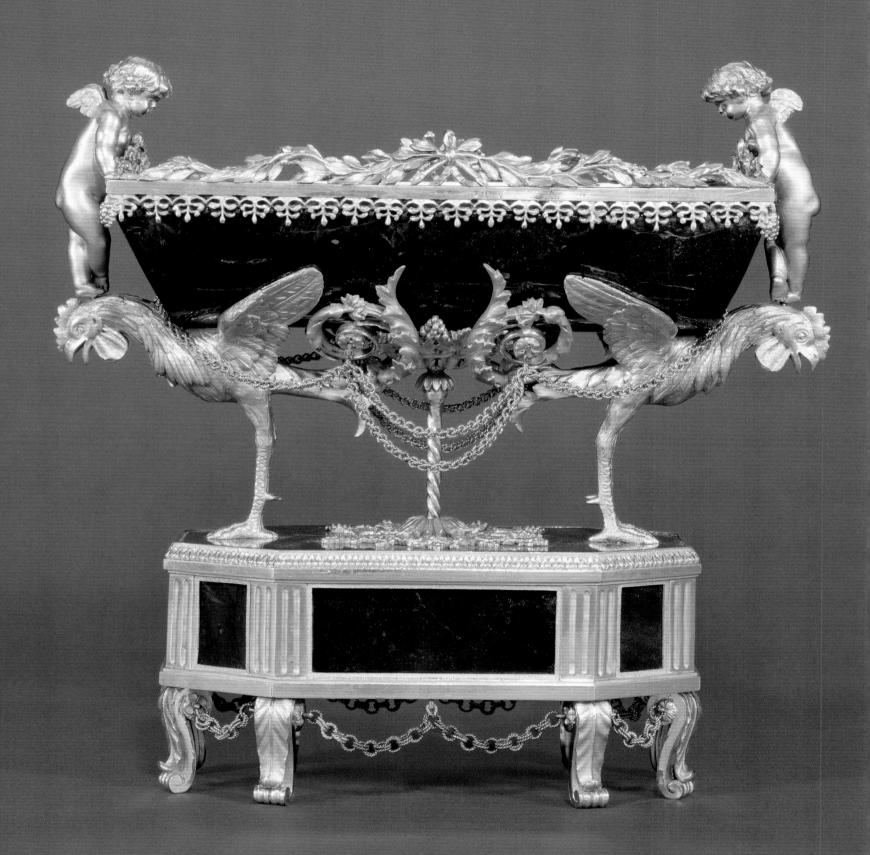

THE PRIVATE COLLECTION OF MARIE-ANTOINETTE

Martin Chapman

A s an avid collector, Queen Marie-Antoinette (1755–1793) surrounded herself with works of art in her private apartments at Versailles. Along with the porcelain and gilt bronzes that she commissioned, she displayed an array of precious hardstone vases, Japanese lacquer, and mounted porcelain on exquisite pieces of furniture by cabinetmaker Jean-Henri Riesener. She preferred objects made of rare and exotic materials, which were then complemented with metal mounts fashioned in a highly refined version of the Neoclassical style and based on models derived from antiquity. Primary among these objects are the vases of semiprecious stones such as agate and jade delicately mounted in gold. Similar collections of mounted hardstones could be found in the great royal treasuries of Dresden, Vienna, and Munich. Louis XIV's own collection of hardstone vases, known as the Gemmes de la Couronne (see section 2), was very much a part of this tradition of royal acquisition. It can be argued that the queen was well aware that she was continuing this symbolic royal association, albeit in a more feminine and intimate style.

In the 1780s Marie-Antoinette revived the taste for the hardstone vases that had been favored by Louis XIV in the seventeenth century. She selected some of the most significant pieces from the Garde-Meuble de la Couronne and installed them in the state apartments at Versailles; the spectacular lapis lazuli nef from Louis XIV's Gemmes de la Couronne (section 2, fig. 1) was displayed on the chimneypiece in her state bedchamber.[1] This brilliantly colored object, the most splendid in Louis XIV's collection of vases, perfectly epitomizes the magnificence of the Versailles of the Sun King. Carved into the shape of a ship, probably in Milan in the sixteenth century, this precious specimen of deep-blue lapis lazuli was remounted in Paris during the 1670s with brightly-colored enamels representing Neptune, sea monsters, garlands, and sphinxes.[2] Marie-Antoinette, evidently recognizing its importance as a work of art that represented a long and princely tradition, displayed it prominently in the most important public room of her suite.

For her personal collection, the queen also commissioned extraordinary works of semiprecious stone. Intended for her private apartments at Versailles, they included the impressive *cassolette* (perfume burner) made of agate and jasper and mounted in gold by Charles Ouizille

Sarcophagus, ca. 1785
(cat. 90)

(cat. 89); the jasper and jade sarcophagus mounted in gilt bronze (cat. 90); and the jade, jasper, and marble pedestal for a vase, also by Ouizille (cat. 91). These objects, provided with the most exquisitely worked gold and gilt-bronze mounts, reflect the queen's extremely delicate and feminine version of the Neoclassical style, which was also found throughout her private apartments at Versailles, from the Grand Cabinet Intérieur (also known as the Cabinet Doré) to the exquisite Cabinet de la Méridienne (see fig. 1), and even in the carving of the paneling in her bathroom. It is a taste associated specifically with Marie-Antoinette, although it was pioneered outside the royal circle by prominent members of the Parisian aristocracy, such as the duc d'Aumont, in the 1770s.

Even though the *cassolette* itself is quite substantial in size for a hardstone object, the mounting by the royal goldsmith Ouizille is exceptional for its detail and miniature scale. It has a preciousness that is akin to the craftsmanship typically seen in smaller snuff boxes. Ouizille, in fact, also specialized in snuff boxes,[3] as did Jacques-Joseph de Gault, the painter of the miniatures inserted into the sides of the pedestal. The oval panels, designed in imitation of ancient intaglios, are of a type that de Gault painted to adorn gold snuff boxes (see cats. 67–68). This *cassolette* is a later example of a type of object much admired by the queen. In 1782, at the sale of the duc d'Aumont, Marie-Antoinette had famously acquired the larger-scale jasper perfume burner (fig. 2) mounted by Pierre Gouthière in 1774–1775. Its restrained and classical tripod form, decorated with rich, heavy garlands of intensely detailed and naturalistically modeled vine leaves, must have led the way in matters of style when she displayed it in her royal apartments. This approach—restraint in form contrasted with richness in detail—would appear on other objects created for the queen in the 1780s. One example can be seen in the miraculously crafted gilt-bronze mounts applied to the furniture made for her by Riesener (see fig. 3), which are even more intricately and richly modeled than either of the perfume burners made by Gouthière or Ouizille.

Instead of gold, gilt bronze is used for the mounts on the queen's sarcophagus of green jasper and jade (cat. 90). Modeled with the rather eccentric winged putti standing on the heads of cockerels, the mounts are nonetheless remarkably balanced and delicate. They were probably modeled by Jean-Démosthène Dugourc, who became the *dessinateur* to the Garde-Meuble in 1784.[4] The supercharged details in these mounts, which are intended to act as a counterpoint to the absolutely plain surface of the stone, enhance the beauty of the mineral.

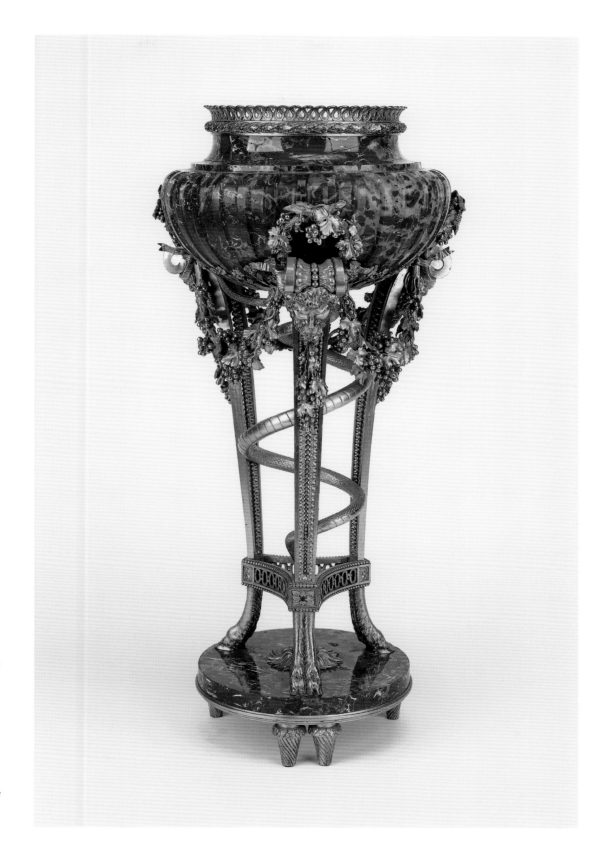

Fig. 2 Perfume burner,
1774–1775
Mounts: Pierre Gouthière
Jasper bowl: François-Joseph
Bélanger, designer; Augustin
Bocciardi, sculptor
Jasper and gilt bronze,
19 × 8 9/16 in. diam.
(48.3 × 21.7 cm diam.)
The Wallace Collection,
London, F292

*This object was made for the duc
d'Aumont and bought by the
queen from his sale in 1782.*

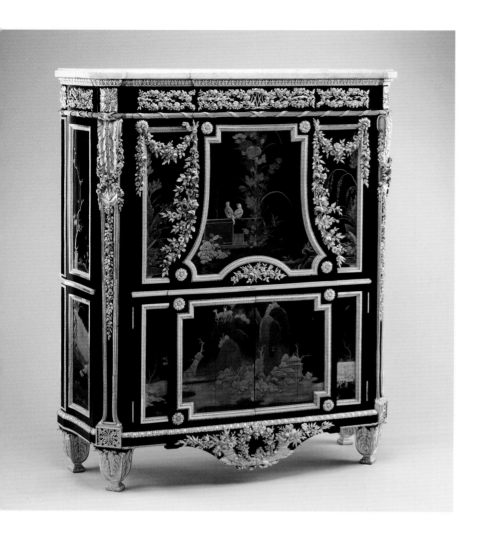

They also reflect one of the most extreme versions of the Neoclassical style, dubbed *goût étrusque* (the Etruscan taste), which Dugourc claimed to have invented. Derived from the arabesque ornament of antiquity, this style tended to contrast simple forms and plain surfaces with the dense ornamentation at which Dugourc excelled. He claimed in his autobiography that he designed many pieces for the queen in these years, and he is known to have worked for her at Fontainebleau.

The design of the queen's precious objects worked in concert with the furniture and decorations of her apartments, which were executed by a team of architects, designers, decorators, cabinetmakers, and upholsterers working under the direction of the *intendant et contrôleur général* of the Garde-Meuble. Their program of ornament was an iteration of the Neoclassical style found on the finish of the mounts on the queen's vases: delicate, balanced, and rich. After the death of the intendant Pierre-Elisabeth de Fontanieu in 1784, the position was taken by Marc-Antoine Thierry de Ville d'Avray; he reorganized the ancient institution of the Garde-Meuble, ostensibly to save money during difficult economic times. Instead, in the years leading up to the Revolution, there ensued a frenzy of refurnishing in the royal palaces, including Marie-Antoinette's apartments at Versailles, which resulted in some of the era's most remarkable decorative interiors and furnishings. The armchair, probably for the queen's *cabinet de toilette* (dressing room) at Saint-Cloud about 1788, reflects this continuing theme of richness combined with refinement (cat. 82).[5] The frame is teeming with delicate, carved ornament derived from the repertory of *goût étrusque*. Gilt bronze was a favorite material in eighteenth-century France: not only did it shine at night under candlelight, but it also revealed a wealth of delicate decoration by day. The pair of wall lights (cat. 84), made in 1788 for the same *cabinet de toilette*, is densely cast with motifs specific to Marie-Antoinette as a wife, such as the torch of Hymen with doves symbolizing love and marriage; it also includes the motif of pearls, slung in the case as a garland between the scrollwork, which occurs frequently on objects and decorations for the queen.[6] In contrast, Marie-Antoinette's rolltop desk, commissioned from Riesener when she decided to reopen the long-unused apartments in the Palais des Tuileries, is much more restrained (cat. 83). Delivered in 1784, the desk is plainer than the pieces then being made for Versailles. Of a relatively simple diaper pattern, it is set with decorative panels representing the Arts, emblems

considered appropriate to the queen. It nevertheless has the astonishing finish typical of this great cabinetmaker visible in the sprays of tiny gilt-bronze flowers, precise in every detail, that surround the central marquetry trophy of Poetry.

In the early days of the Revolution, the queen consigned her collection of precious works of art to Dominique Daguerre, the leading marchand-mercier of Paris, who had been responsible for overseeing the original commission of many of these pieces. He is known to have made any necessary repairs and provided new cases for them, in the expectation that the queen would regain possession of them in better times. After Marie-Antoinette was executed in 1793, the objects, which must have become a liability, were handed over to the Commission des Arts by Daguerre's successor, Martin-Eloi Lignereux. Although some of the objects disappeared, many were placed in the Musée du Louvre (such as cat. 90). More recently the museum has been able to acquire further pieces from the queen's collection, and today the Département des Objets d'Art possesses a large portion of the remarkable hardstones made for Marie-Antoinette (cats. 87, 89).[7]

1. The nef, the grandest of ceremonial objects, was made in the form of a ship and intended for the royal dining table.

2. *Marie-Antoinette* (Paris: Éditions de la Réunion des Musées Nationaux, 2008), cat. 118.

3. For snuff boxes by Ouizille, see Serge Grandjean, *Les tabatières, boîtes et étuis des XVIIIe et XIXe siècles du Musée du Louvre* (Paris: Éditions de la Réunion des Musées Nationaux, 1981), cats. 166–172.

4. *Marie-Antoinette*, cat. 121.

5. Ibid., cat. 156.

6. Ibid., cat. 160.

7. Daniel Alcouffe, Anne Dion-Tenenbaum, and Gérard Mabille, *Les bronzes d'ameublement du Louvre* (Dijon: Éditions Faton, 2004), 254.

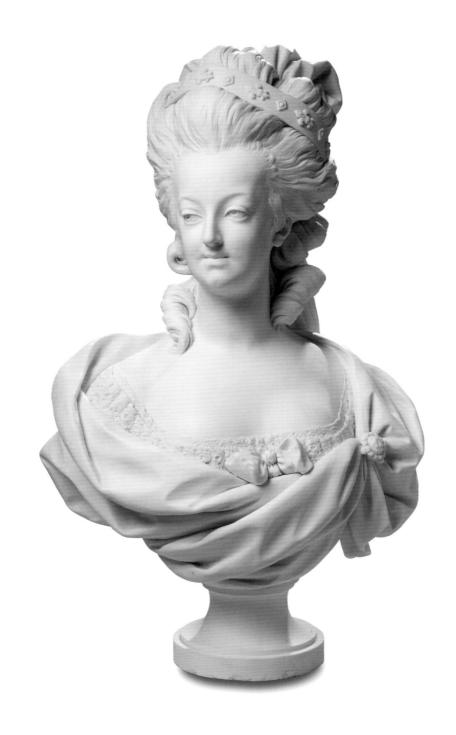

THE QUEEN AND THE ROYAL FAMILY

78
Bust of Marie-Antoinette, 1782
Sèvres Porcelain Manufactory (France, established 1756)
After Louis-Simon Boizot (French, 1743–1809), sculptor
Hard-paste biscuit porcelain

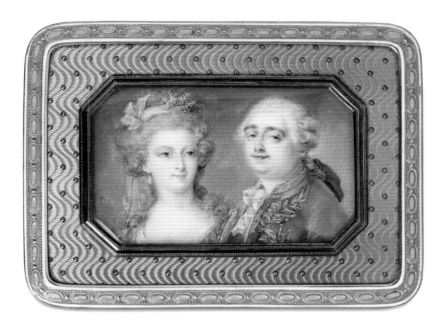

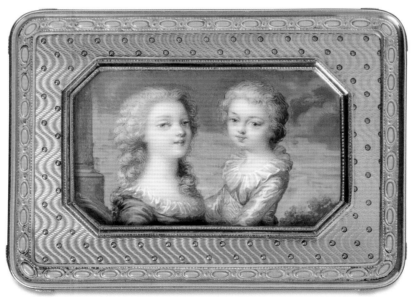

ROYAL PORTRAIT BOXES

79
Snuff box with portraits of the royal family, 1785
Adrien-Jean-Maximilien Vachette (French, 1753–1839; master in Paris in 1779), goldsmith
Gold, enamel, and miniatures

This box has portraits of Marie-Antoinette and Louis XVI set into the cover (above), and their children, Madame Royale and the Dauphin,
are on the base (below), while the sides have miniatures of the king's brothers, the comte de Provence and the comte d'Artois;
his sister, Madame Elisabeth; and the comtesse de Provence.

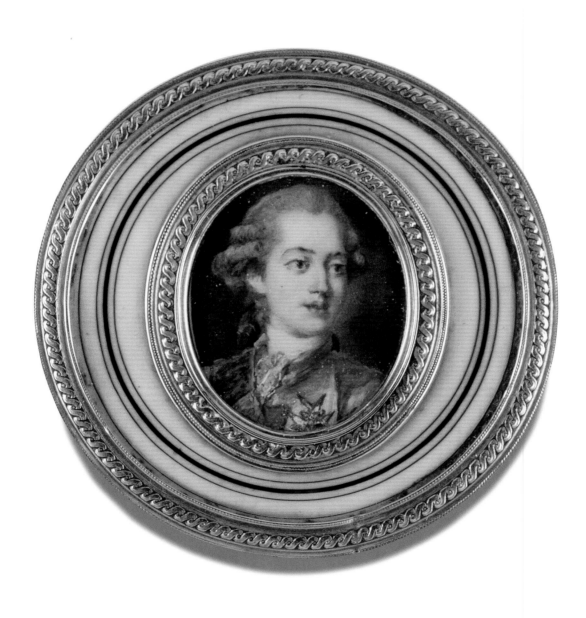

80

Box (*bonbonnière*) with portrait of the comte d'Artois (the future King Charles X), late 18th century

Peter Adolf Hall (Swedish, active France; 1739–1793), goldsmith

Gold in two colors and miniature on ivory

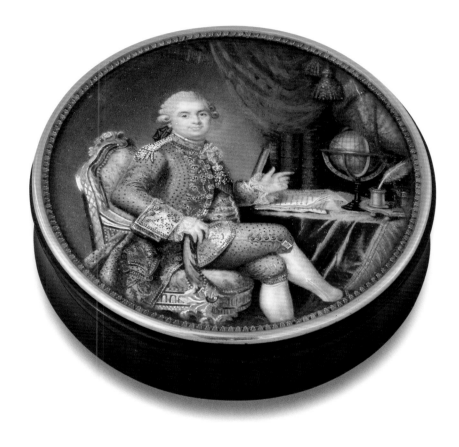

81

Box (*bonbonnière*) with portrait of the comte de Provence (the future King Louis XVIII), early 19th century
After Joseph Boze (French, 1745–1826), miniature painter
Gold, tortoiseshell, and gouache

FURNITURE MADE FOR THE QUEEN

Despite the serious economic depression in France during the 1780s, Queen Marie-Antoinette continued to commission large amounts of furniture for her private apartments at Versailles and at the Petit Trianon, as well as for the Château de Saint-Cloud, which King Louis XVI bought for her in 1785.

82

Armchair with the cypher of Marie-Antoinette, ca. 1788

From a suite probably made for the *cabinet de toilette* (dressing room) of Marie-Antoinette at the Château de Saint-Cloud

Jean-Baptiste-Claude Sené (French, 1747/1748–1803; master in 1769), joiner

Gilded walnut and silk-covered upholstery

83
Rolltop desk, 1784
Made for the apartments of Marie-Antoinette at the Palais des Tuileries
Jean-Henri Riesener (German, active France; 1734–1806), cabinetmaker
Oak and deal frame; veneer of sycamore, purple wood, and tulipwood; polychrome wood marquetry;
gilt-bronze mounts

This desk was part of the furniture delivered by Jean-Henri Riesener in 1784 for the queen's apartment at the Palais des Tuileries, which she used for occasional visits to Paris. The royal residence, all but abandoned after Versailles was built, was reopened to house Louis XVI's family at the beginning of the Revolution. The palace was destroyed during the Paris Commune of 1871, and today the famous Jardin des Tuileries is the only reminder of this once-great royal residence.

84
Pair of wall lights with quivers and turtle doves, 1788
Made for the *cabinet de toilette* (dressing room) of Marie-Antoinette at the Château de Saint-Cloud
Pierre-François Feuchère (French, 1737–1823; master in 1763), bronze maker
Gilt bronze

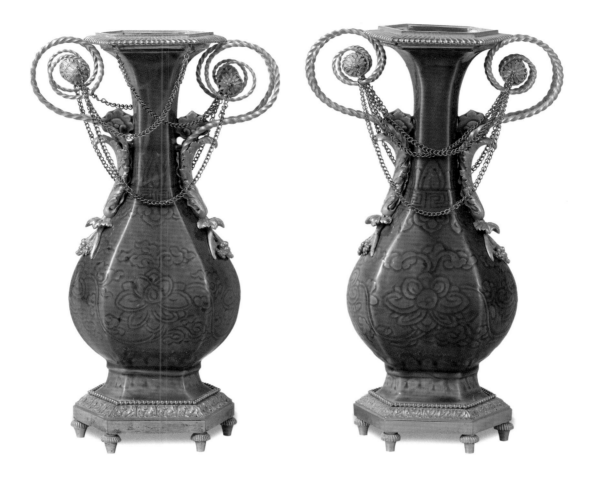

MARIE-ANTOINETTE'S PRIVATE COLLECTION

Marie-Antoinette liked to have the luxury objects that she had commissioned on display in the relatively tiny rooms of her private apartments at Versailles. Chief among these were the mounted hardstones made by the leading goldsmiths and metalworkers of Paris, but she also had a collection of lacquer inherited from her mother, Empress Maria Theresa of Austria, as well as examples of Sèvres and Chinese porcelain.

85
Pair of vases, ca. 1780
Vases: Chinese porcelain, ca. 1700
Mounts (Paris, France): gilt bronze

86
Pair of bowls, ca. 1780
Paris, France
Rock crystal and gilt bronze

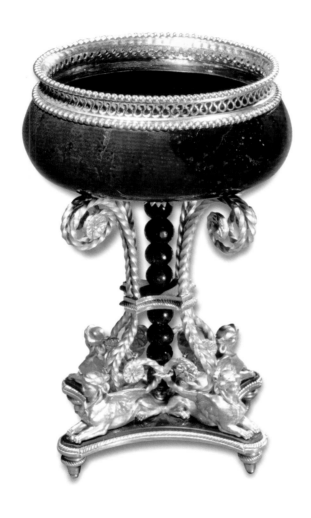

87
Cup, ca. 1785
Paris, France
Bloodstone and gilt-bronze mounts

88
Statuette of a peddler, ca. 1702–1703
Germany
Ivory, silver gilt, diamonds, and painted enamel

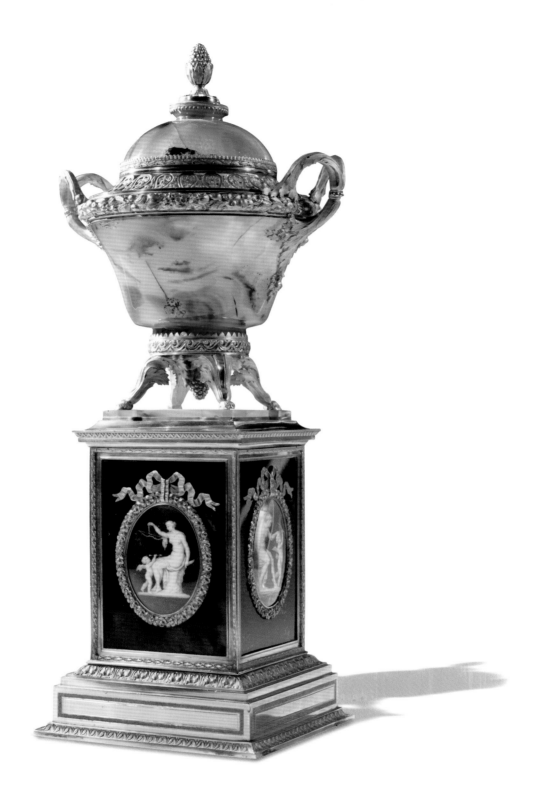

89
Perfume burner, 1784–1785
Charles Ouizille (French, ca. 1744–1830), goldsmith; Jacques-Joseph de Gault (French, ca. 1738–after 1812), painter
Agate, jasper, and gold; miniatures under glass

90

Sarcophagus, ca. 1785

François Rémond (French, ca. 1747–1812; master in 1774), bronze worker, gilder

Probably after a design by Jean Démosthène Dugourc (French, 1749–1825)

Jade and jasper; mounts of gilt bronze

91

Pedestal, 1785

Charles Ouizille (French, ca. 1744–1830) and Pierre-François Drais (French, ca. 1726–1788), goldsmiths

Jade, jasper, marble, gold, and aventurine

Made to support a jade vase (now missing), this pedestal is mounted with figures in gold.

92
Jewel coffer, 1786–1787
Charles Ouizille (French, ca. 1744–1830) and Pierre-François Drais (French, ca. 1726–1788), goldsmiths
Moss agate, jasper, marble, and gold

Set with decorative panels of moss agate, this coffer originally had a lid (now missing).

93
Tabletop
Petrified wood

*Petrified wood was one of the queen's favorite materials. She had four such tabletops mounted on steel frames
in her private apartments to display the prized objects in her collection.*

SELECTED BIBLIOGRAPHY

Compiled by Carole Treton, Département des Objets d'Art, Musée du Louvre

Alcouffe, Daniel. "Un aspect du goût de Marie-Antoinette: Les vases en pierres dures." *Versalia* 2 (1999): 6–15.

———. "Le collezioni francesi di gemme del XVI secolo." *Arte illustrata* 59 (1974): 264–278.

———. *Les Gemmes de la Couronne*. Paris: Réunion des Musées Nationaux, 2001.

———. "Les Gemmes de la Couronne: Une collection unique au monde." *Dossier de l'art* 120 (June 2005).

———. *Revue du Louvre/La revue des musées de France*, acquisitions (1994): no. 3.

Alcouffe, Daniel, and Pierre Ennès. "Un ensemble exceptionnel de meubles et de porcelaines de Sèvres du XVIIIe siècle." *Revue du Louvre/La revue des musées de France* 1 (1991): 53.

Alcouffe, Daniel, Anne Dion-Tenenbaum, and Amaury Lefébure. *Furniture Collections in the Louvre*, 2 vols. Dijon: Éditions Faton, 1993.

———. *Le mobilier du Musée du Louvre*, t. I. Dijon: Faton, 1993.

Alcouffe, Daniel, Anne Dion-Tenenbaum, and Gérard Mabille. *Les bronzes d'ameublement du Louvre*. Dijon: Éditions Faton, 2004.

Alcouffe, Daniel, et al. *Cinq années d'enrichissement du patrimoine national*. Paris: Grand Palais, Réunion des Musées Nationaux, 1980. Exhibition catalogue.

Antoine, Michel. *Louis XV*. Paris: Fayard, 1993.

Arizzoli-Clémentel, Pierre. *Le mobilier de Versailles*, vol. 2. Dijon: Éditions Faton, 2002.

———. "La prestigieuse collection de Marie-Antoinette." *L'Estampille/L'Objet d'Art* 364 (December 2001): 2.

Arquié-Bruley, Françoise. "L'orfèvre Antoine-Sébastien Durant (1712–1787): Eléments biographiques." *Bulletin de la Société de l'Histoire de l'Art français, 1995* (1996): 165–185.

———. "Problèmes des orfèvres au XVIIIe siècle: Les frères Balzac." *Bulletin de la Société de l'Histoire de l'Art français, 1987* (1989): 93–123.

Augarde, Jean-Dominique. "Joseph Baumhauer: Ébéniste privilégié du Roi." *L'Estampille* 204 (June 1987).

Badin, Jules. *La Manufacture de Tapisseries de Beauvais depuis ses origines jusqu'à nos jours*. Paris: Société de Propagation des Livres d'Art, 1909.

Barbet de Jouy, Henry. *Galerie d'Apollon, notice des Gemmes et Joyaux*, série E. Paris: Ch. de Mourgues frères, 1876.

———. *Musée impérial du Louvre: Les gemmes et joyaux de la Couronne*. Paris: Musées Impériaux, 1865.

———. *Notice des antiquités, objets du Moyen-Âge, de la Renaissance et des Temps Modernes composant le musée des Souverains*. Paris: Ch. de Mourgues frères, 1868.

[Barbet de Jouy, Henry, Edmond Saglio, and Louis Courajod]. *Musée National du Louvre: Don de M. & Mme Philippe Lenoir*. Paris: Ch. de Mourgues frères, 1874.

Bascou, Marc. "Une exceptionnelle boîte à portrait de Louis XIV, don des Amis du Louvre." *Revue du Louvre/La revue des musées de France* 3 (June 2009): 13.

———. "La galerie d'Apollon: Galerie royale et galerie des trésors." *Dossier de l'art* 120 (June 2005): 2–4.

———. "Un nécessaire à thé de Françoise-Marie de Bourbon, duchesse d'Orléans (1677–1749)." *Revue du Louvre/La revue des musées de France* 2 (2009): 49–50.

Bastien, Vincent. "Les Ducrollay, de prestigieux orfèvres parisiens au XVIIIe siècle." *L'Estampille/L'Objet d'Art* 415 (July–August 2006).

———. "La famille Drais, une dynastie de 'marchands-orfèvres' à Paris au XVIIIe siècle." Mémoire de DEA under the direction of Alain Mérot, Université de Paris-Sorbonne, 2005. Mémoire dactylographié.

Baulez, Christian. "Deux sièges de Foliot et de Sené pour Versailles." *Revue du Louvre/La revue des musées de France* 1 (March 1991).

———. "Le goût de madame Du Barry." *Connaissance des Arts* 482 (April 1992): 96–105.

———. "Le mobilier et les objets d'art de Madame Du Barry." In *Madame Du Barry de Versailles à Louveciennes*. Marly-le-Roi-Louveciennes: Musée-Promenade, 1992. Exhibition catalogue.

Bimbenet-Privat, Michèle. *Les orfèvres et l'orfèvrerie de Paris au XVIIe siècle*, 2 vols. Paris: Paris-Musées, 2002.

———. "Les pierreries de Louis XIV: Objets de collection et instruments politiques." In *Études sur l'ancienne France offertes en hommage à Michel Antoine*, edited by Bernard Barbiche and Yves-Marie Bercé, 81–96. Paris: École des Chartes, 2003.

———. "Thomas Lejuge: Orfèvre de métier, graveur par nécessité." In *L'estampe au Grand Siècle: Études offertes à Maxime Préaud*, 415–427. Paris: École Nationale des Chartes and Bibliothèque Nationale de France, 2010.

———. "Vases en pierres dures de la collection de Louis XIV provenant des ateliers des orfèvres de la galerie du Louvre et des Tuileries (1620–1640)." In *Les vases en pierres dures: Actes du colloque organisé au musée du Louvre*, 139–164. Paris: La Documentation française, 2003.

Blanc, Charles. *Collection d'objets d'art de M. Thiers léguée au Musée du Louvre*. Paris: Imprimerie Jouaust et Sigaux, 1884.

Blondel, Nicole, and Tamara Préaud. *La Manufacture nationale de Sèvres: Parcours du blanc à l'or*. Charenton: Flohic Éditions, 1996.

Bottineau, Yves. *Catalogue de l'orfèvrerie du XVIIe, du XVIIIe et du XIXe siècle*. Paris: Musée du Louvre, Réunion des Musées Nationaux, 1958.

Brault, Solange, and Yves Bottineau. *L'orfèvrerie française du XVIIIe siècle*. Paris: Presses Universitaires de France, 1959.

Bremer-David, Charissa. *French Tapestries and Textiles in the J. Paul Getty Museum*. Los Angeles: J. Paul Getty Museum, 1997.

Brouzet, David. "L'art de l'ivoire de la Renaissance au XIXe siècle." *L'Estampille/L'Objet d'Art* 404 (July–August 2005).

———. Fiche 434 B, Ivoire: Le Colporteur. *L'Estampille/L'Objet d'Art* 434 (July 2008).

Le cabinet du Duc d'Aumont. 1870. Reprint, New York: Acanthus Books, 1986.

Carlier, Yves. "Remarques sur quelques pièces de l'argenterie royale sous les règnes de Louis XIV et de Louis XV." *Bulletin de la Société de l'Histoire de l'Art français, 1991* (1992): 141–151.

Castelluccio, Stéphane. *Le garde-meuble de la Couronne et ses intendants du XVIe au XVIIIe siècle*. Paris: C.T.H.S., 2004.

———. *Les meubles de pierres dures de Louis XIV et l'atelier des Gobelins*. Dijon: Éditions Faton, 2007.

Charles Le Brun 1619–1690: Peintre et dessinateur. Versailles: Château de Versailles, 1963. Exhibition catalogue.

Cordey, Jean. *Inventaire des biens de madame de Pompadour, rédigé après son décès*. Paris: Société des Bibliophiles Français, 1939.

Courajod, Louis. *Livre-Journal de Lazare Duvaux, marchand-bijoutier ordinaire du Roy 1748–1758*, 2 vols. Paris: Société des Bibliophiles Français, 1873.

Coural, Jean, and Chantal Gastinel-Coural. *Beauvais. Manufacture nationale de Tapisserie*. Paris: Centre national des arts plastiques, 1992.

Coutinho, Isabel Pereira. *O Mobiliário Francês do Século XVIII*. Lisbon: Fundação Calouste Gulbenkian, 1999.

Da Silveira Godinho, Isabel. *A Baixela de Sua Majestade Fidelíssima uma obra de François-Thomas Germain*. Lisbon: Palácio Nacional da Ajuda, 2002.

Demonts, Louis, and Charles Terrasse. *Catalogue de la donation Félix Doistau: Miniatures des XVIIIe et XIXe siècles*. Paris: Imprimerie générale Lahure, 1922.

Demoriane, Hélène. "Les tabatières Louis XV vues sous toutes leurs faces." *Connaissance des Arts* (December 1962): 112.

Diderot, Denis, and Jean le Rond D'Alembert, eds. *Encyclopédie, ou Dictionnaire raisonné des sciences, des arts et des métiers, etc.* Neuchâtel: 1765.

Dreyfus, Carle. *Catalogue sommaire du mobilier et des objets d'art du XVIIe et du XVIIIe siècle*. Paris: Musées nationaux, 1922.

———. *Mobilier du XVIIe et du XVIIIe siècle*. Paris: Gaston Braun, 1913.

———. *Musée du Louvre: Le mobilier français*, 2e série, *Époque de Louis XVI*. Paris: A. Morancé, 1921.

———. *Musée du Louvre: Les objets d'art du XVIIIe siècle: bronzes d'ameublement et pendules, porcelaines, marbres et laques montés en bronze doré: époque de Louis XV*. Paris: A. Morancé, 1923.

Drouas, J. de. "Un orfèvre au XVIIIe siècle: Nicolas Besnier, échevin de Paris." *Bulletin de la Société de l'Histoire de Paris et de l'Île-de-France* (1983): 97–149.

Ennès, Pierre. "Porcelane famose. Clienti di Sèvres." *Antiques* 15 (April 1992): 74.

Ephrussi, Charles. "L'inventaire des collections de la reine Marie-Antoinette." *Gazette des Beaux-Arts* (1879): 389.

Eriksen, Svend. "A propos de six Sèvres du dix-huitième siècle." *Det danske Kunstindustriemuseum Vriksommed* 4 (1964–1969): 144–152.

Eriksen, Svend, and Geoffrey de Bellaigue. *Sèvres Porcelain: Vincennes and Sèvres 1740–1800*. London; Boston: Faber and Faber, 1987.

Fenaille, Maurice. *Etat général des tapisseries de la Manufacture des Gobelins depuis son origine jusqu'à nos jours 1600–1900*, tome III, *Période du dix-huitième siècle (première partie, 1699–1736)*. Paris: Imprimerie nationale/Librairie Hachette et Cie, 1904.

———. *Etat général des tapisseries de la Manufacture des Gobelins depuis son origine jusqu'à nos jours 1600–1900*, tome IV, *Période du dix-huitième siècle (deuxième partie, 1737–1794)*. Paris: Imprimerie nationale/Librairie Hachette et Cie, 1907.

Fuhring, Peter. "Les deux girandoles d'or de Louis XV par Thomas Germain, chefs-d'oeuvre du Rococo." *Revue de l'art* 95 (1992): 52–60.

———. *Juste-Aurèle Meissonnier: Un génie du rococo (1695–1750)*, 2 vols. Turin-London: Allemandi & Co., 1999.

Fuhring, Peter, and Michèle Bimbenet-Privat. "Le style 'cosses de pois': L'orfèvrerie et la gravure à Paris sous Louis XIII." *Gazette des Beaux-Arts* (January 2002): 1–224.

Gaborit, Jean-René, ed. *Renaissance et temps modernes*, vol. 2 of *Sculptures françaises*, 2 vols. Paris: Réunion des Musées Nationaux, 1998.

Giusti, Annamaria. *La marqueterie de pierres dures*. Paris: Citadelles & Mazenod, 2005.

Grandjean, Serge. *Catalogue des tabatières, boîtes et étuis des XVIIIe et XIXe siècles du Musée du Louvre*. Paris: Réunion des Musées Nationaux, 1981. Exhibition catalogue.

———. "Le guéridon de Madame Du Barry provenant de Louveciennes." *La Revue du Louvre et des musées de France* 1 (1979): 44–49.

———. *Inventaire après décès de l'impératrice Joséphine à Malmaison*. Paris: Réunion des Musées Nationaux, 1964.

Gruber, Alain, ed. *L'art décoratif en Europe*, t. II, *Classique et baroque*. Paris: Citadelles & Mazenod, 1992.

Guiffrey, Jules. *Inventaire général du mobilier de la Couronne sous Louis XIV (1669–1705)*, 2 vols. Paris: Société d'encouragement pour la propagation des livres d'art, 1885–1896.

———. "Logements d'artistes au Louvre." *Nouvelles Archives de l'Art français* (1873): 1–221.

Guillemé-Brulon, Dorothée. "Le service à rubans verts de l'Impératrice d'Autriche." *L'Estampille/L'Objet d'Art* (March 1985): 22–33.

———. "Les services de porcelaine de Sèvres, présents des rois Louis XV et Louis XVI aux souverains étrangers." In *Versailles et les tables royales en Europe, XVIIème–XIXème siècles*, edited by the Musée National des Chateaux de Versailles et de Trianon, 184–187. Paris: Réunion des Musées Nationaux, 1993. Exhibition catalogue.

Hackenbroch, Yvonne, and Maria Sframeli. *I gioielli dell'Elettrice palatina al museo degli Argenti*. Florence: Centro Di, 1988.

Havard, Henry. *Dictionnaire de l'ameublement et de la décoration depuis le XIIIe siècle jusqu'à nos jours*, 4 vols. Paris: Librairie Georges Baranger, 1887–1890.

Hibon, Marguerite. "Charles Le Bastier, orfèvre en tabatières." *L'Estampille/L'Objet d'Art* (May 2008): 52–59.

Huard, G. "Les logements des artisans dans la grande galerie du Louvre sous Henri IV et Louis XIII." *Bulletin de la Société de l'Histoire de l'Art français* (1939): 18–36.

Jallut, Marguerite. *Marie-Antoinette et ses peintres*. Paris, n.d. [1955].

Jeannerat, Carlo. "Un émail inédit de Jean Petitot." *Bulletin de la Société de l'Histoire de l'Art français* (1929): 74–80.

Joubert, Fabienne, Amaury Lefébure, and Pascal-François Bertrand. *Histoire de la tapisserie en Europe du Moyen Âge à nos jours*. Paris: Flammarion, 1995.

Kjellberg, Pierre. *Objets montés du Moyen Âge à nos jours*. Paris: Éditions de l'Amateur, 2000.

Klar, Martin. *Die Tabatieren Friedrichs Des Grossen*. Berlin: Verwaltung der Staatlichen Schlösser und Gärten, n.d.

Laborde, Léon de. *Notice des émaux, bijoux et objets divers exposés dans les galeries du musée du Louvre*, 2nd ed. Paris: Ch. de Mourgues frères, 1857.

Lacroix-Lintner, Dominique. "L'orfèvre Daniel Govaers," 2 vols. (vol. 1, "Sa vie, sa carrière"; vol. 2, "Le catalogue de ses oeuvres"). Master's thesis, Université de Paris-Sorbonne, 2007.

Langeois, David. "Identification de deux portes à deux vantaux provenant de la chambre à coucher de la reine Marie-Thérèse au palais des Tuileries." *Bulletin de la Société de l'Histoire de l'Art français*, 2005 (2006): 69–81.

Le Corbeiller, Clare. *European and American Snuff Boxes 1730–1830*. London: B. T. Batsford, 1966.

Lemonnier, Patricia. "Une collection exceptionnelle de vases montés." *L'Estampille/L'Objet d'Art* (February 1991): 38.

Louis XV: Un moment de perfection de l'art français. Paris: Hôtel de la Monnaie, 1974. Exhibition catalogue.

Le Louvre et son quartier: 800 ans d'histoire architecturale. Paris: Mairie Annexe du 1er Arrondissement, 1982. Exhibition catalogue.

Malgouyres, Philippe. *Ivoires de la Renaissance et des temps modernes*. Paris: Musée du Louvre, 2010.

———. *Porphyre: La pierre pourpre des Ptolémées aux Bonaparte*. Paris: Musée du Louvre, 2003. Exhibition catalogue.

———. "Principales acquisitions des musées de France." *Revue du Louvre/ La revue des musées de France* (February 2008): no. 16.

Marie-Antoinette. Paris: Réunion des Musées Nationaux, 2008. Exhibition catalogue.

Marquet de Vasselot, Jean-Jacques. *Musée du Louvre: Catalogue sommaire de l'orfèvrerie, de l'émaillerie et des Gemmes*. Paris: Gaston Braun, 1914.

Martin, Michel. *Les monuments équestres de Louis XIV: Une grande entreprise de propagande monarchique*. Paris: Picard, 1986.

Maze-Sencier, Alphonse. *Le livre des collectionneurs*. Paris: Librairie Renouard, 1885.

Meyer, Charles-Louis. "Les faïences de Nevers de 1645 à 1700: Essai de classement par les origines du décor (1 à 3)." *Bulletin des Amis de Sèvres* 2, 7, 9 (1936).

Meyer, Daniel. *L'histoire du Roy*. Paris: Réunion des Musées Nationaux, 1980.

———. *Tableaux de pierres dures*. Paris: Réunion des Musées Nationaux, 1992.

Migeon, Gaston. "La collection de M. le Baron de Schlichting." *Les Arts* (July 1902).

Migeon, Gaston, Gaston Brière, and Carle Dreyfus. "La collection Schlichting." *Gazette des Beaux-Arts* (1921): 7.

Molinier, Emile. *Le mobilier français du XVIIIe siècle*. Paris: Musée du Louvre, 1902.

———. *Musée du Louvre: Le mobilier français du XVIIe et du XVIIIe siècle*. Paris: Emile Lévy, 1902.

Montagu, J. *Gold, Silver and Bronze: Metal Sculpture of the Roman Baroque*. New Haven and London: Yale University Press, 1996.

Montembault, Marie. *Essai de catalogue. Miniatures et émaux du cabinet des dessins, musée du Louvre*. Paris, 1967. Mémoire dactylographié.

Niclausse, Juliette. *Thomire, fondeur-ciseleur, 1751–1843: Sa vie, son oeuvre*. Paris: Librairie Gründ, 1947.

Nocq, Henry. *Le poinçon de Paris*, 4 vols. Paris: Floury, 1926–1931.

Nocq, Henry, and Carle Dreyfus. *Tabatières, boîtes et étuis: Orfèvreries de Paris XVIIIe siècle et début du XIXe des collections du Musée du Louvre*. Paris: G. Van Oest, 1930.

Nouvelles acquisitions du département des Objets d'art, 1980–1984. Paris: Musée du Louvre, Réunion des Musées Nationaux, 1985. Exhibition catalogue.

Nouvelles acquisitions du département des Objets d'art, 1985–1989. Paris: Musée du Louvre, Réunion des Musées Nationaux, 1990. Exhibition catalogue.

Nouvelles acquisitions du département des Objets d'art, 1990–1994. Paris: Musée du Louvre, Réunion des Musées Nationaux, 1995. Exhibition catalogue.

Nouvelles acquisitions du département des Objets d'art, 1995–2002. Paris: Musée du Louvre, Réunion des Musées Nationaux, 2003. Exhibition catalogue.

Ottomeyer, Hans, and P. Pröschel. *Vergoldete Bronzen, Die Bronzearbeiten des Spätbarock und Klassizismus*, 2 vols. Munich: Klinkhardt & Biermann, 1986.

Perrin, Christiane. *François-Thomas Germain, orfèvre des rois*. Saint-Rémy-en-l'Eau: Éditions Monelle Hayot, 1993.

Pradère, Alexandre. *French Furniture Makers: The Art of the Ébéniste from Louis XIV to the Revolution*. Malibu, California: J. Paul Getty Museum, 1989.

Prunk-Tabatieren Friedrichs des Grossen: Katalog zur Potsdam-Sanssouci Ausstellung der Stiftung Schlösser und Gärten. Potsdam: Hirmer Verlag München, 1993. Exhibition catalogue.

Réau, Louis. "Correspondance artistique de Grimm avec Catherine II." *Archives de l'Art français*, nouvelle période, tome XVII, *L'Art français dans les pays du nord et de l'est de l'Europe (XVIIIe–XIXe siècles)*. Paris: Société de l'histoire de l'art français, 1968.

Rochebrune, Marie-Laure de. "Acquisitions." *Revue du Louvre/La revue des musées de France* (April 1998).

———. "Acquisitions." *Revue du Louvre/La revue des musées de France* (February 2000): no. 1; 22–37.

———. *Le guéridon de madame du Barry*. Paris: Musée du Louvre, Réunion des Musées Nationaux, 2002.

———. "Sept nouveaux vases de la manufacture royale de porcelaine de Sèvres." *L'Estampille/L'Objet d'Art* (February 2000): no. 344; 22–37.

Rosen, Jean. *La faïence de Nevers, 1585–1900*, 2 vols. Dijon: Éditions Faton, 2009.

Samoyault, Jean-Pierre. "Les remplois de sculptures et d'objets d'art dans la décoration et l'ameublement du palais de Saint-Cloud sous le Consulat et au début de l'Empire." *Bulletin de la Société de l'Histoire de l'Art français, 1971* (1972).

Sargentson, Carolyn. *Merchants and Luxury Markets: The Marchands Merciers of Eighteenth-Century Paris*. London: Victoria and Albert Museum; Malibu, California: J. Paul Getty Museum, 1996.

Sauzay, Alexandre. *Notice des ivoires: Série A. Musée de la Renaissance (Musée du Louvre)*. Paris: Ch. de Mourgues frères, 1880.

Scheffler, Wolfgang. *Berliner Goldschmiede: Daten, Werke, Zeichen*. Berlin: Hessling, 1968.

Seelig, Lorenz. *Golddosen des 18. Jahrhunderts aus dem Besitz der Fürsten von Thurn und Taxis*. Munich: Hirmer, 2007.

Snowman, A. Kenneth. *Eighteenth-Century Gold Boxes*. London: Faber and Faber, 1966.

———. *Eighteenth-Century Gold Boxes of Europe*, 2nd ed. London: Antique Collector's Club, 1990.

Stein, Henri. *Augustin Pajou*. Paris: Emile Lévy, 1912.

Truman, Charles. *The Gilbert Collection of Gold Boxes*. Los Angeles: Los Angeles County Museum of Art; New York: Harry N. Abrams, 1991.

Tuetey, Alexandre. "Inventaire des laques anciennes et des objets de curiosités de Marie-Antoinette, confiés à Daguerre et Lignereux…" *Archives de l'Art français* (1916) t. VIII, 286.

Vatel, Charles-Joseph. *Histoire de Madame du Barry d'après ses papiers personnels et les documents des archives*, 3 vols. Versailles: L. Bernard, 1883.

Verlet, Pierre. *Les bronzes dorés français du XVIIIe siècle*. Paris: Picard, 1987.

——. "Le commerce des objets d'art et les marchands merciers à Paris au XVIIIe siècle." *Annales: Économies, sociétés, civilisations* 13, no. 1 (January–March 1958): 10–29.

——. "Louis XV et les grands services d'orfèvrerie parisienne de son temps." *Pantheon* 35 (May–June 1977): 131–142.

——. *Les meubles français du XVIIIe siècle*, I, *Menuiserie*. Paris: Presses Universitaires de France, 1956.

——. *Le mobilier royal français*. Paris: Les Éditions d'Art et d'Histoire, 1955.

——. *Le mobilier royal français I, Meubles de la Couronne conservés en France*. Paris: Les Éditions d'Art et d'Histoire, 1945.

——. "Les nouvelles acquisitions du département des Objets d'art." *Revue des Arts/La Revue des Musées de France* (1953): 241–248.

——. "Objets prestigieux retrouvés." *Revue de l'art* (1976): no. 34.

Verlet, Pierre, Serge Grandjean, and Marcelle Brunet. *Sèvres*. Paris: Le Prat, n.d. [1953].

Versailles et les tables royales en Europe, XVIIe–XIXe siècles. Versailles: Musée National des Châteaux de Versailles et de Trianon, Paris: Réunion des Musées Nationaux, 1993–1994. Exhibition catalogue.

Villard, M.C. "Les tabatières du XVIIIe siècle et leurs décors d'après François Boucher." Master's thesis, Université de Paris-Nanterre, 2002.

Vittet, Jean. "Commandes et achats de madame de Pompadour aux Gobelins et à la Savonnerie." In *Madame de Pompadour et les arts*, edited by Xavier Salmon, 366–405. Versailles-Munich: Réunion des Musées Nationaux, 2002–2003. Exhibition catalogue.

Vittet, Jean, and Arnaud Brejon de Lavergnée. *La collection de tapisseries de Louis XIV*. Dijon: Éditions Faton, 2010.

Watson, Francis John Bagolt. *Mounted Oriental Porcelain in the J. Paul Getty Museum*. Washington, DC: International Exhibitions Foundation, 1986. Exhibition catalogue.

——. *The Wrightsman Collection*, vol. 3, *Furniture, Snuff Boxes, Silver, Bookbindings*. New York: Metropolitan Museum of Art, 1970.

Weigert, Roger-Armand. "Une boîte à portrait inédite offerte par Louis XIV, roi de France, à Antonie Heinsius." *Mededeelingen van den dienst voor kunsten en wetenschappen der gemeente 's-Gravenhage* (December 1933): 98–102.

——. *Les Gobelins (1662–1962): Trois siècles de tapisserie française*. Nyon: Imprimerie du courrier de la Côte, 1962.

Weigert, Roger-Armand, and Carl Hernmarck. *Les relations artistiques entre la France et la Suède, 1693–1718: Nicomède Tessin le Jeune et Daniel Cronström, correspondance (extraits)*. Stockholm: AB Egnellska Boktryckeriet, 1964.

Williamson, Edouard. *Musée du Garde-Meuble: Catalogue*. Paris: Baudry, 1897.

CATALOGUE OF THE EXHIBITION

Compiled by Carole Treton, Département des Objets d'Art, Musée du Louvre

This list reflects the most complete information available at the time of publication. All objects are from the Département des Objets d'Art, Musée du Louvre, unless otherwise noted.

1: ART IN THE SERVICE OF THE KING: THE GALERIE DU LOUVRE AND THE GOBELINS

1. Equestrian statue of Louis XIV, 1680–1690
 After Thomas Gobert (French, ca. 1640–1708), sculptor
 Bronze
 30⁷/₈ × 16⁹/₁₆ × 35⁷/₁₆ in. (78.5 × 42 × 90 cm)
 Département des Sculptures, MR 3263

2. Tapestry: *Chancellerie*, ca. 1685
 Beauvais Manufactory (France, active 1664)
 Central section after François Bonnemer (French, 1638–1689), painter; borders after Jean Lemoyne (French, 1638–1715), painter
 Wool and silk
 142¹/₈ × 173¹/₄ in. (361 × 440 cm)
 OA 5703

3. Mosaic tabletop with emblems of Louis XIV, last quarter of the 17th century
 Gobelins Manufactory (France, established 1662)
 Marble and pietre dure (hardstones)
 40³/₁₆ × 52³/₄ in. (102 × 134 cm)
 MR 406

4. Pair of vases, 17th century
 Rome, Italy
 Porphyry
 Each: 22⁷/₁₆ × 20¹/₂ in. diam. (57 × 52 cm diam.)
 OA 9225–9226

5. Tapestry: *Apollo*, from the series "Tenture des Mois Arabesques," ca. 1697
 Gobelins Manufactory (France, established 1662)
 Workshop of Jean de La Croix (French, 1662–1712)
 After Noël Coypel (French, 1628–1707), painter
 Wool and silk
 110¹/₄ × 87 in. (280 × 221 cm)
 OA 5418

6. Tapestry: *Le Jardin des Plantes*, from the series "Les Maisons Royales," 1662–1712
 Gobelins Manufactory (France, established 1662)
 Workshop of Jean de La Croix (French, 1662–1712)
 After Charles Le Brun (French, 1619–1690), painter
 Wool and silk
 125³/₁₆ × 78³/₈ in. (318 × 199 cm)
 OA 12182

7. Pair of painted doors, ca. 1670
 From the bedchamber of Queen Marie-Thérèse (1638–1683) at the Palais des Tuileries
 Painted and gilded wood
 Each: 119¹¹/₁₆ × 29⁷/₈ × 2³/₄ in. (304 × 76 × 7 cm)
 OA 12111–12112

8. Portrait of Philippe, duc d'Orléans, ca. 1687–1695
 Workshop of Bernard Perrot (Italian, active France; 1619–1709)
 Relief in molded glass with gilding
 14⁹/₁₆ × 12 × ⁹/₁₆ in. (37 × 30.5 × 1.5 cm)
 Gift of Honda-France, 1993, OA 11378

9. Pair of ewers with Bacchic scenes, ca. 1680–1685
 Nevers, France
 Bacchic scenes after Michel Dorigny (French, 1616–1665), painter
 Faience with polychrome decoration
 25³/₁₆ × 15³/₈ × 10⁵/₈ in. (64 × 39 × 27 cm) and 25³/₁₆ × 14¹⁵/₁₆ × 10¹/₄ in. (64 × 38 × 26 cm)
 Bequest of Albert Gérard, 1900, OA 5013/A–B

10. Wine cistern depicting "The Drunkenness of Bacchus," ca. 1680
 Nevers, France
 Faience with polychrome decoration
 19¹¹/₁₆ × 27⁹/₁₆ in. diam. (50 × 70 cm diam.)
 OA 11315

11. Chandelier, ca. 1700
Paris, France
Attributed to André-Charles Boulle (French, 1642–1732; master before 1666)
Gilt bronze
29⅛ × 31⅞ in. (74 × 81 cm)
Gift of Mr. and Mrs. Grog-Carven, 1979, OA 10513

12. Pair of candlesticks, ca. 1700
After Nicolas Delaunay (French, 1646–1727; master in 1672), silversmith;
After Corneille van Clève (French, 1646–1732), sculptor
Gilt bronze
Each: 14¾ × 6⅞ in. diam. (37.5 × 17.4 cm diam.)
Gift of Claude Sère, 2011, OA 12372/1–2

13. Pair of ewers, ca. 1700
After Nicolas Delaunay (French, 1646–1727; master in 1672), silversmith
Gilt bronze
Each: 12³⁄₁₆ × 7¹⁄₁₆ × 5⅛ in. (31 × 18 × 13 cm)
Gift of the heirs of Jacques Guerlain through the Société des Amis, 1965, OA 10264

2: THE GEMMES DE LA COURONNE: THE FRENCH CROWN COLLECTION OF HARDSTONES

14. Tazza (footed tray), ca. 1640
Paris, France
Mounts: attributed to François Roberday (French, active 1621–1651)
Sardonyx and silver gilt
3 × 12 × 9³⁄₁₆ in. (7.7 × 30.5 × 23.4 cm)
MR 250

15. Covered vase with handles, ca. 1630; with additions ca. 1680
Paris, France
Vase: lapis lazuli, ca. 1630
Mounts: silver gilt; attributed to François Roberday (French, active 1621–1651)
8¹⁄₁₆ × 6 × 6⁵⁄₁₆ in. (20.5 × 15.2 × 16 cm)
OA 5380

16. Cup with bust of a boy, ca. 1665
Cup and bust: sardonyx and agate, 1st century BC–AD 1st century, with later additions
Mounts (Paris, France): enameled gold, silver gilt, and agate; Louis Boursin (French, active 1697–1704), goldsmith
8⅛ × 7⅜ in. diam. (20.7 × 18.7 cm diam.)
OA 12

17. Ewer, ca. 1650
Paris, France
Agate with enameled gold mounts
10⁷⁄₁₆ × 4¹⁵⁄₁₆ × 3⁹⁄₁₆ in. (26.5 × 12.5 × 9 cm)
MR 231

18. Covered cup, ca. 1665
Cup (Byzantium): agate, 10th–11th century?
Mounts (Paris, France): enameled gold
6 × 6¹⁵⁄₁₆ in. diam. (15.2 × 17.7 cm diam.)
MR 222

19. Cup, ca. 1630–1635
Paris, France
Bloodstone with enameled gold mounts and rubies
6⅛ × 4⁵⁄₁₆ in. diam. (15.5 × 10.9 cm diam.)
MR 155

20. Cup, ca. 1650
Paris, France
Agate with enameled gold mounts
5⁵⁄₁₆ × 3¹⁵⁄₁₆ in. diam. (13.5 × 10 cm diam.)
OA 2034

21. Shell-shaped cup, ca. 1650 and ca. 1685
Cup (Byzantium): sardonyx, 10th–11th century, with later additions
Mounts (Paris, France): enameled gold, gilt copper, diamonds, sapphires, and rubies
7¹¹⁄₁₆ × 7¹⁄₁₆ in. diam. (19.5 × 18 cm diam.)
MR 123

22. Shell-shaped cup, ca. 1685
Cup (Milan, Italy): amethyst, second half of the 16th century
Mounts (Paris, France): enameled gold, gilt copper, rubies, and diamonds
7¹¹⁄₁₆ × 7½ × 6 in. (19.5 × 19 × 15.2 cm)
MR 218

23. Shell-shaped cup, ca. 1660–1670
Augsburg, Germany
Attributed to Johann Daniel Mayer (German, 17th century)
Jade; mounts of silver partly gilt, coral cameos, amethysts, peridots, citrines, and turquoises
14¹⁵⁄₁₆ × 13 × 7¼ in. (38 × 33 × 18.5 cm)
MR 185

24. Shell-shaped cup, ca. 1660–1670
Augsburg, Germany
Attributed to Johann Daniel Mayer (German, 17th century)
Marble; mounts of enameled silver gilt
8⅞ × 9⅞ × 7⁵⁄₁₆ in. (22.5 × 25.1 × 18.5 cm)
OA 6

25. Cup with dolphins, ca. 1650
Königsberg, Prussia [now Kaliningrad, Russia]
Amber and ivory with gilding
6 × 13⁷⁄₁₆ × 5½ in. (15.2 × 34.1 × 14 cm)
MR 261

26. Shell-shaped cup, ca. 1690–1700
Milan, Italy
Attributed to Giovanni Battista Metellino (Italian, active late
17th century)
Rock crystal; mounts of silver gilt
10⁵⁄₈ × 11⁷⁄₁₆ × 9³⁄₈ in. (27 × 29 × 23.8 cm)
MR 288

27. Handled vase or bucket, ca. 1685
Milan, Italy
Attributed to Giovanni Battista Metellino (Italian, active
late 17th century)
Rock crystal; mounts of silver gilt
6½ × 4¾ in. (16.5 × 12 cm)
MR 308

28. Christ at the Column, ca. 1670
Sculpture (Italy): bloodstone and rock crystal, ca. 1650
Mount (Paris, France): enameled gold and copper pedestal with
medallions representing the Four Evangelists
8⁵⁄₈ × 3⅛ × 3⅛ in. (22 × 7.9 × 7.9 cm)
MR 153

3: ROYAL GIFTS OF GOLD AND DIAMONDS

29. Presentation miniature of Louis XIV in a diamond-set
frame, ca. 1670
Workshop of Pierre and Laurent Le Tessier de Montarsy,
goldsmiths; Jean Petitot I (Swiss, active Paris; 1607–1691),
enameler
Miniature: painted enamel
Mount: rose-cut and table-cut diamonds set in silver and
enameled gold
2¹³⁄₁₆ × 1¹³⁄₁₆ in. (7.2 × 4.6 cm)
Gift of the Société des Amis, 2009, OA 12280

30. Snuff box with portraits of Louis XV and Marie
Leczinska, 1725–1726
Daniel Govaers (Flemish, active France; 1689–1750; master
in Paris in 1717), goldsmith; Jean-Baptiste Massé (?) (French,
1687–1767), enameler
Gold, black tortoiseshell (*piqué*), enamel, and diamonds
Inscribed on the bezel: "GOVERS À PARIS"
1³⁄₁₆ × 3³⁄₈ × 2⁹⁄₁₆ in. (3 × 8.5 × 6.5 cm)
Anonymous gift, 1978, OA 10670

31. Snuff box with portrait of Louis XV, 1726–1727
Daniel Govaers (Flemish, active France; 1689–1750; master
in Paris in 1717), goldsmith; attributed to Jean-Baptiste Du
Canel, enameler
Gold, enamel, diamonds, and emeralds
Inscribed on the bezel: "GOUERS À PARIS"; inscribed on the base:
"DONNÉ PAR LE ROI LOUIS XV AU SYNDIC LOUIS LE FORT 1727"
1⅛ × 3¼ × 2⁷⁄₁₆ in. (2.8 × 8.2 × 6.2 cm)
Gift of J. Paul Getty, 1962, OA 10196

32. Snuff box, 1738–1739
Gabriel Gallois (French, 1714–1754), goldsmith
Gold, enamel, and rose-cut diamonds
1³⁄₈ × 3³⁄₈ × 2¾ in. (3.5 × 8.5 × 7 cm)
Bequest of Georges Heine, 1929, OA 7976

33. Snuff box, 1740–1744
Thomas-Pierre Breton (French, d. 1767), goldsmith;
Pasquier-Rémi Mondon, chaser
Gold and diamonds
Inscribed on the bezel: "MONDON A PARIS"
1⁷⁄₁₆ × 3¹¹⁄₁₆ × 2¹³⁄₁₆ in. (3.7 × 9.3 × 7.2 cm)
Gift of the Duchess of Windsor, 1973, OA 10878

34. Snuff box with military trophies, 1759–1760
Dominique-François Poitreau (French, 1757–1781), goldsmith
Gold in four colors, diamonds, and emeralds
1⁵⁄₈ × 3¼ × 2½ in. (4.2 × 8.2 × 6.4 cm)
Bequest of baron Basile de Schlichting, 1914, OA 6827

35. Snuff box, ca. 1760–1770
Berlin, Germany
Made for Frederick the Great of Prussia (1712–1786)
Gold in four colors, agate, carnelian, amethyst, jasper, and
diamonds set in silver
1¾ × 3⁹⁄₁₆ × 2¹⁵⁄₁₆ in. (4.5 × 9 × 7.5 cm)
Bequest of Mr. and Mrs. Philippe Lenoir, 1874, OA 2142

36. Snuff box, ca. 1750
Dresden, Germany
Attributed to Heinrich Taddel (German, 1715–1798), goldsmith
Gold in four colors, carnelian, amethyst, and diamonds set
in silver
1⁹⁄₁₆ × 3¼ × 2¾ in. (4 × 8.2 × 7 cm)
Bequest of baron Basile de Schlichting, 1914, OA 6829

37. Snuff box depicting "The Birth of Bacchus," ca. 1755
Berlin, Germany
Attributed to Daniel Baudesson (French, active Berlin; 1716–1785),
goldsmith; Daniel Nikolaus Chodowiecki (German, 1726–1801),
enameler
After François Boucher (French, 1703–1770), painter
Gold, enamel, and diamonds set in silver
1⁹⁄₁₆ × 3⅛ × 2³⁄₈ in. (4 × 7.9 × 6 cm)
Bequest of the baronne Salomon de Rothschild, 1922, OA 7683

38. Bust of Louis XV, 1760
 Sèvres Porcelain Manufactory (France, established 1756)
 After Jean-Baptiste Lemoyne the younger (French, 1704–1778),
 sculptor
 Soft-paste biscuit porcelain
 14⁹/₁₆ × 10¼ × 6¹¹/₁₆ in. (37 × 26 × 17 cm)
 OA 12195

39. *Portière* with the arms of France, ca. 1740
 Gobelins Manufactory (France, established 1662)
 Workshop of Pierre François Cozette (French, 1714–1801) and
 Mathieu Monmerqué
 After Pierre-Josse Perrot (French, active at Gobelins 1724–1735),
 painter
 Wool and silk
 127¹⁵/₁₆ × 105½ in. (325 × 268 cm)
 OA 5042

4: THE ROYAL SILVERSMITHS

40. Pair of platters, 1723–1724
 Arms of William Hall, 2nd Viscount Gage (1718–1791)
 Attributed to Nicolas Besnier (French, 1686–1754; master in
 1714), silversmith
 Silver
 Engraved: "courage sans peur"
 Diameter (each): 12¹³/₁₆ in. (31 cm)
 Gift of Stavros Niarchos, 1955, OA 9655

41. Pair of candlesticks, 1732–1733
 Probable arms of Anne-Sophie Serre de Saint-Roman,
 marquise de Buzancy
 Thomas Germain (French, 1673–1748; master in 1720),
 silversmith
 Silver
 Each: 9¹³/₁₆ × 5¹¹/₁₆ × 5¹¹/₁₆ in. (25 × 14.5 × 14.5 cm)
 Bequest of Elisabeth Mège, 1958, OA 9955

42. Covered bowl (*écuelle*) and stand bearing the coat of
 arms of Cardinal da Mota e Silva, 1733–1734
 Thomas Germain (French, 1673–1748; master in 1720),
 silversmith
 Silver gilt
 5⅛ × 11¹³/₁₆ × 7½ in. (13 × 30 × 19 cm)
 Gift of the Société des Amis, 1907, OA 6118

43. Tureen and stand, 1754–1755
 François-Thomas Germain (French, 1726–1791), silversmith;
 completed by Jean-Charles Roquillet-Desnoyers (French; master
 in Paris in 1772), ca. 1780
 Silver
 Inscribed: "f. t. germain sculpᴿ orfᴱ du roi fecit aux galleries
 du louvre a paris 1755"
 10¹³/₁₆ × 22¼ × 11⁷/₁₆ in. (27.5 × 56.5 × 29 cm)
 On loan to the Département des Objets d'art from the Musée
 national des châteaux des Versailles et de Trianon, Bequest of
 viscountess Vigier, 1970, V 4721

44. Saltcellar, 1758–1759
 From the Penthièvre-Orléans service
 Antoine-Sébastien Durand (French, 1712–1787; master ca. 1740),
 silversmith
 Silver
 6⅛ × 8⁹/₁₆ × 4⅝ in. (15.5 × 21.7 × 11.8 cm)
 Gift of Pierre David-Weill, 1971, OA 10412

45. Pair of wine coolers, 1759–1760
 From the Penthièvre-Orléans service
 Edme-Pierre Balzac (French, 1705–after 1786; master in 1739),
 silversmith;
 Liners added by Jean-Baptiste-Claude Odiot (French, 1763–1850;
 master in 1785), ca. 1820
 Silver
 Each: 9⅝ × 11 × 9⅜ in. (24.5 × 28 × 23.8 cm)
 OA 11116–11117

46. Pair of tureen stands, 1770–1771
 From the Penthièvre-Orléans service
 Robert-Joseph Auguste (French, 1723–1805; master in
 1757), silversmith
 Silver
 1⁹/₁₆ × 16⁷/₈ in. (4 × 42.3 cm) and 1⁹/₁₆ × 15¹⁵/₁₆ in. (4 × 40.5 cm)
 Gift of the Société des Amis, 1994, OA 11352 and 11393

47. Pair of candelabra, 1757
 Made for Joseph I, king of Portugal (1714–1777)
 François-Thomas Germain (French, 1726–1791), silversmith
 Silver
 Inscribed: "fait par f-t germain sculpᴿ orfᴿᴱ du roy aux
 galleries du louvre a paris 1757. du nᴼ 52"; monogram: "ᴘ 1ᴼ"
 Each: 18⅛ × 12⅝ in. (46 × 32 cm)
 OA 10961–10962

5: SÈVRES DIPLOMATIC GIFTS

48. Plate (*assiette à petites palmes*) with green ground, 1756
From the service offered by Louis XV to Frederick V, king of
Denmark (1723–1766)
Sèvres Porcelain Manufactory (France, established 1756)
Soft-paste porcelain
Diameter: 9¹³⁄₁₆ in. (25 cm)
Gift of Albert and Paul Pannier, 1918, OA 7197

49. Plate (*assiette à guirlandes*) decorated with green
ribbons, 1757
From the service offered by Louis XV to Empress Maria Theresa of
Austria (1717–1780)
Sèvres Porcelain Manufactory (France, established 1756)
Soft-paste porcelain
Diameter: 9¹³⁄₁₆ in. (25 cm)
Gift of Albert and Paul Pannier, 1918, OA 7192

50. Fruit plate (*compotier mosaïque*), 1759
From the service offered by Louis XV to the Elector Palatine
Charles Theodore of Bavaria (1724–1799)
Sèvres Porcelain Manufactory (France, established 1756)
Soft-paste porcelain
Diameter: 8⅝ in. (22 cm)
Bequest of Mrs. Élise Dosne-Thiers, 1881, Th 1180

51. Wine cooler, 1774
From the service offered by Louis XV to Maria Carolina, queen of
Naples (1752–1814)
Sèvres Porcelain Manufactory (France, established 1756)
Soft-paste porcelain
6¹¹⁄₁₆ × 7¹⁄₁₆ × 9¹⁄₁₆ in. (17 × 18 × 23 cm)
Gift of Marcelle Brunet, 1980, OA 10879

52. Platter (*plat à contours*), 1775
From the dinner service offered by Louis XV to his granddaughter
Maria Luisa of Parma (1751–1819)
Sèvres Porcelain Manufactory (France, established 1756)
François-Antoine Pfeiffer (active France 1741–1800), painter;
Pierre-Nicolas Pierre (French, active 1759–1776), gilder
Hard-paste porcelain
1⁹⁄₁₆ × 14¹⁵⁄₁₆ × 10⅝ in. (4 × 38 × 27 cm)
OA 11022

53. Tureen (*pot à oille*) and stand, 1784
From the dinner service offered by Louis XVI to Gustav III, king of
Sweden (1746–1792), or from a second, identical service made for
Queen Marie-Antoinette
Sèvres Porcelain Manufactory (France, established 1756)
Tureen: Jacques-François Micaud (French, active 1757–1810),
painter; Étienne-Henri Le Guay (French, active 1748–1749,
1751–1796), gilder
Stand: Jacques-François-Louis de Laroche (French, active
1758–1802), painter; Henri-François Vincent the elder (French,
active 1753–1800), gilder
Soft-paste porcelain
Tureen: 9¹³⁄₁₆ × 11 × 9¹⁄₁₆ in. (25 × 28 × 23 cm);
stand: 18⅛ × 18³⁄₁₆ × 14¾ in. (46 × 46.2 × 37.5 cm)
OA 11979–11980

54. Soup plate (*plat à potage*), 1785
From the service offered by Louis XVI to Archduke Ferdinand
of Austria (1754–1806)
Sèvres Porcelain Manufactory (France, established 1756)
Cyprien-Julien Hirel de Choisy (French, active 1770–1812),
painter; Michel-Barnabé Chauvaux the elder (French, active
1752–1788), gilder
Soft-paste porcelain
Diameter: 9⁷⁄₁₆ in. (24 cm)
Gift of the Old Royal Manufactory of Limoges, 1999, OA 11916

6: THE MARCHANDS-MERCIERS,
THE DEALERS IN LUXURY GOODS

55. Tea service (*nécessaire*), 1717–1722
Belonged to the duchesse d'Orléans (1677–1749), wife of the
Régent, Philippe d'Orléans (1674–1723)
Paris, France
Chinese porcelain decorated with gold (*piqué d'or*), gold, and
rock crystal; kingwood and mahogany case with gilt-bronze
mounts, and velvet
7⁵⁄₁₆ × 12⁹⁄₁₆ × 9⁵⁄₁₆ in. (20.2 × 31.9 × 23.6 cm)
OA 12237

56. Figure of a Naiad, 1756
Vincennes/Sèvres Porcelain Manufactory (France, established
1756)
Charles-Nicolas Dodin (French, 1734–1803), painter; Jean-Claude
Duplessis *père* (French and Italian, active Paris; ca. 1695–1774),
metalworker
Soft-paste porcelain and gilt bronze
14³⁄₁₆ × 20½ × 12³⁄₁₆ in. (36 × 52 × 31 cm)
Bequest of Mrs. Élise Dosne-Thiers, 1881, Th 693

57. *Table à la Bourgogne* (mechanical desk), ca. 1760
Jean-François Oeben (German, active France; 1721–1763; master in 1761), cabinetmaker
Tulipwood, kingwood, sycamore, and purple wood on an oak carcase; gilt bronze; red Griotte marble, silk, glass, and velvet
Open position: 56⁵/₁₆ × 27⁹/₁₆ × 20¹/₁₆ in. (143 × 70 × 51 cm)
Gift of René Penard y Fernandez in memory of his brother Richard, 1960, OA 10001

58. Pair of vases with candle branches (*pot pourris à bobèches*), ca. 1762
Made for Madame de Pompadour (1721–1764)
Sèvres Porcelain Manufactory (France, established 1756)
Charles-Nicolas Dodin (French, 1734–1803), painter
Soft-paste porcelain
Each: 9¹/₁₆ × 5⁷/₈ × 3 in. (23 × 15 × 7.7 cm)
OA 11306–11307

59. Coffee grinder, 1756–1757
Made for Madame de Pompadour (1721–1764)
Jean Ducrollay (French, ca. 1708–after 1776), goldsmith
Gold in three colors, steel, and ivory
3³/₄ × 2¹/₁₆ in. (9.5 × 5.2 cm)
OA 11950

60. Tea table with Sèvres porcelain plaques, 1774
Made for Madame du Barry (1743–1793)
Martin Carlin (German, active France, ca. 1730–1785; master in 1766), cabinetmaker;
Charles-Nicolas Dodin (French, 1734–1803), painter
Oak, mahogany, and purple wood veneer; gilt-bronze mounts; and soft-paste porcelain
32⁵/₁₆ × 31¹/₂ in. (82 × 80 cm)
OA 10658

61. Snuff box with Sèvres porcelain plaques, 1756–1759
Sèvres Porcelain Manufactory (France, established 1756)
Jean Ducrollay (French, ca. 1708–after 1776), goldsmith
Gold in two colors and soft-paste porcelain
1¹/₄ × 2⁵/₁₆ × 1³/₄ in. (3.1 × 5.9 × 4.5 cm)
OA 12148

62. Snuff box with lacquer, 1761–1763
Jean-Marie Tiron, called Tiron de Nanteuil (French, active 1748–1781), goldsmith
Gold, red, and black lacquer with piqué in four colors
1¹/₂ × 3¹/₈ × 2⁵/₁₆ in. (3.8 × 8 × 5.8 cm)
Bequest of baronne Salomon de Rothschild, 1922, OA 7636

63. Snuff box depicting "Bacchus Embracing Ariadne," 1764–1765 and 1773–1774
Pierre-François Drais (French, ca. 1726–1788), goldsmith
Gold and enamel
Inscribed on the bezel: "MADAME DU BARRY AU BIEN AIMÉ"
1³/₈ × 3¹/₈ × 2³/₈ in. (3.5 × 8 × 6 cm)
Bequest of baron Basile de Schlichting, 1914, OA 6821

64. Snuff box depicting "Sacrifice to Love," 1775–1776
Charles Le Bastier (French, master in 1754; active until 1783), goldsmith
Gold and enamel
Inscribed on the bezel: "DU PT DUNKERQUE"
1³/₁₆ × 2⁹/₁₆ × 1⁷/₈ in. (3 × 6.5 × 4.8 cm)
Bequest of baron Basile de Schlichting, 1914, OA 6781

65. Snuff box with genre scenes, 1760–1761
Mathieu Coiny *fils* (French, b. 1723; master in 1755; recorded 1788), goldsmith
Gold in two colors, diamonds, and enamel
1³/₄ × 3⁷/₁₆ × 2¹⁵/₁₆ in. (4.5 × 8.7 × 7.5 cm)
Bequest of baron Basile de Schlichting, 1914, OA 6767

66. Snuff box depicting "Venus and Mars," 1762–1775
Noël Hardivilliers (French, active 1729–1771), goldsmith
Gold in four colors and diamonds
1⁷/₁₆ × 3³/₈ × 2¹¹/₁₆ in. (4 × 8.5 × 6.8 cm)
Bequest of baron Basile de Schlichting, 1914, OA 6765

67. Snuff box with scenes from antiquity, 1768–1770
Pierre-François Drais (French, ca. 1726–1788), goldsmith
After Jacques-Joseph de Gault (French, ca. 1738–after 1812), painter
Gold and enamel
1⁵/₁₆ × 3 × 2³/₁₆ in. (3.4 × 7.6 × 5.6 cm)
Bequest of baron Basile de Schlichting, 1914, OA 6777

68. Snuff box with scenes from antiquity, 1770–1771
Pierre-François Drais (French, ca. 1726–1788), goldsmith
After Jacques-Joseph de Gault (French, ca. 1738–after 1812), painter
Gold and mother-of-pearl
1⁵/₁₆ × 3¹/₄ × 2¹/₂ in. (3.3 × 8.3 × 6.4 cm)
Bequest of Mr. and Mrs. Philippe Lenoir, 1874, OA 2204

69. Snuff box with "The Triumph of Silenus," 1773
Pierre-François Drais (French, ca. 1726–1788), goldsmith
Gold, red agate, and enamel
1⁷/₁₆ × 3³/₁₆ × 2⁵/₁₆ in. (3.6 × 8.1 × 5.9 cm)
Bequest of Georges Heine, 1929, OA 7997

7: LOUIS XVI AS A PATRON OF THE ARTS

70. Bust of Louis XVI, ca. 1779
 After Augustin Pajou (French, 1730–1809), sculptor
 Marble
 33$^{1}/_{16}$ × 21$^{5}/_{8}$ × 14$^{3}/_{16}$ in. (84 × 55 × 36 cm)
 Département des Sculptures, MR 2653

71. The "Temple of Love," back panel of a *lit à la duchesse*
 (state bed), ca. 1775
 Gobelins Manufactory (France, established 1662)
 Workshop of Jacques Neilson (English, active France; 1714–1788)
 After Alexis-Simon Belle (French, 1674–1734) and Maurice
 Jacques (French, ca. 1712–1784), painters
 Low-warp tapestry; wool and silk
 122$^{7}/_{16}$ × 89$^{3}/_{4}$ in. (311 × 228 cm)
 OA 9546

72. Figure of Henri de La Tour d'Auvergne, vicomte de
 Turenne, model made in 1783
 Sèvres Porcelain Manufactory (France, established 1756)
 After Augustin Pajou (French, 1730–1809), sculptor
 Hard-paste biscuit porcelain
 18$^{1}/_{2}$ × 8$^{5}/_{8}$ × 6$^{11}/_{16}$ in. (47 × 22 × 17 cm)
 OA 11059

73. Figure of Sébastien Le Prestre de Vauban, model made
 ca. 1780s
 Sèvres Porcelain Manufactory (France, established 1756)
 Reduction of the plaster cast by Charles-Antoine Bridan (French,
 1730–1805), sculptor
 Hard-paste biscuit porcelain
 19$^{11}/_{16}$ × 9$^{1}/_{16}$ × 7$^{7}/_{8}$ in. (50 × 23 × 20 cm)
 OA 11831

74. Vase: "Jardin à dauphins," 1781
 Given to Prince Henry of Prussia (1762–1802) by Louis XVI
 Sèvres Porcelain Manufactory (France, established 1756)
 Pierre-Joseph Rosset *l'aîné* (French, active 1753–1799), painter;
 Jean-Pierre Boulanger (French, active 1754–1785), gilder
 Hard-paste porcelain
 19$^{5}/_{16}$ × 6$^{7}/_{16}$ × 14$^{9}/_{16}$ in. (49 × 16.3 × 37 cm)
 Gift of Philippe Olivier and Laurent Kraemer, 1997, OA 11854

75. Vase in the form of a perfume burner decorated with a
 siren and a female faun, ca. 1775
 Made for the duc d'Aumont
 Pierre Gouthière (French, 1732–1813), bronze worker
 Serpentine marble and gilt bronze
 14$^{15}/_{16}$ × 14$^{15}/_{16}$ × 11$^{13}/_{16}$ in. (38 × 38 × 30 cm)
 OA 5178

76. Great vase, ca. 1780
 Made for the duc d'Aumont
 Pierre Gouthière (French, 1732–1813), bronze worker
 Vase: Chinese celadon, 18th century
 Mounts (Paris, France): gilt bronze
 Porcelain, red porphyry, and gilt bronze
 22$^{13}/_{16}$ × 14$^{15}/_{16}$ × 11$^{13}/_{16}$ in. (58 × 38 × 30 cm)
 OA 5514

77. Pair of low cabinets with Florentine pietre-dure
 panels, ca. 1765–1770
 Made for the duc d'Aumont
 Joseph Baumhauer (German, active France; d. 1772), cabinetmaker
 Pietre dure (hardstones), ebony, tortoiseshell, brass, pewter,
 marble, and gilt-bronze mounts
 Each: 40$^{3}/_{16}$ × 30$^{5}/_{16}$ × 19$^{5}/_{16}$ in. (102 × 77 × 49 cm)
 OA 5448–5449

8: THE PRIVATE COLLECTION OF
MARIE-ANTOINETTE

78. Bust of Marie-Antoinette, 1782
 Sèvres Porcelain Manufactory (France, established 1756)
 After Louis-Simon Boizot (French, 1743–1809), sculptor
 Hard-paste biscuit porcelain
 15$^{3}/_{4}$ × 9$^{5}/_{8}$ × 5$^{7}/_{8}$ in. (40 × 24.5 × 15 cm)
 Anonymous gift in memory of Sir Robert Abdy, 1982, OA 10898

79. Snuff box with portraits of the royal family, 1785
 Adrien-Jean-Maximilien Vachette (French, 1753–1839; master in
 Paris in 1779), goldsmith
 Gold, enamel, and miniatures
 1$^{1}/_{4}$ × 3$^{1}/_{16}$ × 2$^{5}/_{16}$ in. (3.2 × 7.8 × 5.8 cm)
 Bequest of baronne Salomon de Rothschild, 1922, OA 7681

80. Box (*bonbonnière*) with portrait of the comte d'Artois
 (the future King Charles X), late 18th century
 Peter Adolf Hall (Swedish, active France; 1739–1793), goldsmith
 Gold in two colors and miniature on ivory
 1$^{1}/_{8}$ × 1$^{5}/_{16}$ in. diam. (2.8 × 3.4 cm diam.)
 Département des Arts Graphiques, Gift of Félix Doistau, 1919,
 RF 5013

81. Box (*bonbonnière*) with portrait of the comte de
 Provence (the future King Louis XVIII), early
 19th century
 After Joseph Boze (French, 1745–1826), miniature painter
 Gold, tortoiseshell, and gouache
 $^{7}/_{8}$ × 3$^{1}/_{2}$ in. diam. (2.2 × 8.9 cm diam.)
 Bequest of Mr. and Mrs. Philippe Lenoir, 1874, OA 2242

82. Armchair with the cypher of Marie-Antoinette, ca. 1788
From a suite probably made for the *cabinet de toilette* (dressing room) of Marie-Antoinette at the Château de Saint-Cloud
Jean-Baptiste-Claude Sené (French, 1747/1748–1803; master in 1769), joiner
Gilded walnut and silk-covered upholstery
$36^{13}/_{16} \times 24^{13}/_{16} \times 25^{5}/_{16}$ in. (93.5 × 63 × 64.3 cm)
On loan to the Département des Objets d'art from the Musée national des châteaux des Versailles et de Trianon, V5357

83. Rolltop desk, 1784
Made for the apartments of Marie-Antoinette at the Palais des Tuileries
Jean-Henri Riesener (German, active France; 1734–1806), cabinetmaker
Oak and deal frame; veneer of sycamore, purple wood, and tulipwood; polychrome wood marquetry; gilt-bronze mounts
$40^{9}/_{16} \times 44^{1}/_{2} \times 25^{3}/_{16}$ in. (103 × 113 × 64 cm)
OA 5226

84. Pair of wall lights with quivers and turtle doves, 1788
Made for the *cabinet de toilette* (dressing room) of Marie-Antoinette at the Château de Saint-Cloud
Pierre-François Feuchère (French, 1737–1823; master in 1763), bronze maker
Gilt bronze
Each: $28^{3}/_{8} \times 15^{3}/_{4} \times 9^{13}/_{16}$ in. (72 × 40 × 25 cm)
OA 5256–5257

85. Pair of vases, ca. 1780
Vases: Chinese porcelain, ca. 1700
Mounts (Paris, France): gilt bronze
Each: $11^{9}/_{16} \times 6^{5}/_{8} \times 3^{7}/_{8}$ in. (29.3 × 16.8 × 9.8 cm)
OA 5267/1–2

86. Pair of bowls, ca. 1780
Paris, France
Rock crystal and gilt bronze
Each: $4^{5}/_{16} \times 4^{3}/_{4}$ in. (11 × 12 cm)
OA 14

87. Cup, ca. 1785
Paris, France
Bloodstone and gilt-bronze mounts
$5^{1}/_{16} \times 3^{1}/_{8} \times 2^{9}/_{16}$ in. (12.8 × 8 × 6.5 cm)
Gift of Daniel Pasgrimaud, 1988, OA 11172

88. Statuette of a peddler, ca. 1702–1703
Germany
Ivory, silver gilt, diamonds, and painted enamel
$3^{5}/_{16} \times 1^{5}/_{16} \times 1^{15}/_{16}$ in. (8.4 × 3.4 × 4.9 cm)
MR 380.33

89. Perfume burner, 1784–1785
Charles Ouizille (French, ca. 1744–1830), goldsmith;
Jacques-Joseph de Gault (French, ca. 1738–after 1812), painter
Agate, jasper, and gold; miniatures under glass
$10^{13}/_{16} \times 4^{3}/_{4} \times 3^{5}/_{8}$ in. (27.5 × 12 × 9.2 cm)
OA 10907

90. Sarcophagus, ca. 1785
François Rémond (French, ca. 1747–1812; master in 1774), bronze worker, gilder
Probably after a design by Jean Démosthène Dugourc (French, 1749–1825)
Jade and jasper; mounts of gilt bronze
$8^{7}/_{16} \times 8^{5}/_{8} \times 3^{9}/_{16}$ in. (21.5 × 22 × 9 cm)
OA 15

91. Pedestal, 1785
Charles Ouizille (French, ca. 1744–1830) and Pierre-François Drais (French, ca. 1726–1788), goldsmiths
Jade, jasper, marble, gold, and aventurine
$10^{1}/_{16} \times 8^{7}/_{16} \times 8^{7}/_{16}$ in. (25.5 × 21.5 × 21.5 cm)
OA 5328

92. Jewel coffer, 1786–1787
Charles Ouizille (French, ca. 1744–1830) and Pierre-François Drais (French, ca. 1726–1788), goldsmiths
Moss agate, jaspar, marble, and gold
$9^{1}/_{4} \times 11 \times 8^{7}/_{8}$ in. (23.5 × 28 × 22.5 cm)
OA 5343

93. Tabletop
Petrified wood
$27^{9}/_{16} \times 16^{9}/_{16} \times 1^{9}/_{16}$ in. (70 × 42 × 4 cm)
OA 5271

ACKNOWLEDGMENTS

PICTURE CREDITS

The curators of the exhibition wish to thank Diane B. Wilsey, President of the Board of Trustees of the Fine Arts Museums of San Francisco, and Henri Loyrette, President-Director of the Musée du Louvre, who entrusted us with this ambitious project. Our thanks are also given to the chief officers at the Fine Arts Museums, Richard Benefield, Deputy Director; Michele Gutierrez-Canepa, Chief Administrative Officer and Chief Financial Officer; and Julian Cox, Founding Curator of Photography and Chief Administrative Curator; and at the Louvre, Hervé Barbaret, Chief Executive Director; and Claudia Ferrazzi, Assistant General Administrator.

The Fine Arts Museums wish to thank their staff involved in this project: Krista Brugnara, Director of Exhibitions, for her skills in developing this exhibition; Maria Santangelo, Curator of Special Projects, European Decorative Arts and Sculpture, for her hard work on the checklists, the catalogue, and the installation; and Therese Chen, Director of Collections Management, and her staff for the complex undertaking of shipping and registration. Leslie Dutcher, Acting Director of Publications, steered this book with great tact together with Danica Hodge and Lucy Medrich. Further thanks are given to the catalogue team: Jennifer Boynton for her deft editing, Bob Aufuldish for his elegant design, Nerissa Vales and Sue Medlicott at The Production Department for their detailed production work, and Mary DelMonico of DelMonico Books · Prestel for working with us to create such a beautiful publication. Many others in the museum have contributed their expertise to the exhibition, including Lesley Bone, Head Objects Conservator; Sarah Gates, Textiles Conservator; Bill White and Elizabeth Etienne, Exhibition Designers; Bill Huggins, Lighting Designer; Daniel Meza, Director of Graphic Design, and his department; and Craig Harris, Director of Exhibition and Collection Support, and his team of museum technicians.

The Musée du Louvre wishes to thank Béatrix Saule, Director of the National Museum of Versailles and Trianon Palaces; Juliette Armand, Director of the Department of Cultural Production; Geneviève Bresc-Bautier, Director of the Department of Sculptures; Christophe Monin, Director of Development and Sponsorship; and Carel Van Tuyll, Director of Prints and Drawings. Thanks are also given to the staff involved in this project: Catherine Bossis, David Brouzet, Thibaut Bruttin, Suzelyne Chandon, Roberta Cortopassi, Béatrice Coullaré, Laurent Creuzet, Frédéric Dassas, Anne-Gabrielle Durand, Sonia Février, Catherine Gougeon, Sophie Kammerer-Farant, Céline Marchand, Fatiha Mihoubi, Laurence Petit, Marie-Hélène de Ribou, Céline Rebière-Plé, and Carole Treton.

Published by the Fine Arts Museums of San Francisco and DelMonico Books • Prestel, on the occasion of the exhibition

Royal Treasures from the Louvre: Louis XIV to Marie-Antoinette

Legion of Honor, San Francisco, November 17, 2012–March 17, 2013

This exhibition is organized by the Fine Arts Museums of San Francisco with the
exceptional collaboration of the Musée du Louvre, Paris.

GRAND PATRONS • Cynthia Fry Gunn and John A. Gunn

MAJOR PATRON • San Francisco Auxiliary of the Fine Arts Museums

Generous support is also provided by the Richard B. Gump Trust.

This catalogue is published with the assistance of the Andrew W. Mellon Foundation Endowment for Publications.

Library of Congress Cataloging-in-Publication Data
Bascou, Marc.
 Royal treasures from the Louvre : Louis XIV to Marie-Antoinette / Marc Bascou, Michèle Bimbenet-Privat, Martin Chapman.
 pages cm
 Published by the Fine Arts Museums of San Francisco and DelMonico Books Prestel, on the occasion of the exhibition Royal Treasures from the Louvre: Louis XIV to Marie-Antoinette, Legion of Honor Museum, San Francisco, November 17, 2012–March 17, 2013.
 This exhibition is organized by the Fine Arts Museums of San Francisco in collaboration with the Musée du Louvre, Paris.
 Includes bibliographical references.
 ISBN 978-0-88401-134-7
 1. Decorative arts--France--History--17th century--Exhibitions. 2. Decorative arts--France--History--18th century--Exhibitions. 3. France--Kings and rulers--Art collections--Exhibitions. 4. Decorative arts--France--Paris--Exhibitions. 5. Musée du Louvre--Exhibitions. I. Legion of Honor (San Francisco, Calif.) host institution. II. Musée du Louvre. III. Fine Arts Museums of San Francisco. IV. Title.
 NK947.B37 2012
 745.0944'07444361--dc23
 2012030615

FINE ARTS MUSEUMS OF SAN FRANCISCO
Golden Gate Park
50 Hagiwara Tea Garden Drive
San Francisco, CA 94118-4502
www.famsf.org

Leslie Dutcher, Acting Director of Publications
Danica Hodge, Editor
Lucy Medrich, Associate Editor

Edited by Jennifer Boynton
Translations by Chris De Angelis
Proofread by Susan Richmond and Dianne B. Woo
Designed by Bob Aufuldish, Aufuldish & Warinner
Typeset by Bob Aufuldish and Hope Meng
Separations by GHP, West Haven, Connecticut
Production management by The Production Department
Printed and bound in China by Midas Printing International

DelMonico Books is an imprint of Prestel,
a member of Verlagsgruppe Random House GmbH

Prestel Verlag
Neumarkter Strasse 28
81673 Munich
Germany
TEL: 49 89 4136 0
FAX: 49 89 4136 2335
www.prestel.de

Prestel Publishing Ltd.
4 Bloomsbury Place
London WC1A 2QA
United Kingdom
TEL: 44 20 7323 5004
FAX: 44 20 7636 8004

Prestel Publishing
900 Broadway, Suite 603
New York, NY 10003
TEL: 212 995 2720
FAX: 212 995 2733
EMAIL: sales@prestel-usa.com
www.prestel.com

OPENING ILLUSTRATIONS
Portière with the arms of France, ca. 1740 (detail of cat. 39)
Ewer, ca. 1650 (cat. 17)